OVER THE COASTS

AN AERIAL VIEW OF GEOLOGY

*Steep cliffs above Bear Harbor on northern
California's Forgotten Coast.*

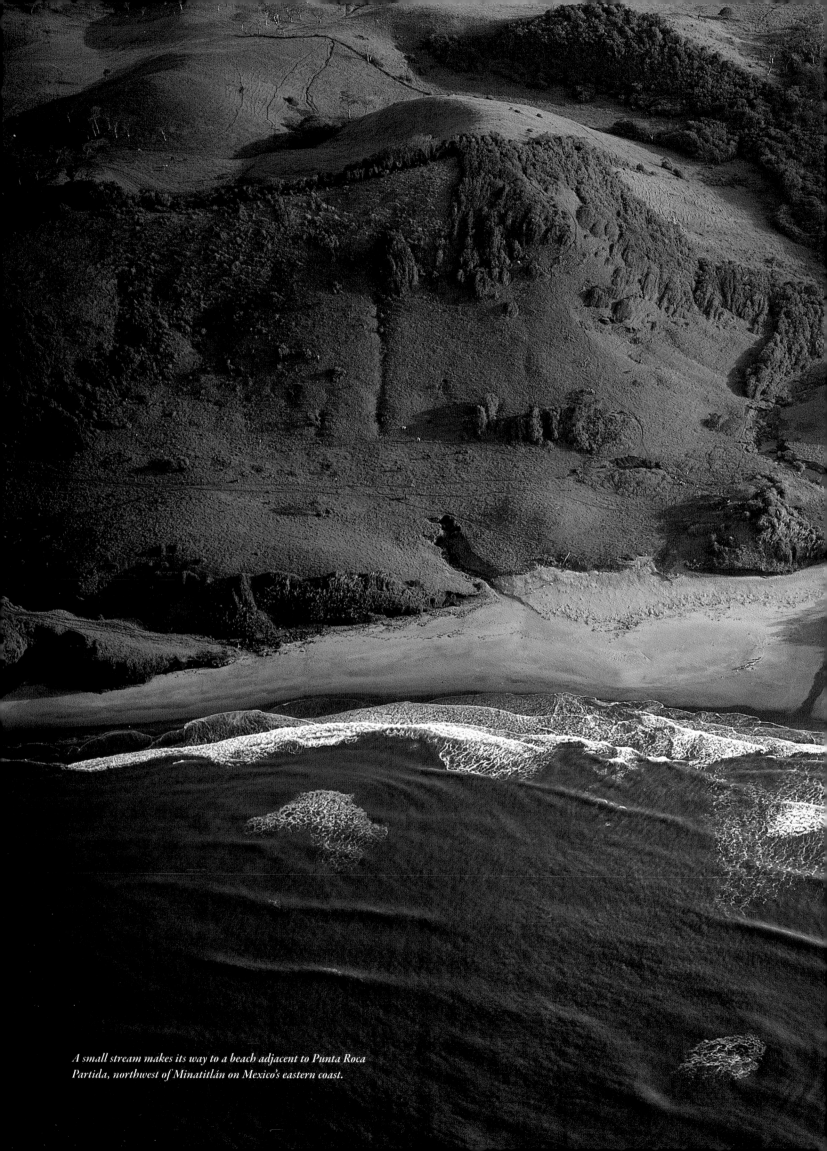

A small stream makes its way to a beach adjacent to Punta Roca Partida, northwest of Minatitlán on Mexico's eastern coast.

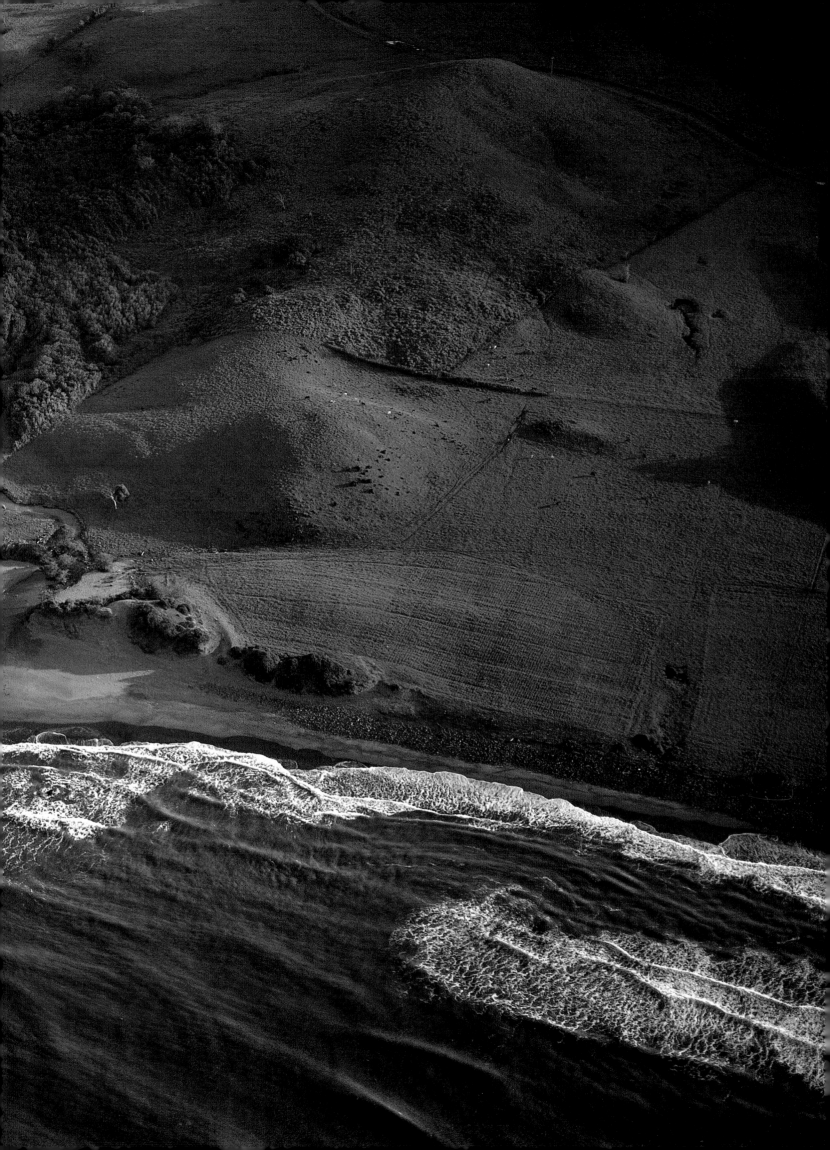

EDITORS: STUART WALDMAN AND ELIZABETH MANN
DESIGN & ILLUSTRATION: LESLEY EHLERS DESIGN

ALSO BY MICHAEL COLLIER
OVER THE MOUNTAINS
AN AERIAL VIEW OF GEOLOGY
OVER THE RIVERS
AN AERIAL VIEW OF GEOLOGY

Cataloging-in-publication data available from the Library of Congress

Printed in China

OVER THE COASTS

AN AERIAL VIEW OF GEOLOGY

MICHAEL COLLIER

MIKAYA PRESS
NEW YORK

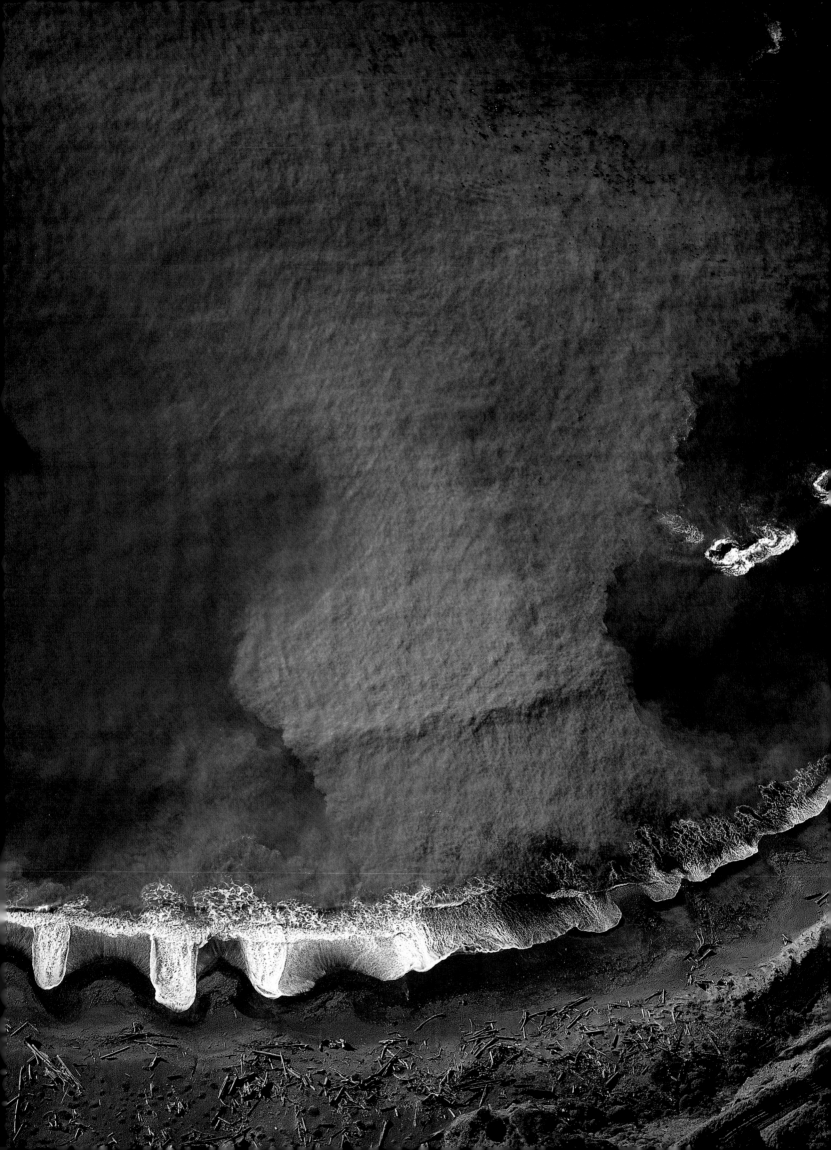

CONTENTS

Currents carry sediment away from a wave-swept beach north of Point Arena, California.

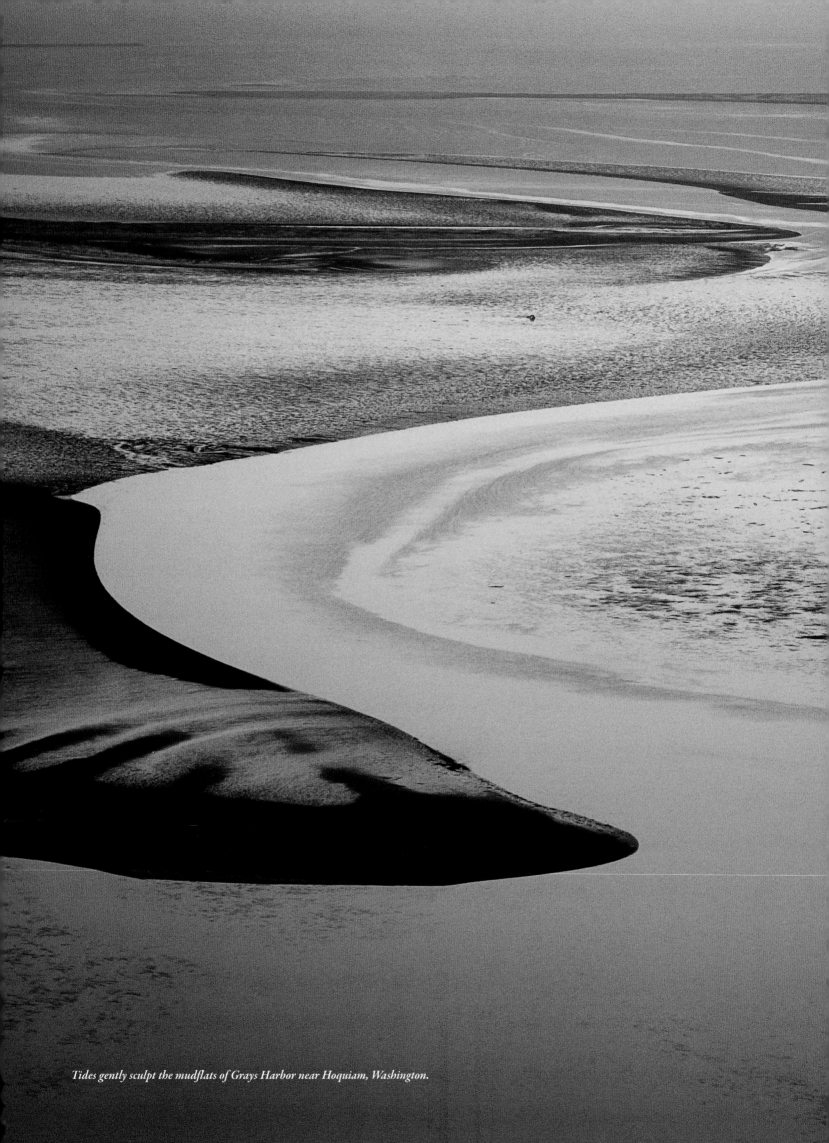

Tides gently sculpt the mudflats of Grays Harbor near Hoquiam, Washington.

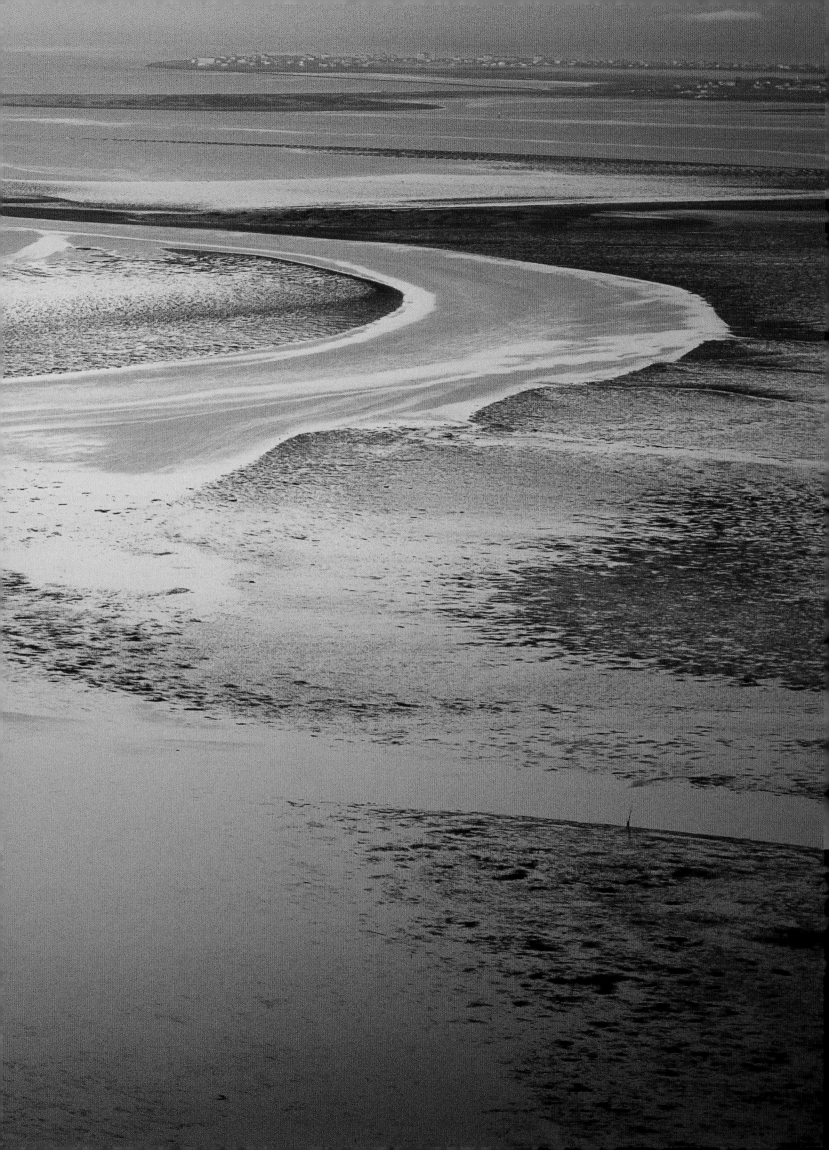

Introduction

Coastlines that separate deep ocean from dry continent are blessed with an astonishing array of moods —angry, serene, tense, placid, explosive, confused. How could sunrise glowing upon the waters of Cape Cod Bay be any more peaceful? How could the winter waves of a frothy-mawed monster rage any more wildly against the cliffs of California's Forgotten Coast?

No other environment varies as rapidly or continuously as the coast. Waves redefine beaches second by second. Tides roll the boundary between land and sea back and forth between their fingers every day. Since the ice ages began two million years ago, sea levels around the world have risen and fallen by hundreds of feet, as if the oceans were breathing in and then out. And over hundreds of millions of years, the earth's interior has repeatedly shrugged in its sleep, crumpling up mountain ranges and displacing shorelines by many miles. Change, whether measured in seconds or millennia, is the norm for coastal environments.

For years I've reveled in an aerial view of the earth. Sometimes, flying west at sunset, it seems that the world is small and that daylight could last forever. But my flying career got off to a rocky start. It was 1972. I'd spent many evenings walking the beaches of central California, sieving sand with my fingers, pondering the waves at my feet. I was mesmerized by the ocean, seduced by its water. When I climbed a 200-foot cliff behind the beach north of Point Arguello, my imagination flew west toward the horizon. I came up with the bird-brained idea of leaping off that cliff, nominally supported by a hang glider I'd just purchased secondhand—no questions asked, no instructions given. The first and final sortie involved multiple crashes at 40-foot intervals on my way down the cliff. I found myself lying on a beach, upside down, tangled in guy-wires, shaking with laughter at my foolishness. The beach sand felt good between my unbroken toes.

An inauspicious beginning, to be sure, but the ill-fated flight nevertheless struck a chord that continues to resonate. An earthbound bond was broken and I've never looked back. I've since learned to fly a little better, and with this book I want to share that aerial vantage point. I want to retell from the air the stories of an endlessly energetic ocean whose tides, waves, surges and storms have been shaping shorelines for billions of years.

Waves relentlessly roll left toward the California coast at Morro Bay.

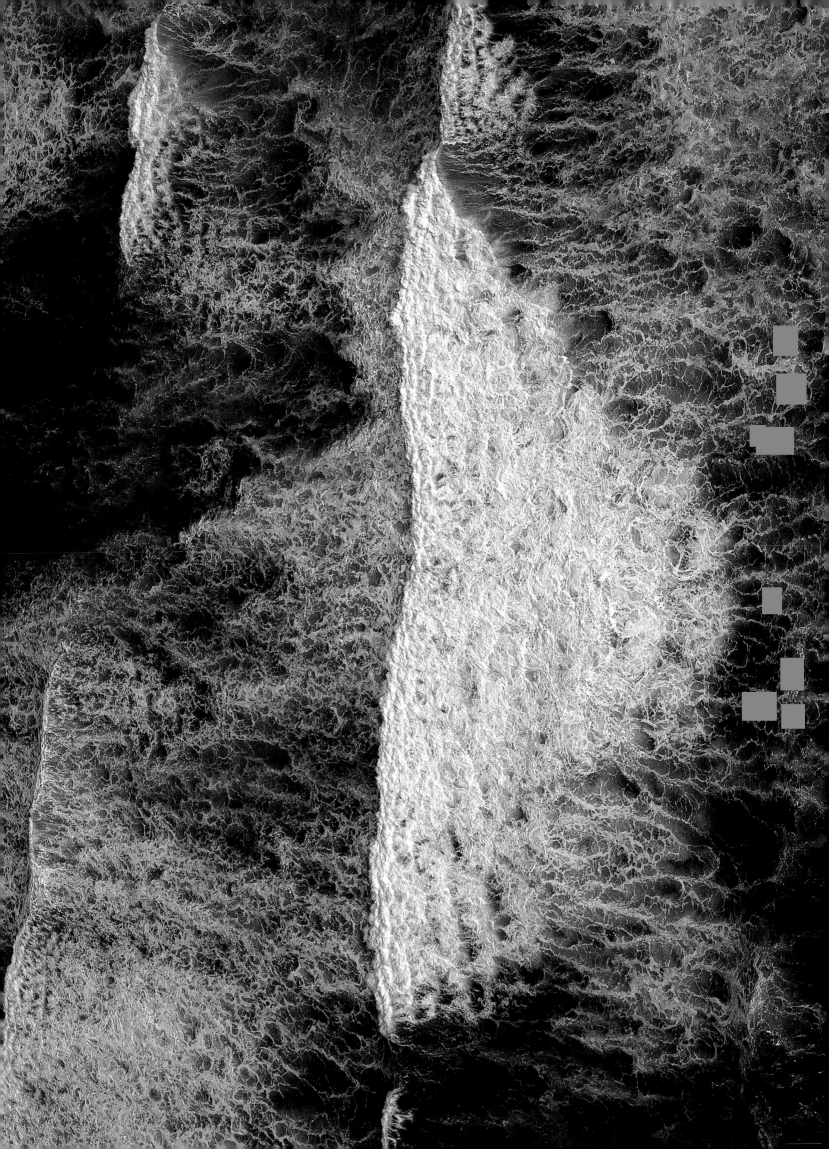

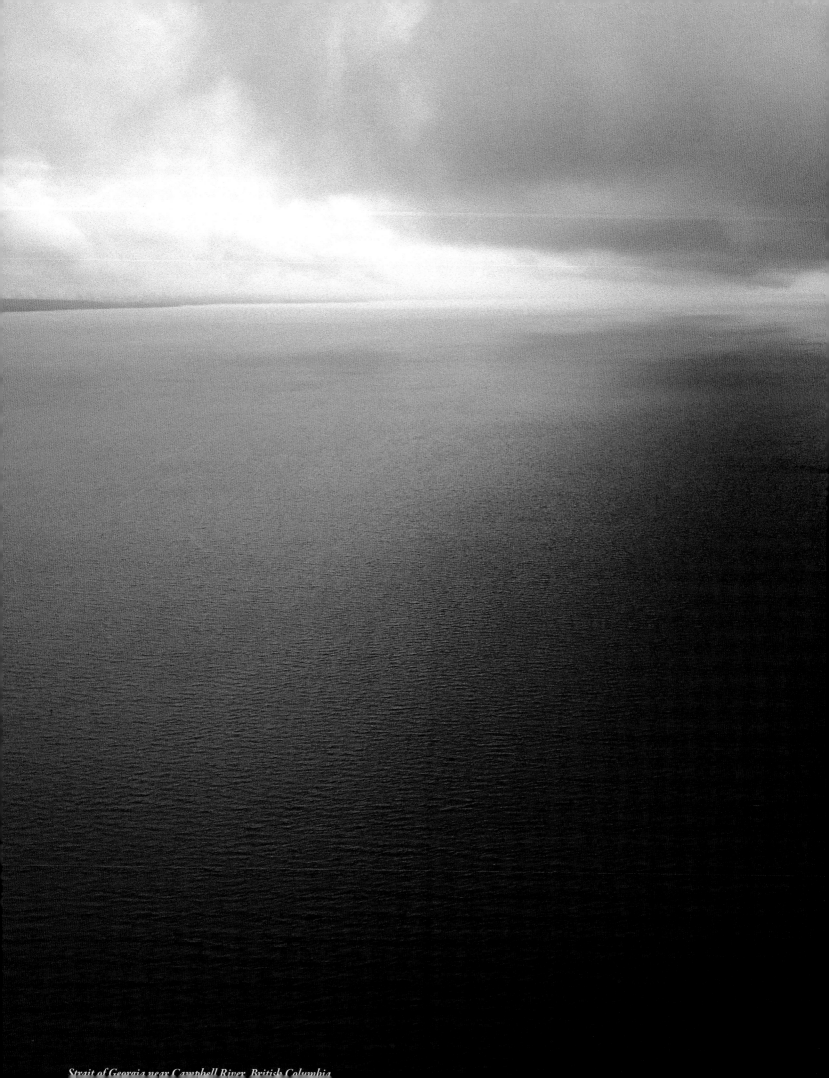

Strait of Georgia near Campbell River, British Columbia

Once there were no oceans. Four and a half billion years ago, six sextillion metric tons of meteors, comets, and assorted space debris coalesced into a sterile ball called Earth. Heat first generated by this compaction gradually dissipated while heavy minerals like iron and nickel migrated inward to form the planet's core. That initial burst of warmth would have lasted only a few tens of millions of years, but new fires of radioactive decay provided an internal source of heat that continues to this day. In the beginning, the earth was a lonely lump of molten matter with a barren surface that gradually solidified into crust. There were no shorelines because there were no oceans. No seas, no lakes, no rivers. No free water.

Then, as the crust cooled, minerals reorganized, releasing a variety of gases including hydrogen and oxygen that formed molecules of H_2O. Unlike our smaller neighboring planets, Earth's mass (and therefore its gravity) was sufficient to prevent solar winds from ripping away most of these nascent gases. Volcanoes belched sulphurous gusts, creating a toxic but moisture-bearing primordial atmosphere. Clouds formed and rain began to fall. Ice-ball asteroids slammed into the young earth, adding more water to puddles that grew into lakes, maybe into seas. Water was accumulating, a first step toward forming oceans and shorelines as we know them today.

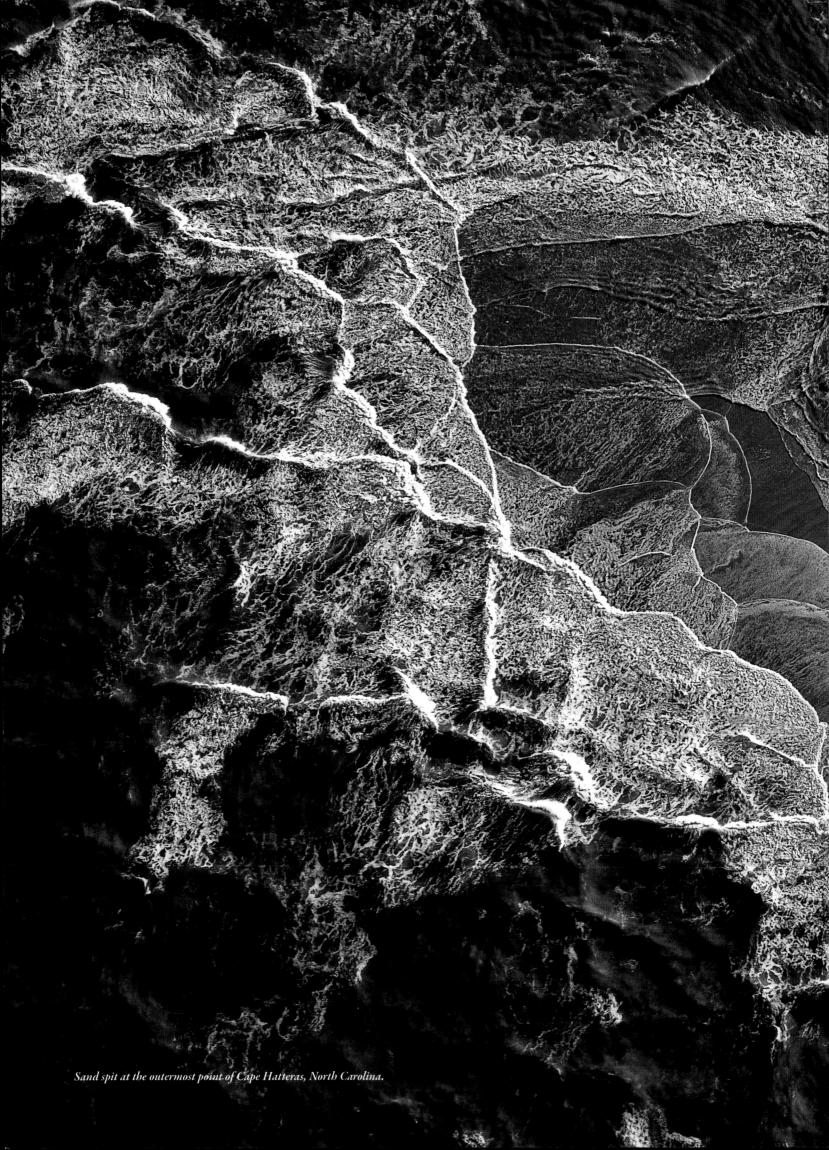

Sand spit at the outermost point of Cape Hatteras, North Carolina.

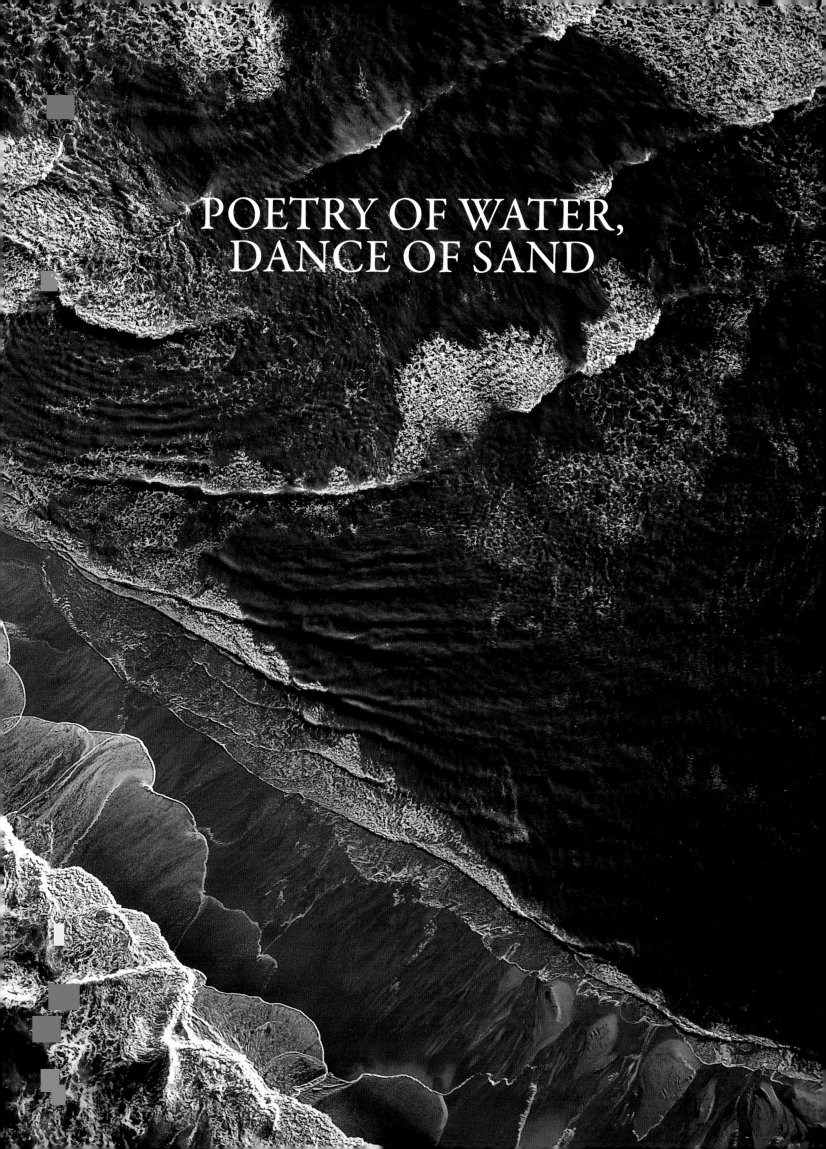

POETRY OF WATER,
DANCE OF SAND

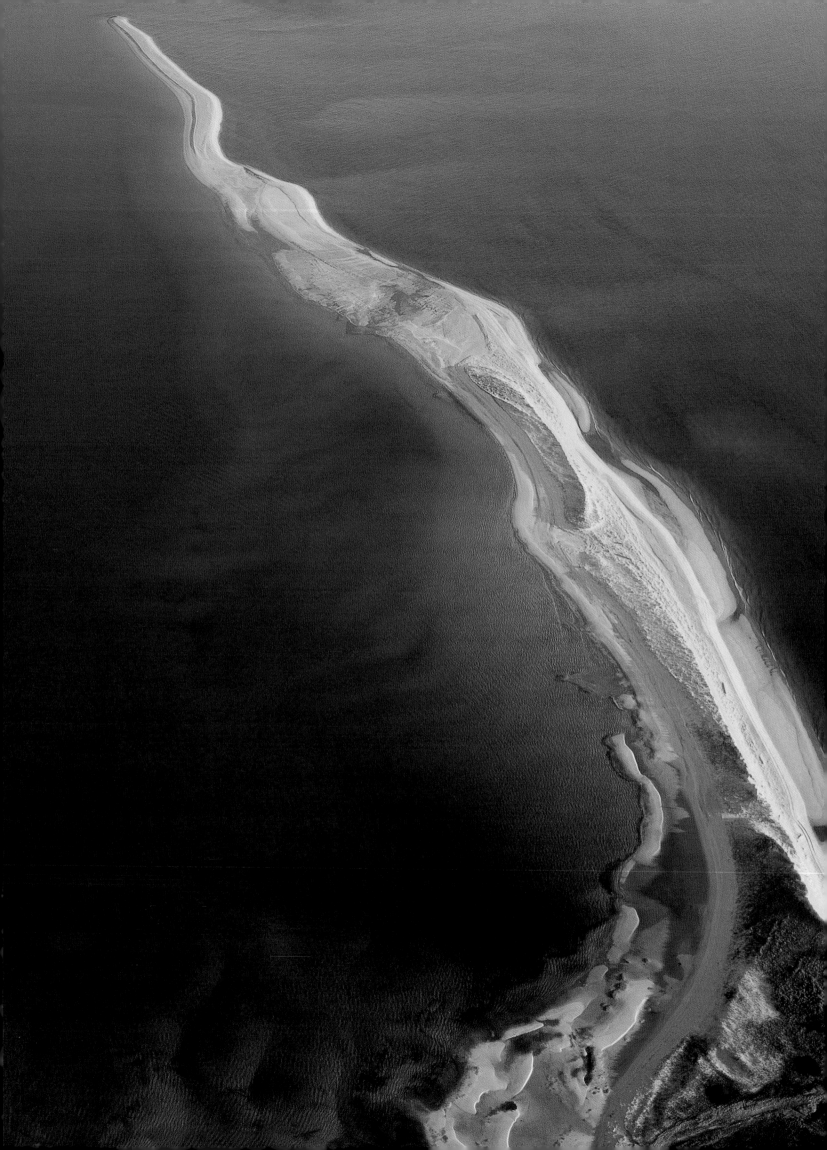

Geology, that science that is a meditation upon the earth, might seem static to some people. If you stare at a rock for an hour or two expecting it to get up and dance a jig, you're eventually going to get bored and walk away. But wait; geologic events occur sporadically, and to see them you need to be in the right place at just the right time. Try lounging next to an Alaskan volcano when an unexpected eruption tears its head off. Or straddle the San Andreas Fault when it rips open the seams of California, instantly yanking one of your feet ten yards beyond the other. These exceptional convulsive events are a sure cure for geologic boredom. But there is a more reliable, usually less traumatic, way to experience geology in perpetual motion: go to the beach.

It might be prudent at the outset to define a few terms that apply to coastlines and the water's edge. A shoreline is the actual, instantaneous dividing line between water and land. A coast is the broader zone that includes near-shore portions of the sea floor that are scoured by waves, beaches beveled by breakers, and dunes blown by the wind back from the sea. A coast might include estuaries or a delta, rocky cliffs or a low-lying lagoon. A shoreline changes its position with the run and retreat of every wave that races up a beach. Entire coasts can also change, though usually more slowly and on a grander scale. Coasts evolve over millennia as continents and rivers rise and erode. But a shoreline can change overnight with the slap and kiss of a single storm.

Coasts are among the most dynamic landscapes on earth. Nowhere else on earth is so much going on at once: sand swaying to and fro in the surf like a grass skirt, hungry waves nibbling at the toes of a cliff, rip tides hauling hapless swimmers out to sea. This geomorphic hubbub is due to gravity (bringing rivers and sediment down from the highlands), the sun's heat (stirring up winds around the world), and the tug of the moon (creating tides). All of these forces play out on this edge between land and sea.

Freshets of wind in the middle of an ocean can tickle the surface into a frenzy. Small waves grow larger when a steady gale blows across the Pacific, wrinkling the water's surface into an eight-thousand-mile-long wave train that rolls eastward, unimpeded, toward North America. Waves in mid ocean can easily grow to heights of 20 feet (sometimes a hundred) as measured from their top (crest) to bottom (trough).

A wave is a form of energy that moves through water, carrying individual molecules of water up, forward, down, and back with its passage. In the open ocean this motion is essentially circular, the net result being that waves move but water doesn't. When a wave approaches the shore, however, it begins to scrape bottom. Friction decelerates the wave, and it grows steeper and taller. The once-circular orbit lists into a forward-leaning ellipse. The wave, having traveled thousands of miles, is about to break. And all that wind-derived energy is brought to bear on one narrow little place: the shore.

Jeremy Point near Wellfleet, Massachusetts, is constantly being shaped by tidal currents that curl around Provincetown and carry sediment into Cape Cod Bay.

Rolling in from the open ocean, a wave breaks when it encounters a bottom about as deep as the wave is tall, falling apart as water foams down its face. Depending on the sea's mood at the moment, the break might be described as spilling, plunging, or surging. Spilling happens in shallow water some distance from a beach. Plunging occurs when waves encounter a steeply inclined sea floor, and their crests curl over and fall forward. Surging waves rush up a beach and collapse with a watery sigh.

A deep-water wave that suddenly rams into a vertical cliff might reflect off (rather than break on) a wall, its mirror image then heading back to sea. Surfers delight in spilling and plunging waves, can take or leave surging waves, and really ought to avoid reflecting waves.

Water piled up by waves on a beach must eventually slide back downhill. This return flow creates either an undertow or a rip current, notorious for dragging sediment and those hapless swimmers out to sea. Smart swimmers will dog-paddle off to the side and then back to the beach.

Breaking waves, those yeomen of coastal geomorphology, do the heavy lifting of erosion and sediment transport along a shoreline. When plunging waves crash into a rocky coast, pockets of air trapped within the tumbling water will jack-hammer rocks into smithereens with pressures that approach 2,000 pounds per square inch. The forward swash of steady waves carries bucket after bucket of sand up a beach with Sisyphean determination. On the other hand, the robust waves of winter storms often have a powerful backwash. In their rush to return to the sea they can soon strip a beach bare, dragging sand back into the depths of the ocean.

Waves don't always strike a shoreline perpendicularly. When breakers from powerful winter storms rake the beaches of Maryland, they usually arrive from the northeast and intersect the coast at an angle. As they bang into Assateague Island, most of their energy is dissipated against the shore. But because of that angular arrival, some energy is redirected down the shoreline, transformed into a longshore current that flows steadily south toward Florida. Longshore currents can transport prodigious quantities of sand along a coast hundreds of miles away from its source.

If a wave approaches a shoreline head on, it will break all at once along the length of a beach. But if that shoreline includes a headland that juts out, then one part of the wave will "feel" the shore earlier than the rest of the wave. The section of wave that hits the headland slows down as the remainder continues full throttle toward the shore. Different parts of the same wave are now traveling at different speeds, and the wave bends (or "refracts") toward the headland. Waves thus focus their erosive energy on promontories, and over time an irregular coastline will eventually be eroded into a straight beach.

Surf crashes in from the Pacific Ocean to dissect California's ragged coast south of Carmel. The breaking waves exploit minute zones of weakness in the rocks— pre-existing fractures, loose grains—in their eternal effort to erode these cliffs.

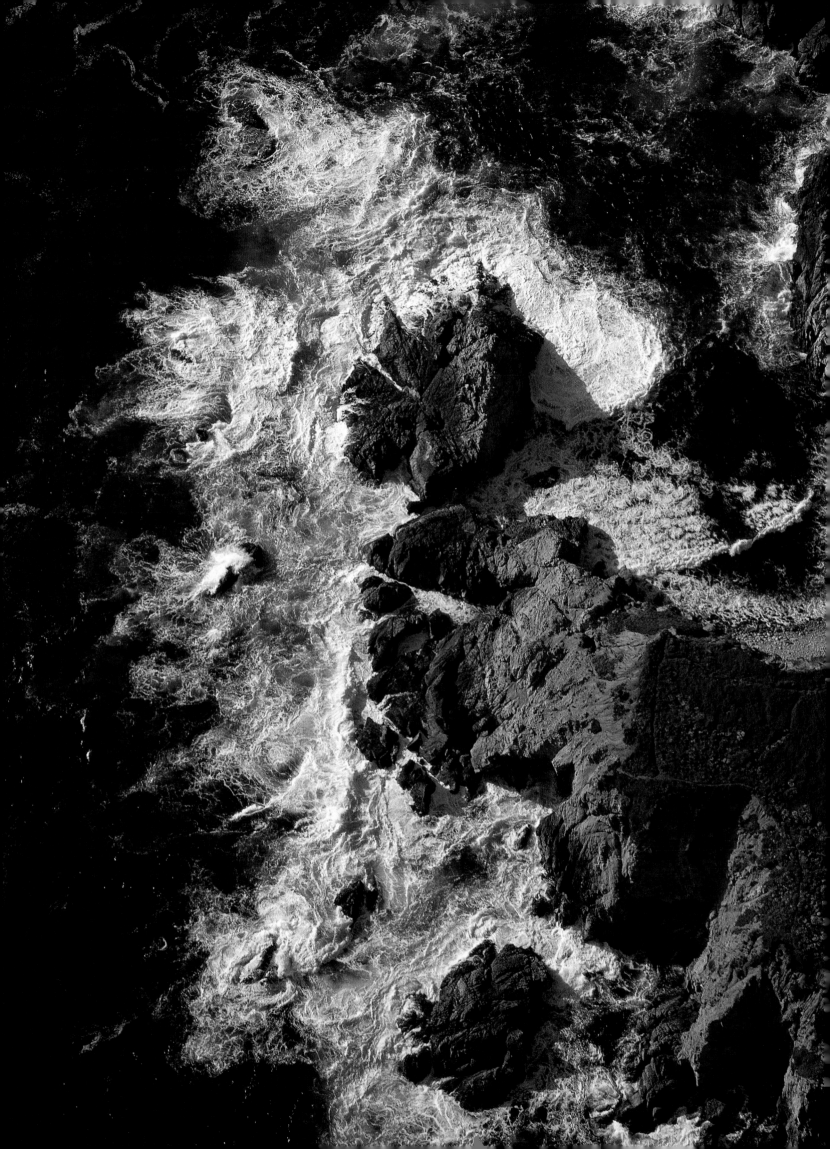

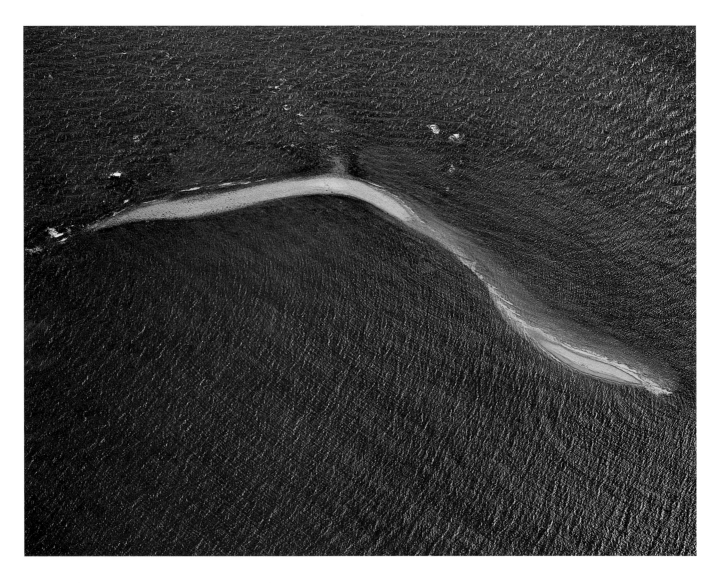

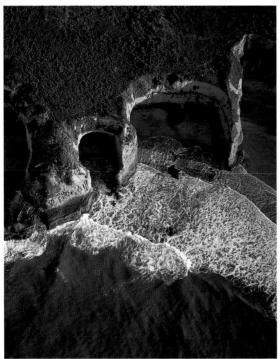

The behavior of wind-driven waves is dictated by the interaction of their own properties (height, wave length, timing) and characteristics of the shores they encounter (rocky or sandy, steep or shallow). At the top of this page, waves gently slap sand into a wispy island near Stonington, Connecticut in Little Narragansett Bay. The bottom photograph shows how waves cut sea caves near Point Año Nuevo, California. When surf breaks it can compress trapped air, generating thousands of pounds of destructive pressure that further enlarges these caves.

All waves slow down as they enter shallow water. On the facing page, top, we see waves moving right to left that bend as they pass either side of rocks near Point Grenville, Washington. This bending, called refraction, happens because a given wave encounters shallow water near the rocks, while the rest of the wave, still traveling over deeper water, hasn't yet slowed down as much. When the part of the wave close to the rocks slows, the once-straight wave bends, curling around and focusing its erosive energy behind the obstruction.

Waves in the three pictures at the bottom were spaced further apart when they were out at sea, but, like cars on a suddenly clogged freeway, they slow down and pile up when they approach the California coast. From left to right, surf breaks against the foot of Chamisal Mountain, south of Shelter Cove. In the middle photo, waves almost ride up on top of one another as they enter shallow water near Pescadero. At right, waves climb narrow beaches near Point Año Nuevo; if the tide were higher, these waves might crash against the cliffs and reflect back out to sea.

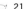

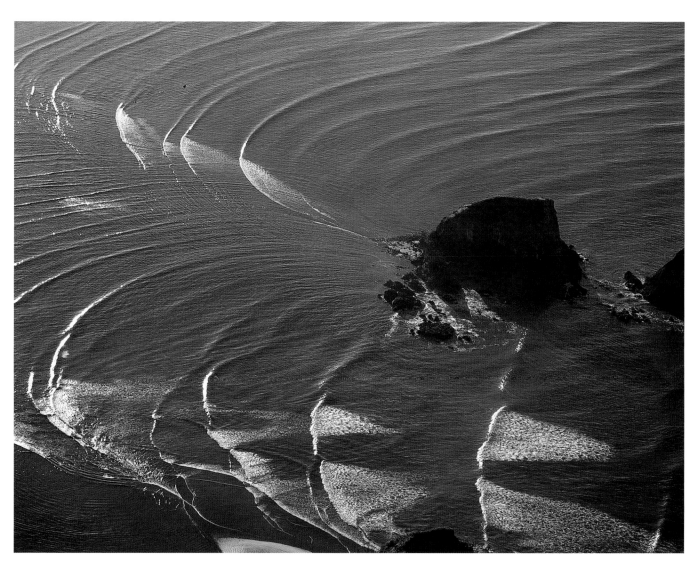

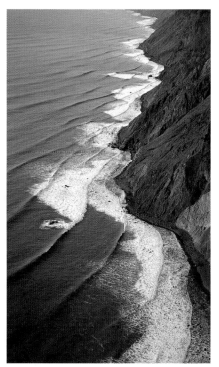

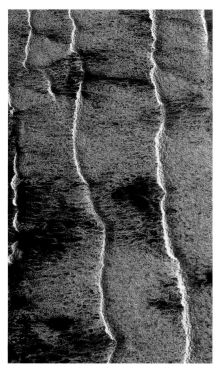

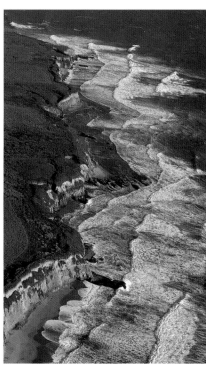

Like dogs, waves come in various sizes and personalities. There are the yappy little waves of summer, barking incessantly at a beach every few seconds. There are the big bad boys of winter growling in packs that push sea water up against cliffs at the back of a beach. Then there are the true mastiffs—surges, tides, and tsunamis—generated not by ordinary winds but by hurricanes, gravity, and earthquakes.

Atlantic hurricanes and their Asian equivalents, typhoons, drive great surges of water far inland ahead of the storms themselves. Coastal regions of Louisiana and Mississippi were battered in August 2005 by Hurricane Katrina. Its surge rose 28 feet in some locations. Salt water from the Gulf of Mexico washed 20 miles inland, inundating freshwater wetlands that buffer the mainland.

The behavior of hurricanes can be hard to anticipate. Tides, on the other hand, are very predictable, world-traveling waves generated by the gravitational tug of the moon and sun on oceans. They typically take 12 hours to rise and fall, with amplitudes as great as 50 feet at the Bay of Fundy in Nova Scotia. Tidal currents have scoured a 350-foot-deep channel at the Golden Gate mouth of California's San Francisco Bay. High tide rips through Deception Pass in Washington's Puget Sound at speeds that approach nine knots. Doesn't sound like much? Try swimming one-fourth as fast.

Tsunamis (a Japanese term meaning "harbor waves," often mislabeled as "tidal waves") are giant waves launched by the lurching of the sea floor at a point that may be thousands of miles from the shores where they eventually break. These waves are long, low, and lean, traveling at speeds that rival jet airplanes across entire ocean basins. A ship at sea might feel nothing at all as a tsunami passes underneath, but as it enters shallow water, the wave rears up to heights of 30 feet or more. Hundreds of thousands of people died when an underwater earthquake west of Sumatra generated a tsunami that struck the day after Christmas 2004.

We've looked at some aspects of waves and water. Now let's turn our attention to ocean basins: why are they so deep, and what shapes their rims? Plate tectonics is a sweeping theory that offers an understanding of the shape and breadth of oceans and continents. According to this theory, earth's crust is made of plates composed of one of two fundamental ingredients: either oceanic rocks or continental rocks. Oceanic plates are thin, dense layers of heavy rocks such as basalt and gabbro, with an average thickness of only five miles. Continental plates, on the other hand, are fat layers of lighter rock such as granite and shale, typically twenty-five miles thick. Both types float on the earth's fluid middle region, called the mantle.

Hurricanes have repeatedly swept over Petit Bois Island, Mississippi, one of the many barrier islands and spits that lie a few miles off the Gulf Coast between Texas and Florida. The island, home to laughing gulls and snowy plovers, has sand dunes that face left toward the open water of the Gulf. A thin veneer of tenacious vegetation struggles to survive the onslaught of storm waves during hurricane season.

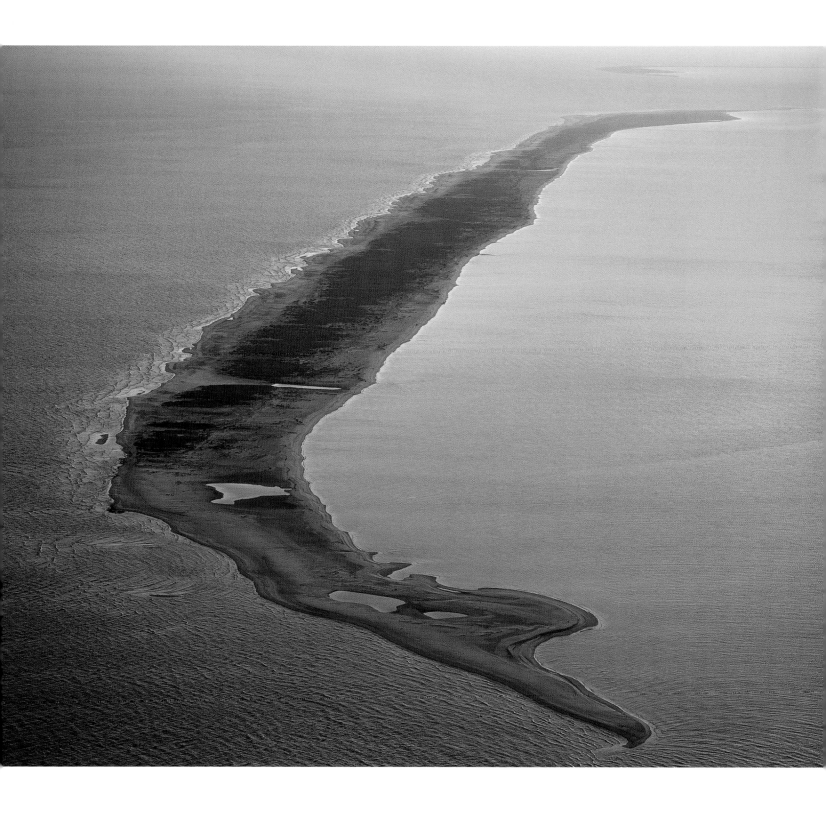

Dense oceanic plates rest heavily on the underlying mantle, creating great depressions, which over time have filled with water to become ocean basins. For the most part, the depth of modern oceans tends to be about 12,000 feet below sea level, but the ocean floor can lie as much as 35,000 feet beneath the water's surface. In contrast, the surface of continental plates averages 2,500 feet above sea level, with peaks like Mount Everest reaching another five miles into the sky. In between the low oceans and higher, drier continents are continental shelves, which are underwater plains sloping away from the continents, submerged beneath 600 feet of water or less. Even though they are underwater, the outer edges of these shelves define the continents' true boundaries.

Africa and South America were a seamless landmass 150 million years ago but are now separated by the South Atlantic Ocean. Viewing a typical map with brown land and blue oceans, it's not difficult to mentally reapproximate the two continents by snugging the nose of South America's east coast into the crook of Africa's west coast. A much more precise fit is achieved, though, by aligning not modern coastlines but their continental shelves.

Crustal plates—both oceanic and continental—slowly roam the face of the earth in a dance choreographed by viscous fluids within the mantle. Plates gliding over a sphere will inevitably collide. When two equally buoyant continental plates collide their leading edges are crumpled, but neither is driven up over the other. When an ocean plate collides with a continent, though, the more dense oceanic crust will always dive beneath the lighter continental crust. Such a collision is currently taking place along the western edge of our continent where the dense Pacific oceanic plate is sliding under the more buoyant North American continental plate. Such crustal collisions give rise to "leading edge coasts" with steep mountains leaping out of deep oceans. Erosion is brisk, rivers are boisterous, and young mountains enthusiastically shed a great deal of sediment into the nearby sea.

Alternatively, rather than collide, plates can separate, a process which occurred 180 million years ago when North America pulled away from Africa and Europe, creating a "trailing edge coast." It sports a broad coastal plain of low relief, long sandy beaches, and lazy, well-developed river systems. The continental shelf adjacent to the East Coast extends far out to sea. By comparison, the shelf on a leading edge coast like California is quite narrow, foreshortened by its ongoing crustal collision.

Highway 1 clings to the Santa Lucia Mountains, which rise out of the Pacific Ocean south of Big Sur. This portion of the California coast forms the leading edge where North America overrides the Pacific Plate. Mountain uplift is here occurring far faster than wave erosion, resulting in steep, unstable cliffs.

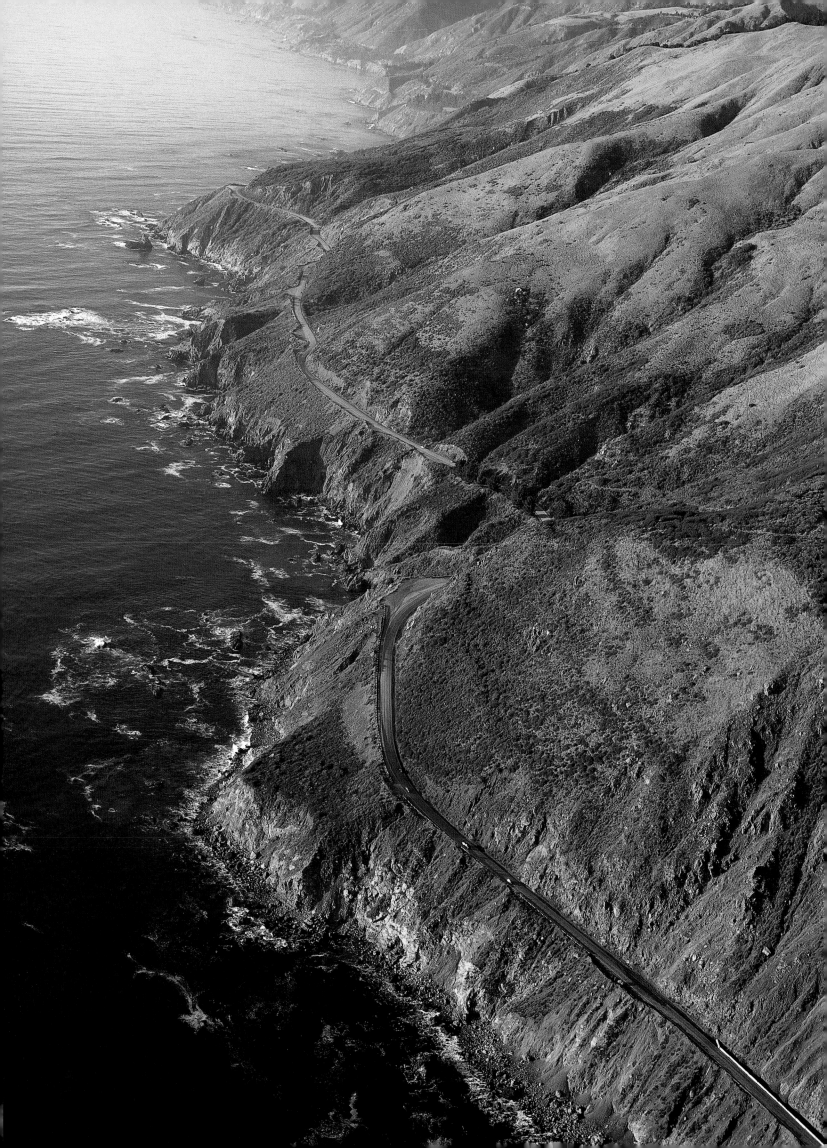

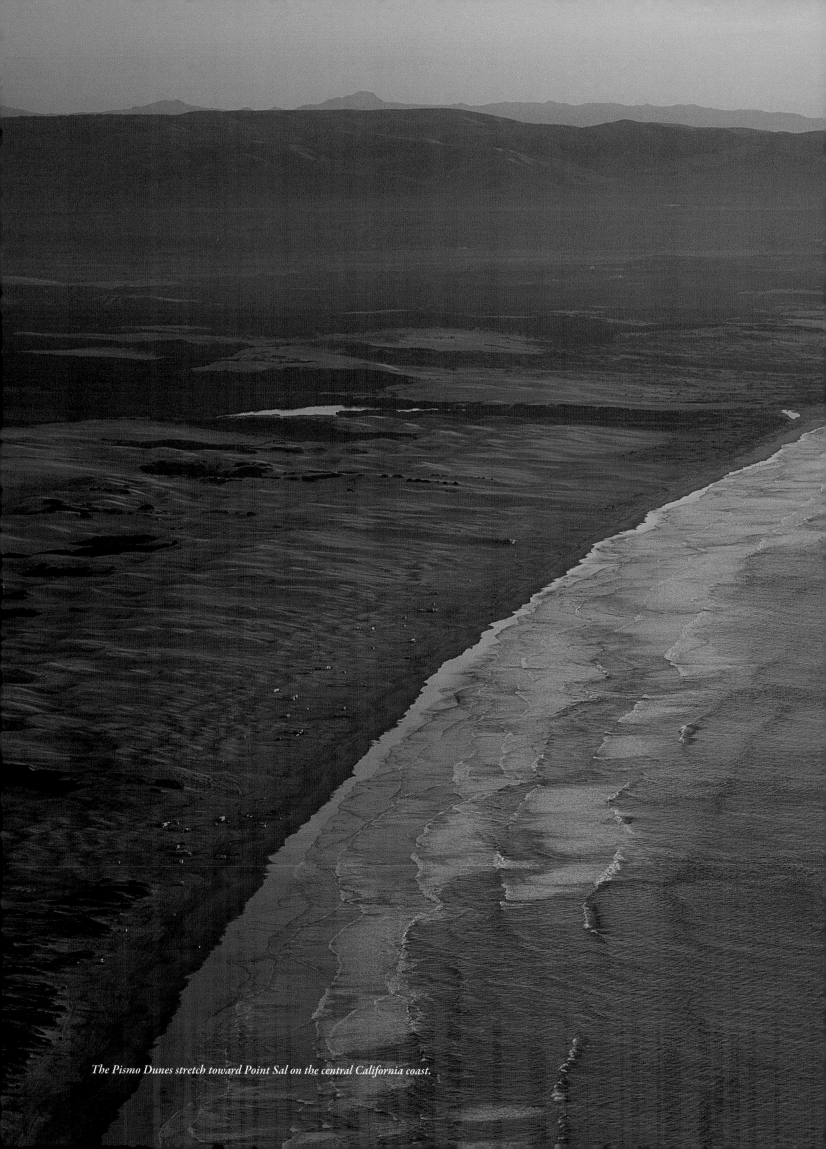

The Pismo Dunes stretch toward Point Sal on the central California coast.

COASTING AROUND
THE CONTINENT

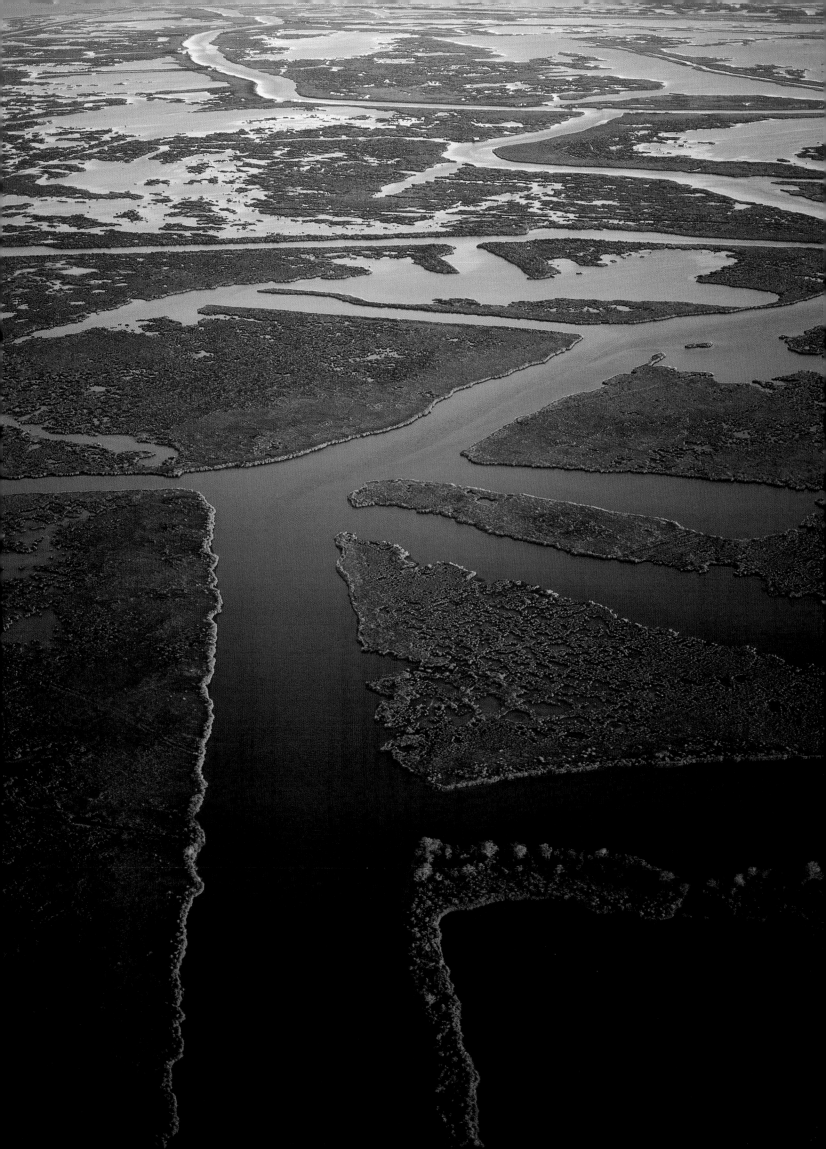

Gulf Of Mexico

The Gulf of Mexico is a big bowl that holds a lot of sand. That sand is draped over the rim of the bowl in beautiful beaches that stretch from Brownsville, Texas, to the Florida Keys. Most of the sediment came down from the heartland of America, carried by the Mississippi River. To accumulate sand, a coastline must possess three prerequisites: 1) sand, 2) a way to move it, and 3) a place to put it. When a river like the Mississippi reaches sea level, it still has momentum but loses the gravitational impetus that caused it to flow downhill in the first place. As the river loses its identity at sea, its current slows and eventually dies, and its sediment load is dropped.

Rivers carry a wide assortment of sediments—cobbles, sand, silt, and mud—with a diverse mixture of grain sizes and densities. Floods that burst directly from mountains are able to carry large cobbles or even boulders, but these rocks are usually abraded and broken before traveling very far. Even those that make it closer to the sea will be dropped like hot potatoes the instant the current wanes. Gravel and sand grains fall next from the river's grasp. They probably won't fall far, though, because they're relatively heavy and, for the most part, they were just rolling or hopping along the bottom anyway. Progressively finer sediments like silt and mud linger in suspension a while longer as the river mingles with sea water. Waves will agitate water along a beach, enough so that these light particles are likely to drift off shore before settling out. The sediments that reach the ocean form a blanket of silt and mud that can extend to the edge of the continental shelf.

When a coastline isn't disturbed by big waves or strong currents, sediments carried by a river will build a delta close to its mouth. Surprisingly, there are relatively few places on the North American coastline where this happens on a grand scale. Two are in the far north—the Yukon River in Alaska, and the Mackenzie River in northwest Canada. But the greatest is in Louisiana where the Mississippi River reaches the Gulf of Mexico.

For millions of years the Mississippi has been delivering more than 500,000 tons of sediment to the Gulf every day. Lotta time, lotta mud. The sand and silt pile up so high and fast that the river must repeatedly carve new distributary channels to reach the sea. In this way, the delta grows outward into the Gulf in a roughly semicircular fashion. The lower Mississippi has broken through its banks into an entirely new riverbed at least seven times in the last 10,000 years, each time adding a large new lobe to its overall delta.

The Mississippi River enters the Gulf of Mexico below New Orleans, Louisiana. Its delta is a crazy quilt of low, soggy islands, shredded by a myriad of waterways—some natural, some not. Sand and silt carried down from 31 states in the heartland of America here settle to the shallow bottom, thus extending the river and its delta farther out into the Gulf.

The Mississippi River continuously sprays a concoction that is 10 percent mud and 90 percent water into the Gulf of Mexico. As sediment accumulates and layers are piled one on top of the other, water is slowly squeezed out. Consequently, gravity is slowly compacting the entire north end of the Gulf of Mexico. In the past, the lower Mississippi River region remained above sea level because episodic floods would distribute river-borne sediments across the delta, raising the land's surface just a little bit faster than compaction was lowering it. But a great deal of sediment is now trapped behind dams in the river's upper basin while the coast continues to subside. Levees protect cities along the river, but they also prevent floods from spreading their sand and silt across the region. Like it or not, with or without those levees, it's only a matter of time before the coast of Louisiana will once again be submerged. It's impossible to predict if this will this occur a hundred years from now, or during next year's hurricane season. We watch while nature rolls the dice.

Unlike Louisiana, the low-lying rivers of Alabama and Florida deliver minimal sediment to the Gulf of Mexico, so no deltas form. Every few decades a hurricane might churn up Florida's Gulf Coast, but on most days this area can be accurately described as a "zero-energy shoreline," referring not to idle tourists, but to the absence of any waves higher than a few inches. Longshore currents here are weak, and mangroves and palms sprout along the muddy shores while oysters build pygmy reefs further out in the water. In places you can walk miles out to sea and not get your hair wet. Lackluster tides here rise and fall with a daily ebb and flow that provides a reliable bidirectional current to maintain lacy channels that stretch inland across miles of unvegetated mud flats.

Over on the other end of the Gulf of Mexico, in Texas, the coast is interrupted by rivers like the Brazos and Rio Grande, which may be short on water but are long on sediment. In its day, before being hamstrung by upstream dams, the Brazos delivered 30 million tons of silt to the Gulf each year. Strong currents sweep up or down this portion of the Gulf Coast depending on the season's predominant wind direction and wave action. Sediments from the Rio Grande and Brazos have been spread by these currents to form barrier islands. These islands lie parallel to the shore and soften the blow of storms that would otherwise directly strike the mainland. Starting at the mouth of the Rio Grande near Brownsville on the U.S./Mexico border, Padre Island stretches an essentially unbroken 130 miles past Corpus Christi. At its southern end, Padre Island is separated from the mainland by Laguna Madre. The lagoon's water is so warm that evaporation concentrates its salt to a level three times greater than the average ocean. Together with other barrier islands to the north and east, this chain presents a smooth Texan face to the open waters of the Gulf of Mexico.

Padre Island is a barrier that protects southern Texas from storms arriving from the Gulf of Mexico. Much of the 130-mile-long island is built from sand carried to the Gulf by the Rio Grande and then distributed by northbound currents. Winds off the Gulf build dunes, which offer temporary footing for vegetation—plants like red lovegrass, bushy bluestem, and whitestem wild indigo—that is intermittently stripped away by hurricanes.

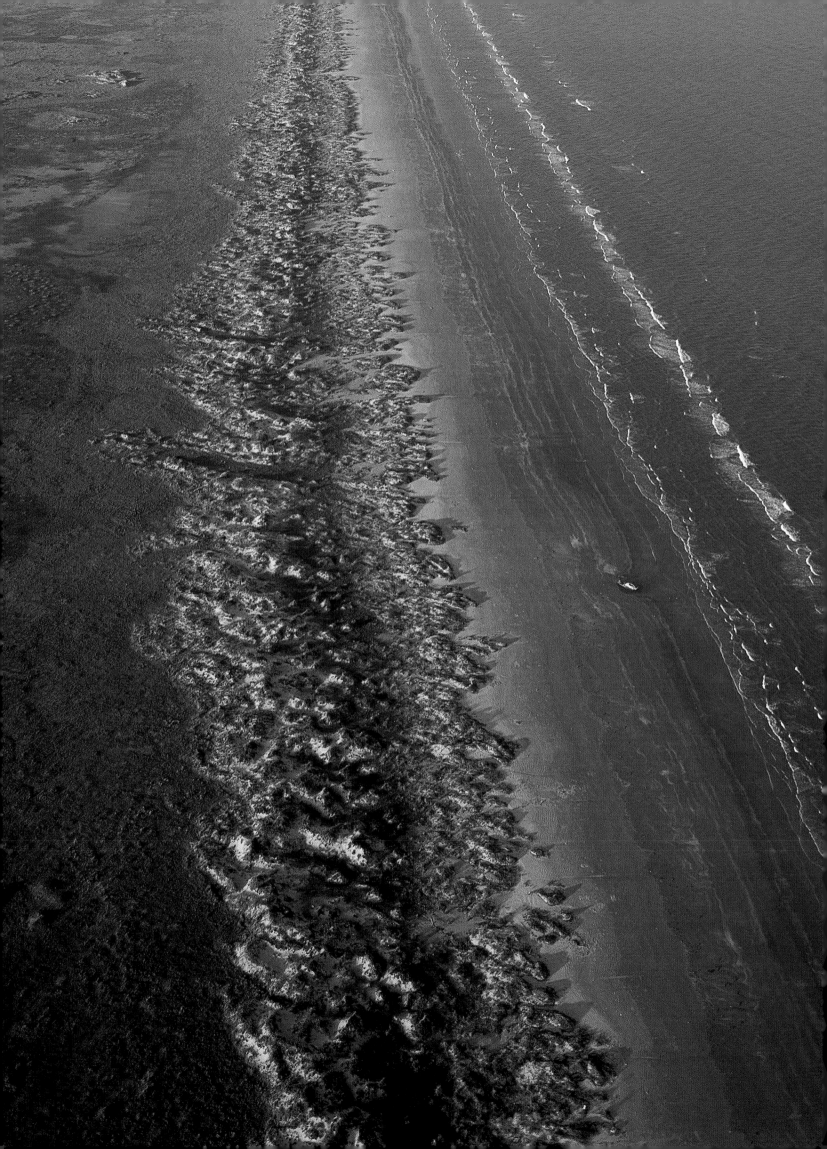

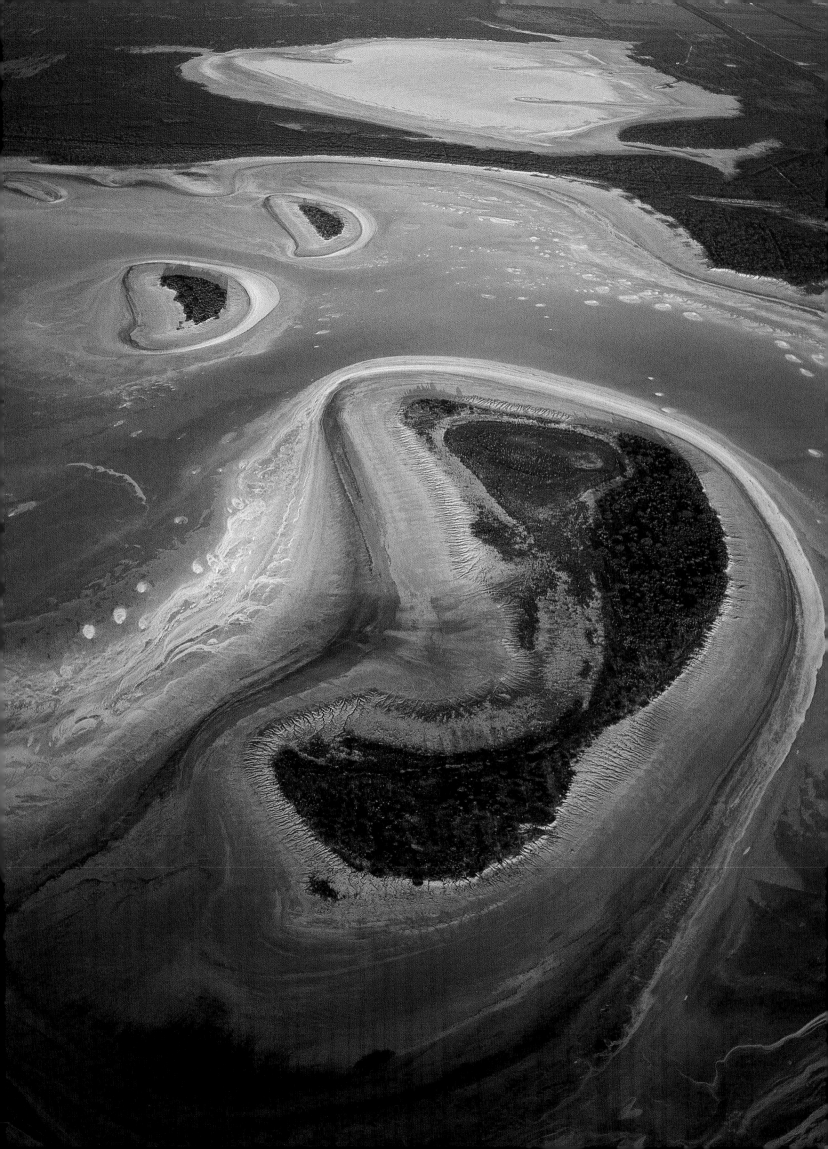

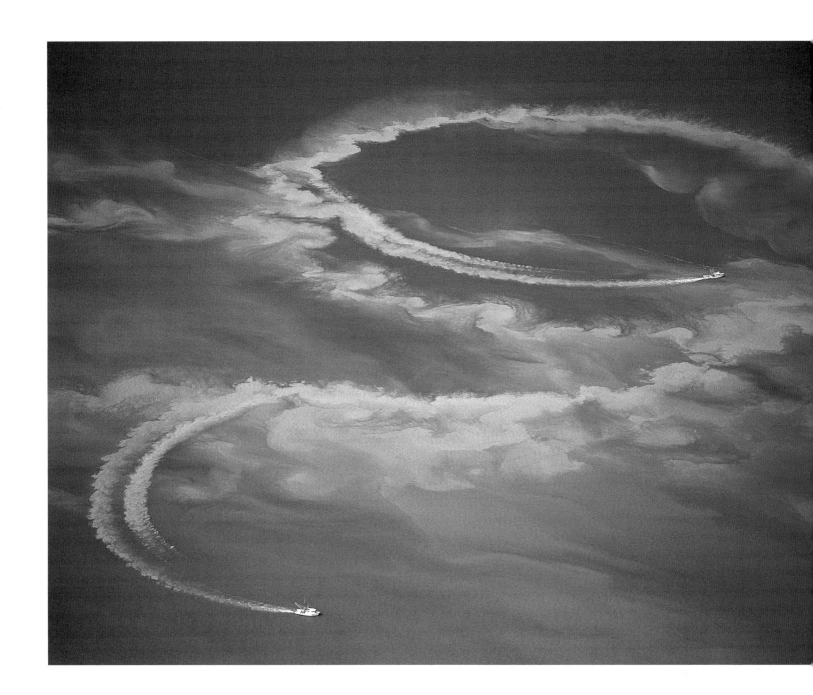

Above: Boats near Houston, Texas, drag the bottom of Trinity Bay for shrimp. Their nets stir up sediment brought into the bay by the San Jacinto and Trinity Rivers.

Left: La Sal Vieja, just inland from Port Mansfield and Padre Island, has provided salt to Texans and their predecessors for hundreds of years. Rainwater that occasionally fills this lake becomes saturated from an underlying salt dome; high evaporation rates in this hot, dry climate leave the lakebed coated with powdery white salt.

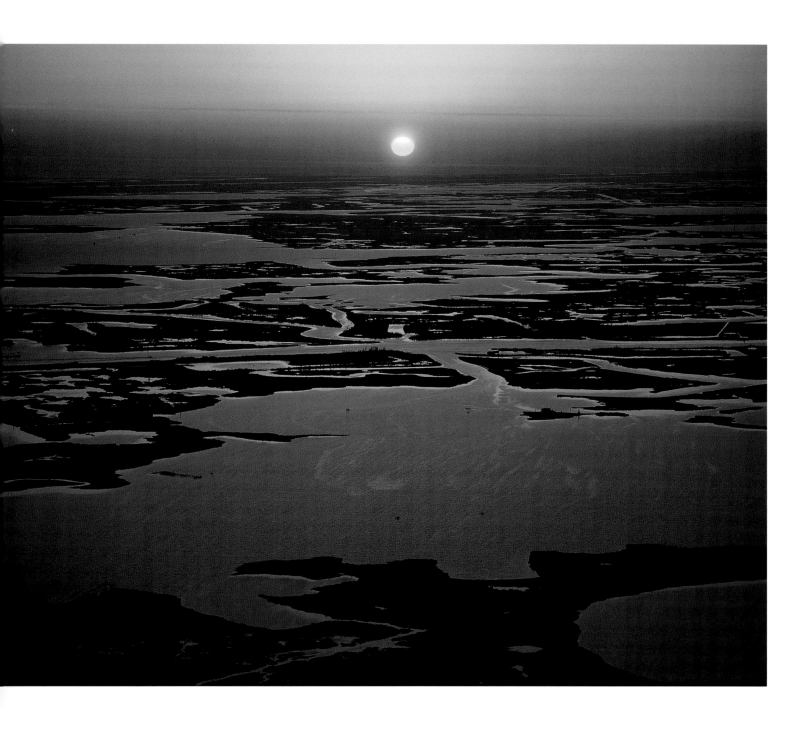

Above: Sunset descends upon the Mississippi River Delta near Spoonbill Bay in Louisiana. Wetlands of the delta act as giant buffers, absorbing the blows of hurricanes and sopping up storm surges.

Right: This spit, formerly called Pelican Island, is now attached to Dauphin Island which stretches across the mouth of Mobile Bay in Alabama. From the air, underwater dunes are visible, showing the direction of currents that sweep down the spit's left side.

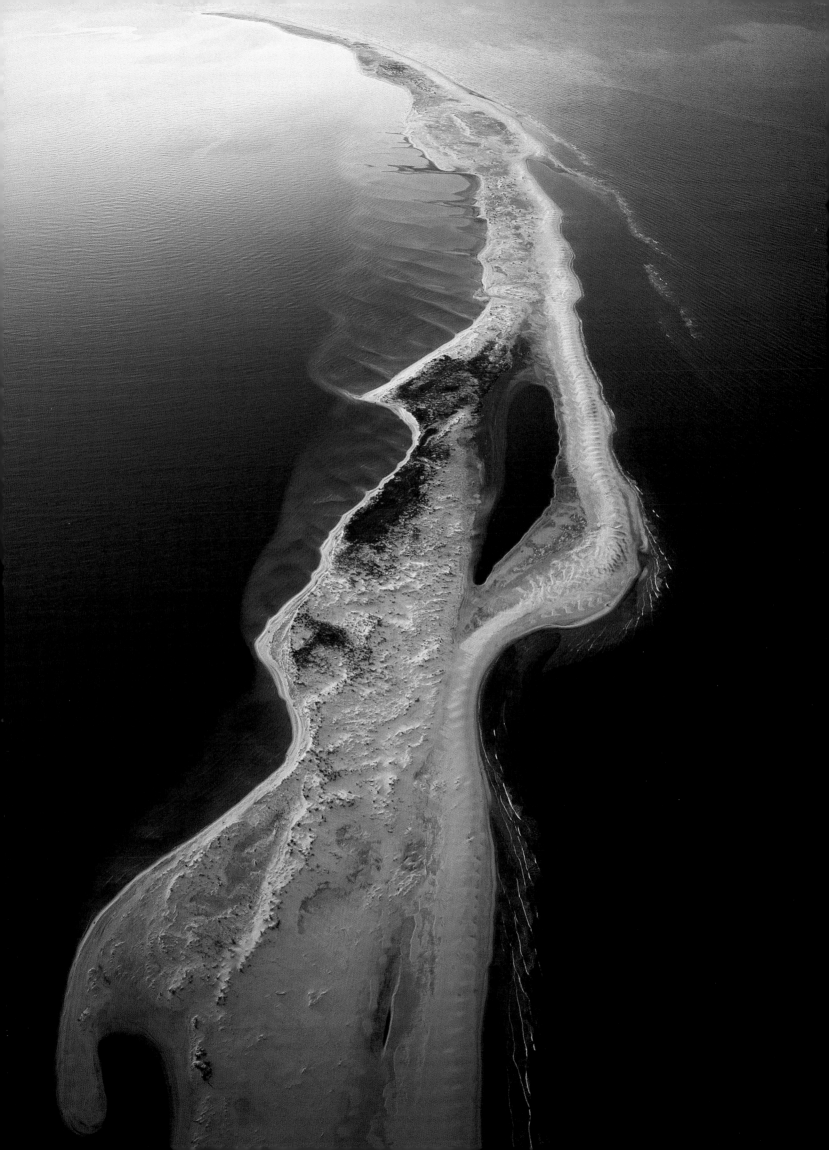

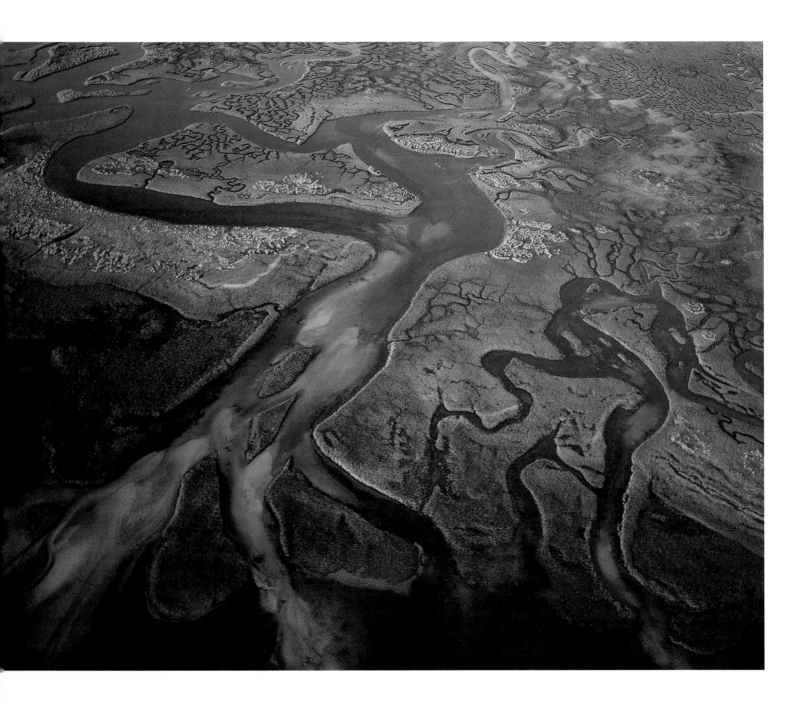

Above: Overflow from the nearby Suwannee River brings sediment to these interlaced tidal channels on the western Florida coast north of Cedar Key. Depths offshore are so shallow that ocean waves rarely stir the sediment. Instead, tidal currents flowing to and fro each day slowly move sand and silt to deeper water.

Right: Saint Marks National Wildlife Refuge south of Tallahassee, Florida, is only infrequently visited even though it lies close to places with irresistible names like Kitchen Cove, Panacea, and Alligator Island. The refuge is home to endangered wood storks, West Indian manatees, and leatherback turtles.

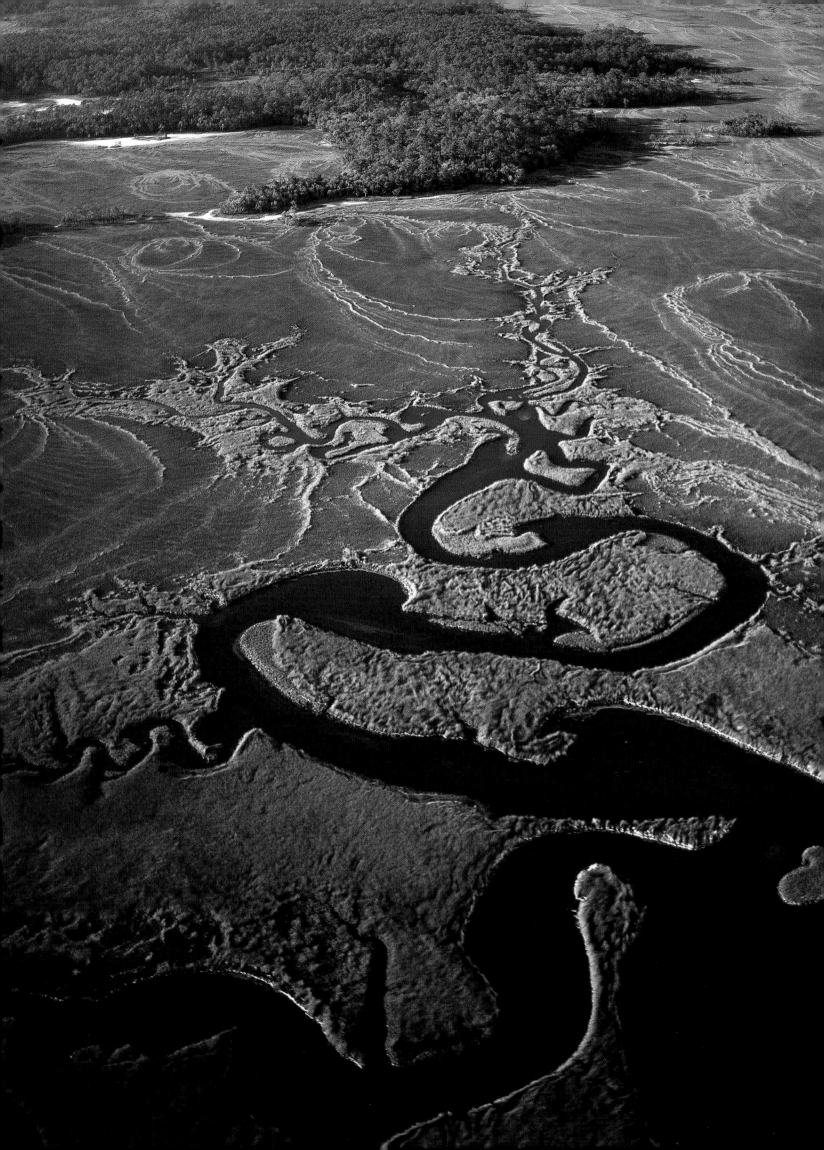

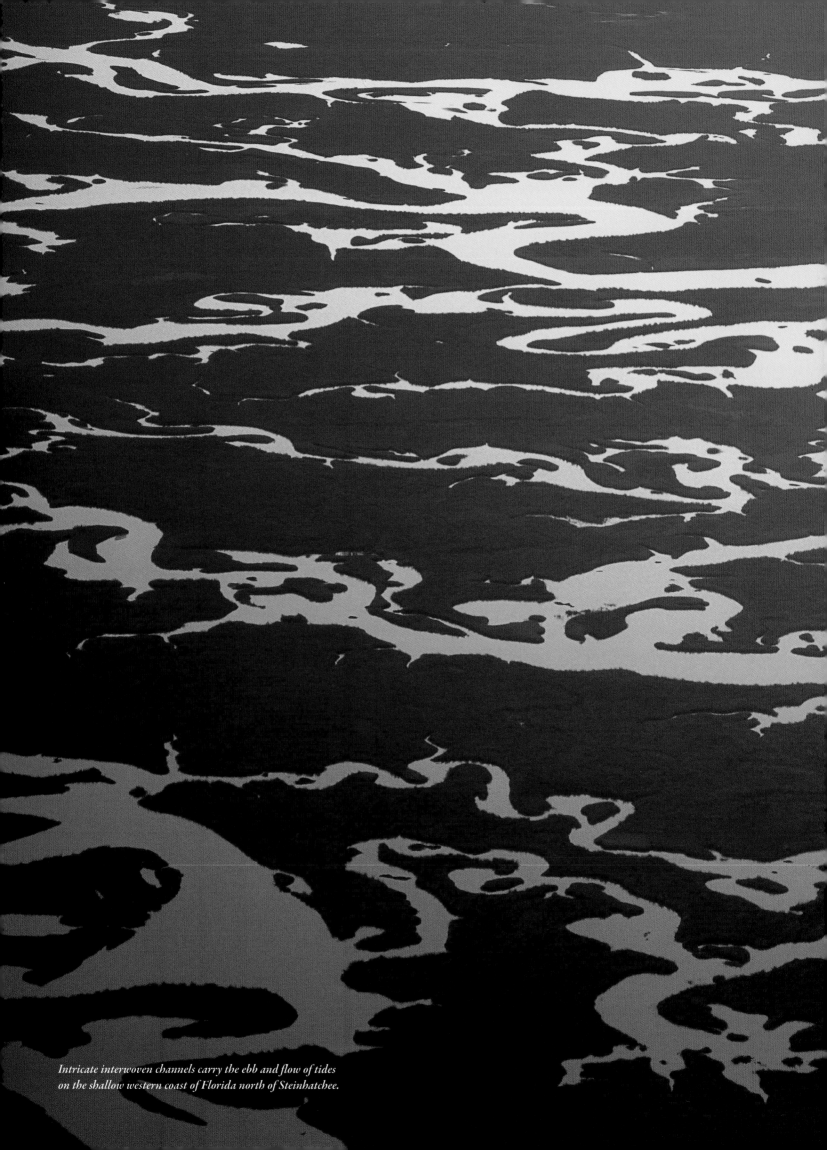

Intricate interwoven channels carry the ebb and flow of tides on the shallow western coast of Florida north of Steinhatchee.

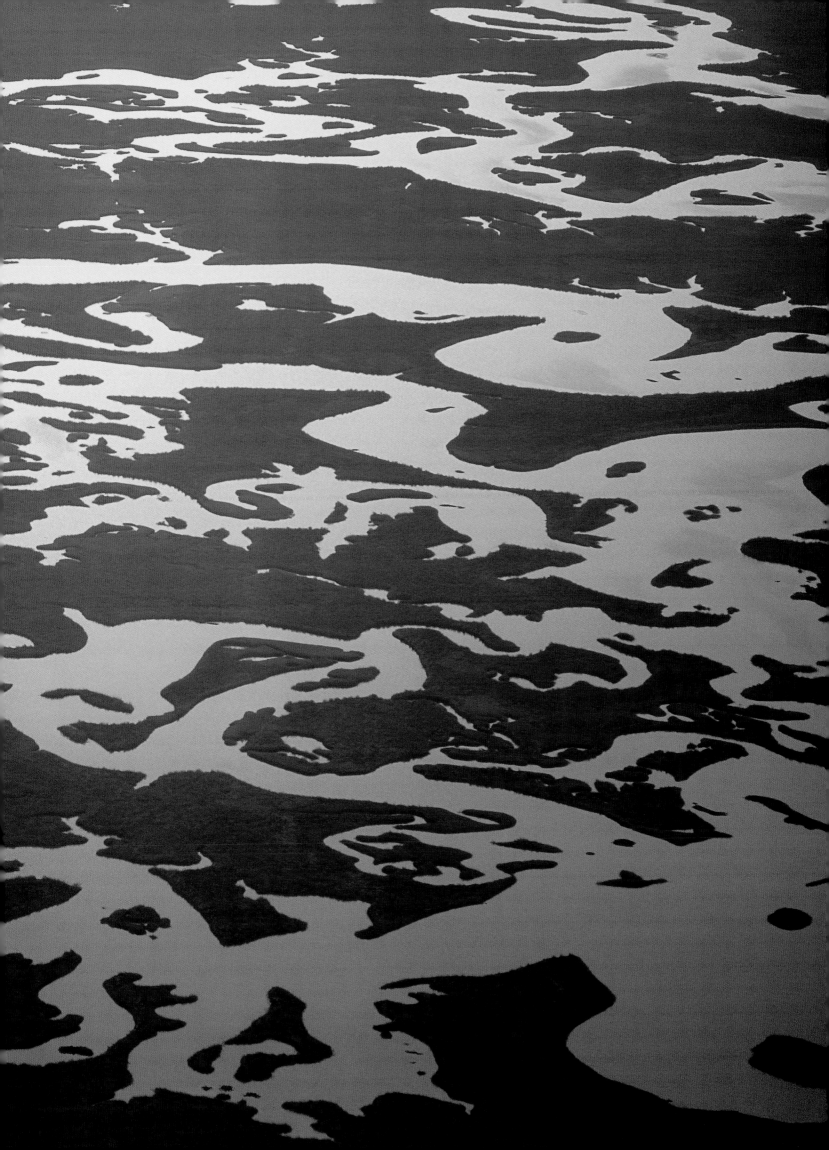

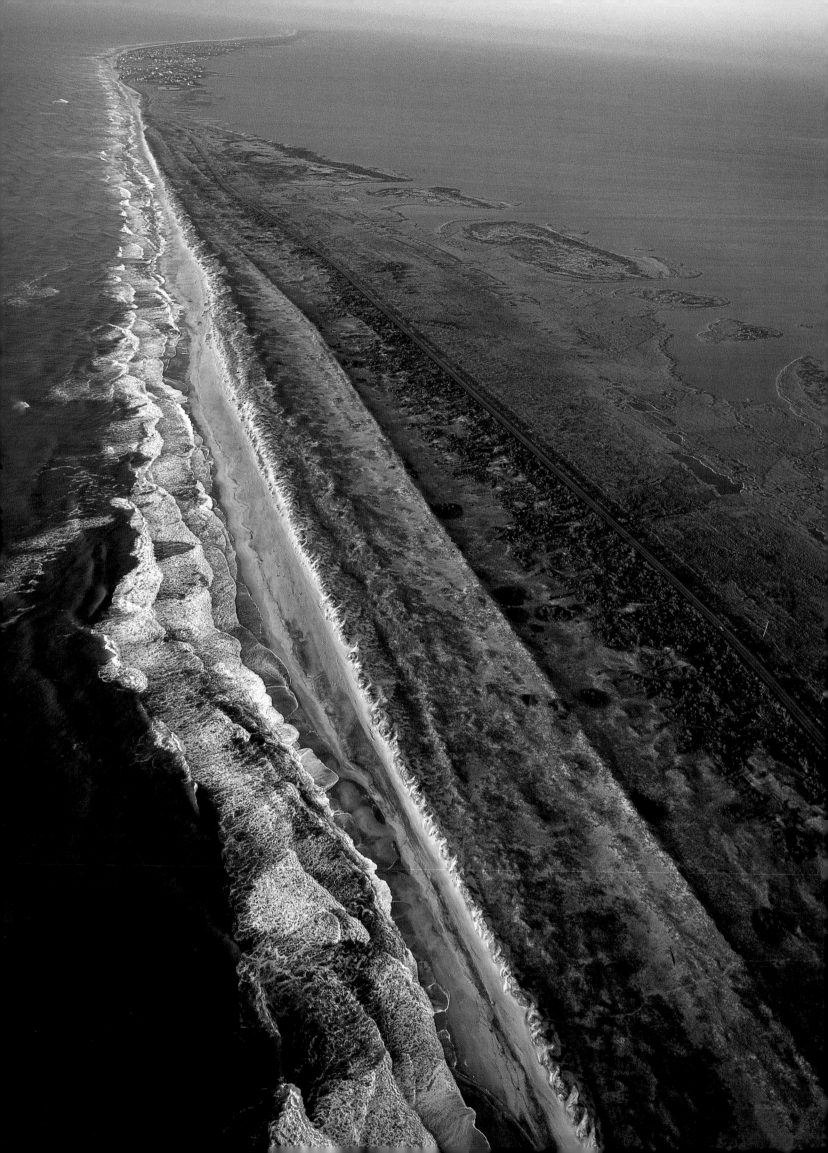

Southern Atlantic

N orth America's eastern shoreline, from Maine to Florida, is a classic trailing edge coast that has been stable for tens of millions of years. The East Coast's rivers have had a lot of time to wear down their basins and now carry relatively little sediment. The northern and southern halves of the East Coast were born of the same "trailing edge" stock, but they grew to maturity under very different geologic circumstances: the north was glaciated, the south was not.

North Carolina's Outer Banks are a 200-mile-long wisp of sand, the most extensive barrier island system in the world. This system was created by a great northbound current in the Atlantic Ocean called the Gulf Stream, much stronger than currents that flow past Padre Island along the coast of Texas. Barrier islands both in the Gulf of Mexico and along the Atlantic coastline are thought to have originated as low offshore mounds whose surface gradually climbed above water as surf deposited more and more sand.

Most barrier islands, including the Outer Banks, are relatively young in geologic terms, because sea levels around the world have only recently stabilized sufficiently to allow such islands to become established. During the ice ages, huge quantities of frozen water were locked up on land, and ocean surfaces worldwide were far below their current levels. With the end of the Pleistocene Epoch 10,000 years ago, the ice started to melt, and sea levels rose so quickly that most barrier islands that previously existed were drowned and washed away. Four thousand years later the rate of rise slackened, and the Outer Banks were able to gain a foothold against the sea. Since then, worldwide sea levels have continued to inch upward but at a much slower rate, allowing the islands to persist.

Barrier islands are molded season by season, reshaped storm by storm. Hurricanes hurtling northward off the equatorial Atlantic have pummeled the Outer Banks more than 150 times since European settlers first began to keep records in 1585. These storms roll waves like great bowling balls over the 15-foot-tall islands, chewing up sand and spitting it toward the mainland. The Outer Banks are gradually migrating toward the mainland as sea level slowly continues to rise. The barber pole lighthouse at Cape Hatteras, built 1,500 feet back from the shoreline in 1870, had to be hauled half a mile inland in 1999 to accommodate ongoing shoreline erosion of Hatteras Island.

Barrier islands are created parallel to a mainland coast when suitably strong
currents carry sufficient sand along a shallow ocean floor. Worldwide, they are
far more likely to be found on trailing edge than on leading edge coasts.
Hatteras Island here nicely displays a classic sequence of ocean-facing beach,
foredunes, washover sands, and silty back-barrier lagoons.

The Outer Banks are actually a series of islands, currently separated by seven inlets that open and close according to the whims of hurricanes. At least 30 different inlets have been recorded in the past 400 years. Pamlico Sound separates the Outer Banks at Cape Hatteras from the mainland by 30 miles. Tides within the sound regularly rise and fall two or three feet, causing huge volumes of salt water to rush through the inlets twice a day. Sediments carried by these bidirectional currents are deposited in symmetric tidal deltas on either side of each inlet.

Behind the Atlantic Coast's barrier islands lies a vast network of lagoons and estuaries. Lagoons are saltwater bodies protected from tides and cut off from fresh water. Estuaries are coastal embayments with a significant influx of fresh water regularly stirred by the tides. An estuary accumulates large quantities of sediment and, like a delta, its shores might be lined with mangroves and bordered by tidal flats. But unlike deltas, estuaries are bodies of water that are cut into the coastline, rather than landforms that fan out from it. Chesapeake Bay is a grand champion of estuaries, 180 miles from stem to stern. Within its depths lie the mouths of the Rappahannock, Potomac, Susquehanna, and other smaller rivers that were drowned when sea levels rose at the end of the Pleistocene. Since then, these rivers no longer carry their sediment loads out of Chesapeake Bay to reach the Altantic Ocean. Instead, tidal currents sweep sediment out of the old river beds, maintaining depths of about 70 feet; otherwise the bay tends to be 15 to 30 feet deep.

The East Coast from New Jersey to Florida is justifiably famous for its long white beaches, some more pristine than others. These beaches are the East Coast's first and strongest buffer against assaults by storms from the Atlantic. Here waves dissipate their erosive energy against endlessly forgiving grains of sand. A beach constantly reinvents itself to accommodate the demands of high tides, fluctuating sediment supply, and changing sea levels. A beach is a complicated machine with many moving parts—a nearshore zone where waves first rise up and begin to break; a foreshore where water and sand swash up and rush back down; and a backshore that usually lies beyond the reach of water and waves. Wind whisks dry grains away, wafting sand onto dunes that reside behind the beach. If plants don't anchor a dune, wanderlust can carry its windborne sand grains completely beyond the coastal environment. But like truant children, escapee grains usually fall into inland rivers and return chastened to the shoreline.

The Altamaha River (a small part is visible in the lower right corner) flows past Little Saint Simons Island, Georgia, into the Atlantic Ocean. River water, stained brown by tannin from upstream vegetation, lingers near the mouth of the Altamaha before mixing with the ocean's blue salty water. Longshore currents steadily move sand northward along the coast, creating beaches. Trapped behind the beaches, smaller rivers (top center) are forced to flow parallel to the coastline until they can break through and flow freely into the ocean.

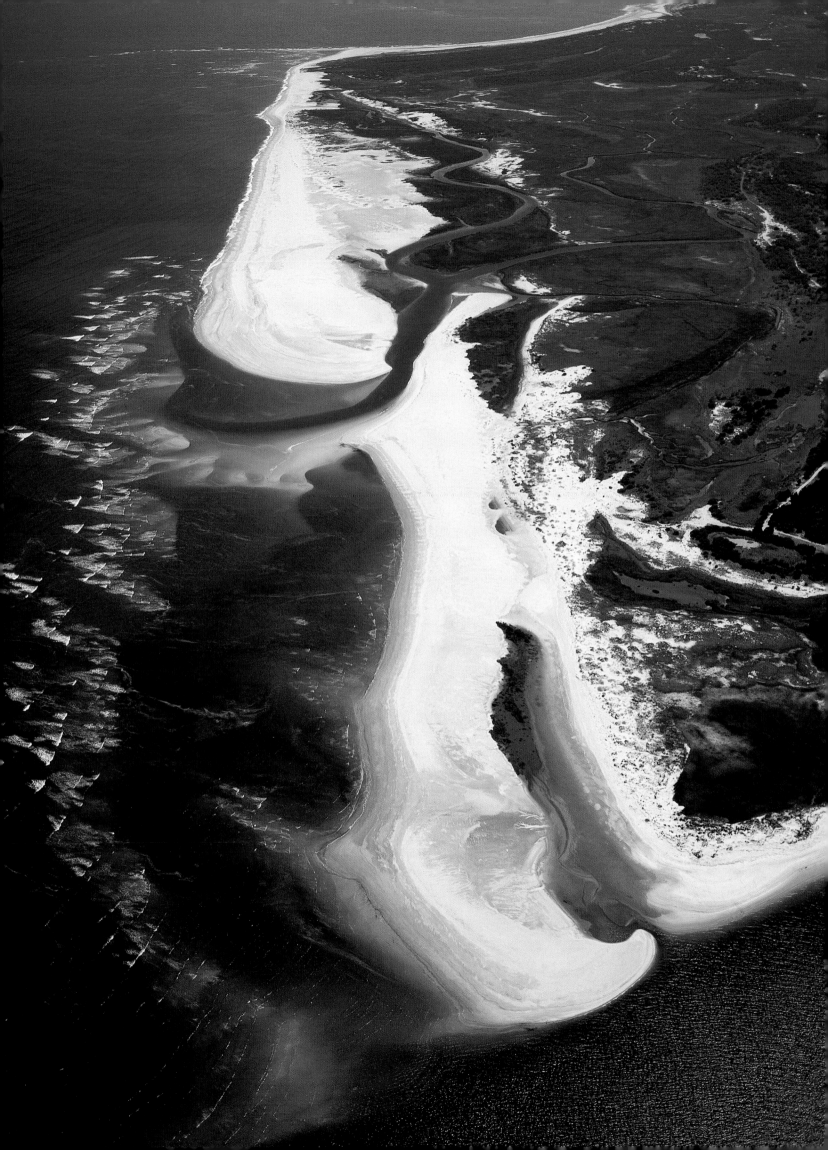

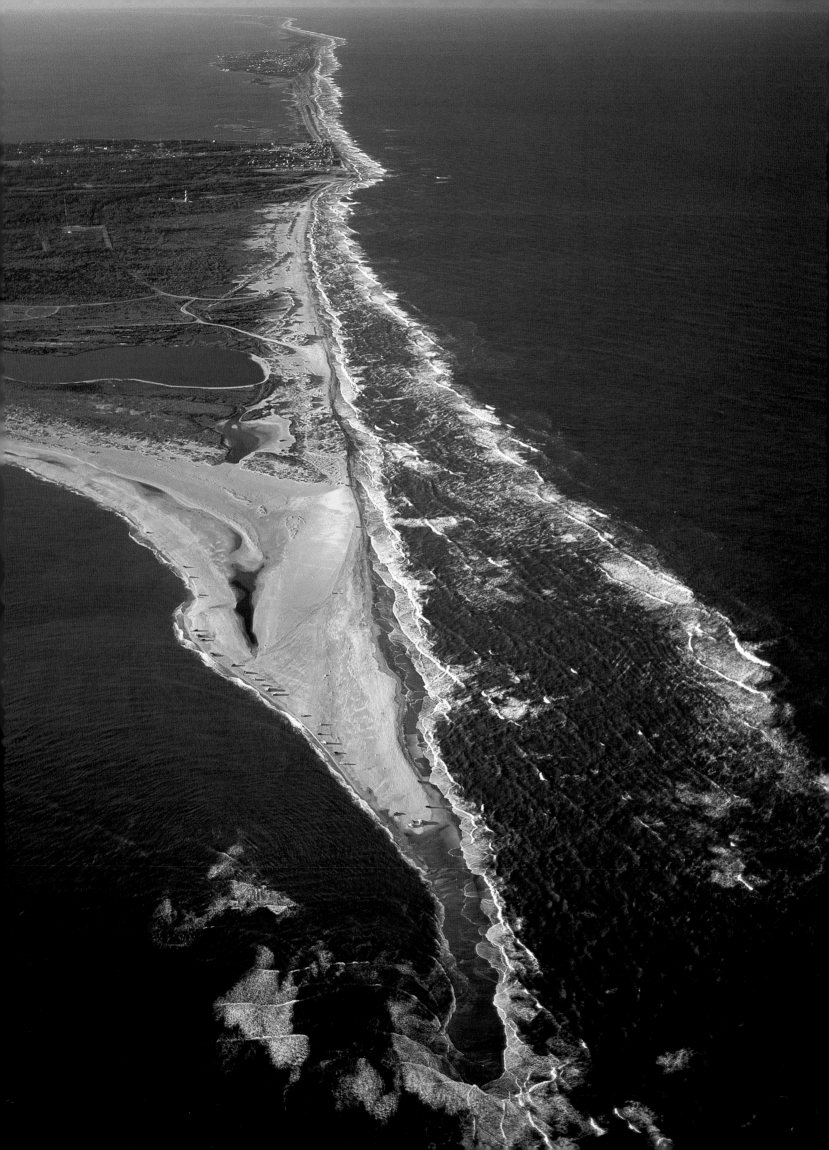

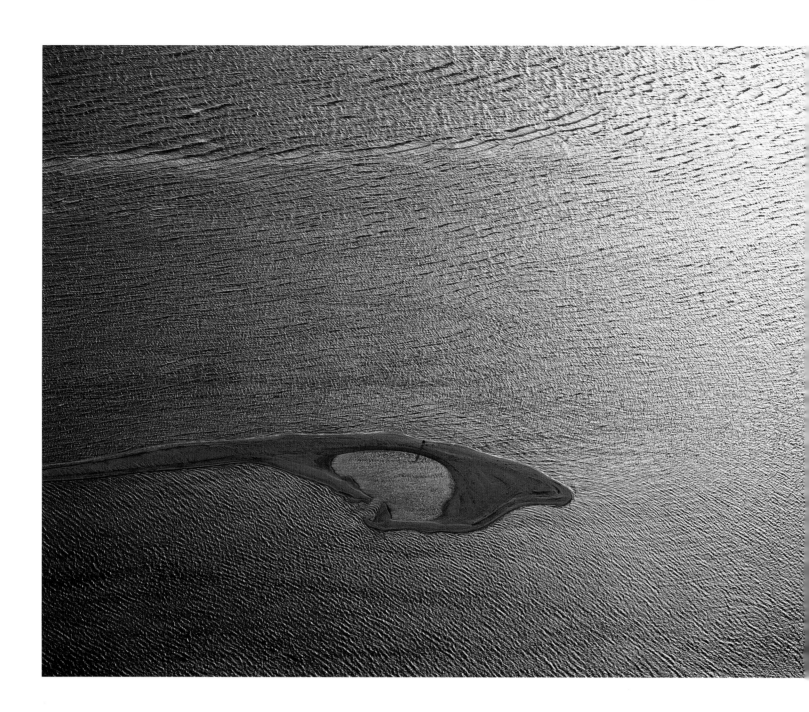

Above: The sand spit at the southern end of Gwynn's Island, Virginia, blocks a steady train of waves that march in from Chesapeake Bay. Small waves at the bottom of the picture are moving from left to right in response to a morning breeze, while waves from the open bay are moving from top to bottom, set in motion by more distant winds blowing in a different direction.

Left: With changes in sea level, barrier islands such as Hatteras Island in North Carolina adjust their position offshore. Rising sea level means that Atlantic storm waves can more easily overtop Hatteras, carrying sand from its ocean side on the right and redepositing it on the inland side, effectively shifting the entire island inland.

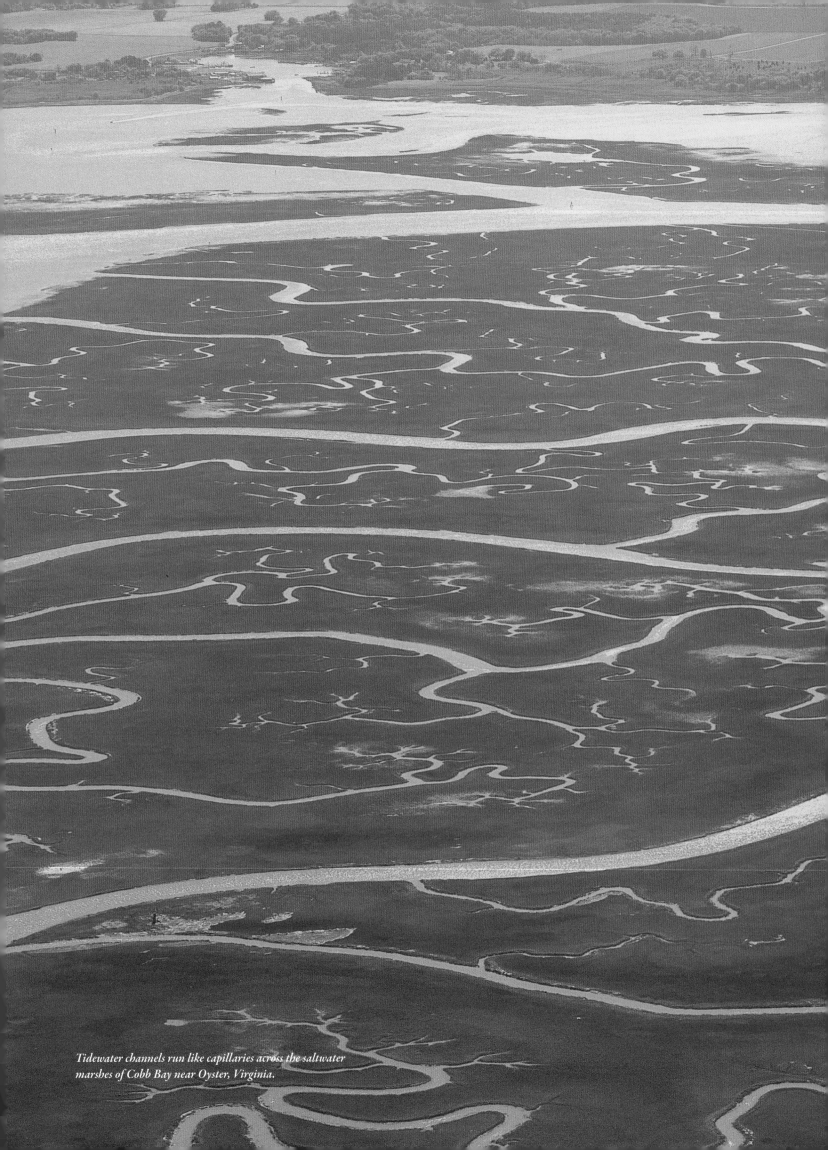

Tidewater channels run like capillaries across the saltwater marshes of Cobb Bay near Oyster, Virginia.

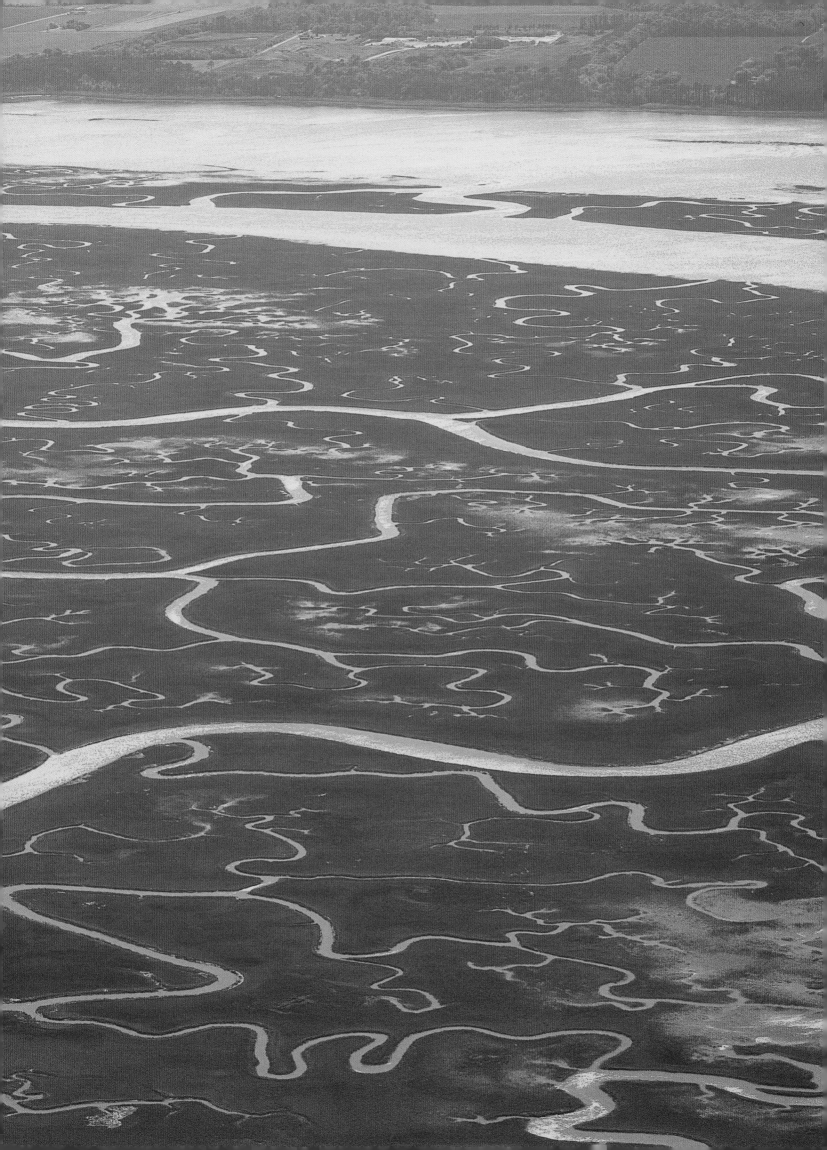

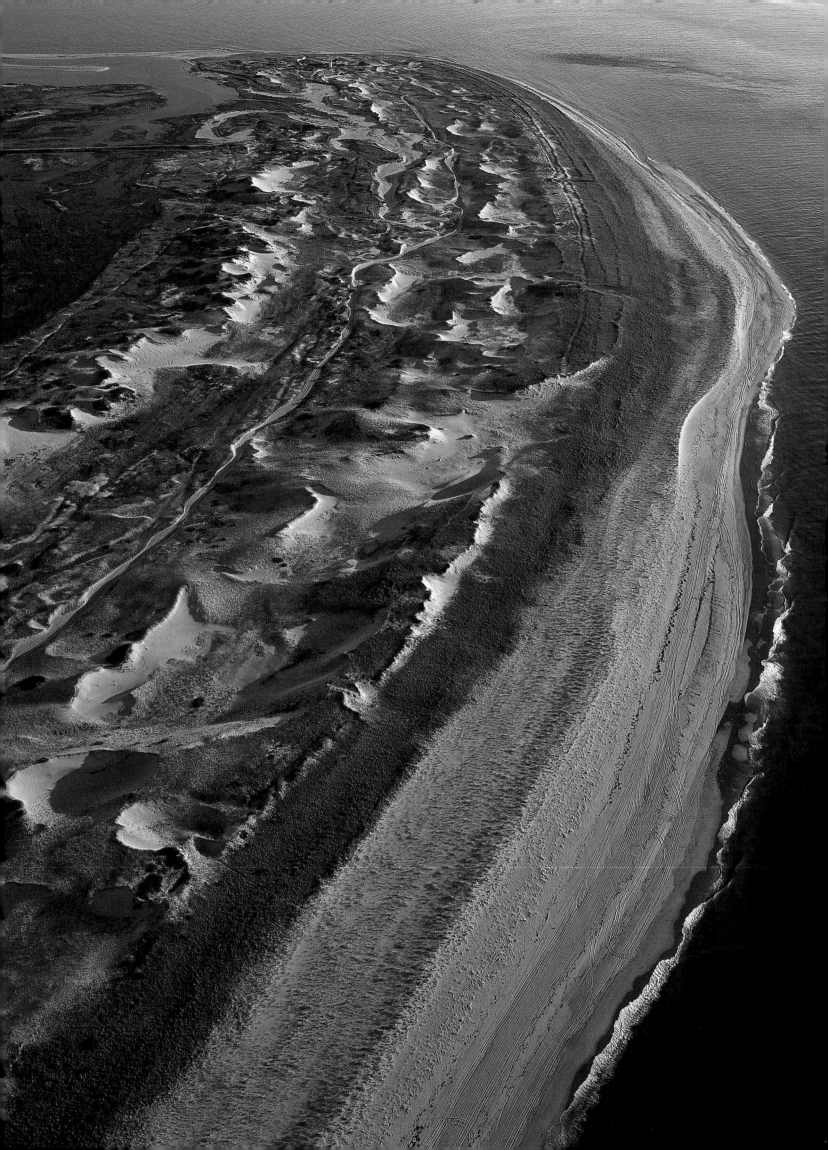

Northern Atlantic

Rivers on the East Coast once gently flowed into the Atlantic, their mouths adjusted to a sea level that had been stable for millions of years. But during the Pleistocene Epoch, 1.6 million to 10,000 years ago, 16 million cubic miles of water were locked on land within glaciers, and oceans were 400 feet lower than present levels. The Atlantic shoreline lay 60 miles east of New York City rather than lapping at the feet of Coney Island as it does today. Sea level was so low that rivers were forced to cut deep valleys as they approached the ocean. When the ice finally melted, sea level shot up by almost half an inch a year. Squint at a map of the modern East Coast and you'll see the ghost of those now-drowned valleys in the outlines of Chesapeake and Delaware bays.

The northeastern seaboard was totally transformed both by the arrival and the departure of the Pleistocene ice ages. Nothing, absolutely nothing, can haul heavy loads like a glacier. Glaciers pluck mountains apart, scrape valleys open, and transport entire landscapes rock by rock to new locations tens or even hundreds of miles away. Back in the Pleistocene, ice sheets spread out from northern Canada, extending from southern Alaska to coastal New England. Other sheets were centered over England and affected Europe. At the peak of the most recent glacial stage called the Wisconsinan, 17 million square miles of the world's surface lay buried beneath ice.

Glaciers overrode portions of New England, including Martha's Vineyard and Nantucket Island, and then migrated as far south as Long Island. En route, the glaciers scooped up sand and gravel that would eventually be deposited as a vast gentle slope at the farthest extent of the ice. Bedrock was covered locally to depths of 600 feet, its surface pocked here and there with isolated blocks of ice. With time, the blocks melted and left behind depressions called kettles that now dot Cape Cod.

Packs of Pleistocene glaciers repeatedly prowled south as far as the harbor of New York City, only to slink back during interglacial periods. For the moment, we now enjoy a warm interglacial period that began 10,000 years ago. It's hardly an accident that the human species ascended to primacy during this period with its fair climate and expanded opportunities for migration and agriculture. But warm temperatures and the rise of sea level have been tough on Cape Cod.

Water has scoured the beach sands of Race Point at the northern tip of Cape Cod, while sand out of reach of the waves has been reworked into dunes by the wind. The sand of Cape Cod was first deposited by outwash from glaciers in the Pleistocene Epoch.

Nor'easter storms slam into the Cape with particular vengeance, casting waves that angrily undermine east-facing cliffs. The outer shore loses as much as five feet a year to the ocean's wrath. Sand liberated from the Cape has been shuffled by longshore currents to extend either north toward Provincetown, or south to Monomoy Island which, from the air, appears to be rolling like a tear toward Nantucket. The modern Atlantic ceaselessly claws at Cape Cod's unconsolidated bluffs, washing sand and gravel out to sea. This material collects offshore, creating dangerous shoals that have claimed 3,500 ships since 1850. Scientists, looking into the future, are grimly confident that at some point Cape Cod will erode away, to be nothing more than a handful of underwater shoals and a pocketful of memories.

North of Cape Cod, Pleistocene glaciers scraped New England bare to the bone. All told, only two percent of Maine's 3,500-mile coast is sandy. The state was covered in places by ice two miles thick. Boulders embedded in the bottom of the ice gouged bedrock striations that are exposed now, offering clues about the direction in which the ice once moved. Preservation of these superficial striations shows that minimal erosion has occurred along this granitic coast in the intervening 10,000 years. Maine's craggy headlands and plentiful islands are aligned northwest/southeast, roughly parallel to the striations, displaying a linear fabric that confirms a glacial heritage. Deep embayments, such as Somes Sound within Acadia National Park, are good examples of fjords that were whittled like scrimshaw by the busy knives of ice.

North America is the solid and relatively stiff continental crust that floats atop a more viscous mantle. It's difficult to conceive of this crust bending, but when an average of 3,300 feet of ice was loaded on top of Maine, bend it did. The underlying mantle slowly oozed aside to accommodate the crust's downward bulge. When glaciers started to melt at the end of the Pleistocene, sea level rose and salt water immediately rolled in to form an embayment called the DeGeer Sea, swamping Bangor and reaching more than 60 miles inland between Millinocket and Bingham. But with the ice gone, the crust of Maine rebounded upward, so the DeGeer Sea subsequently drained away. Pockets of muddy lake deposits now called the Presumpscot Formation are all that remain to inform scientists of this inland sea's former existence.

Off-shore sand dunes near Hyannis, Massachusetts, are sculpted by water rather than by wind.

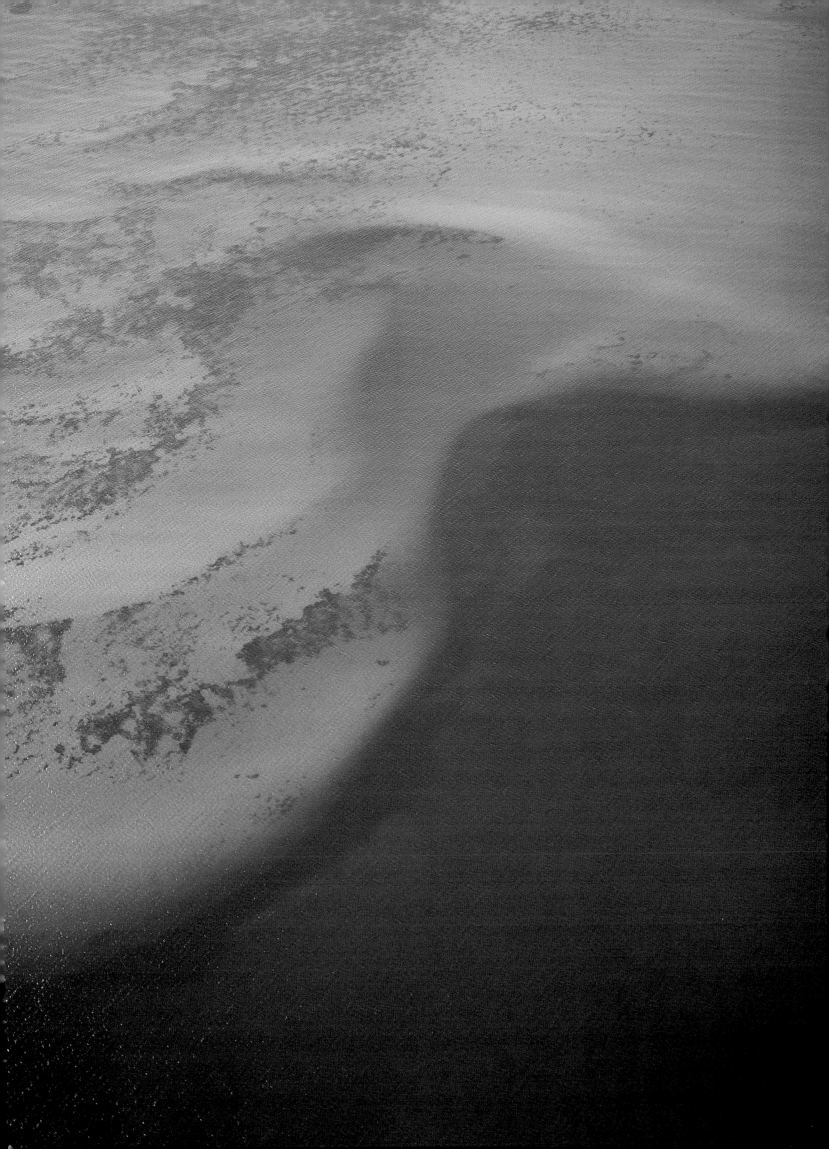

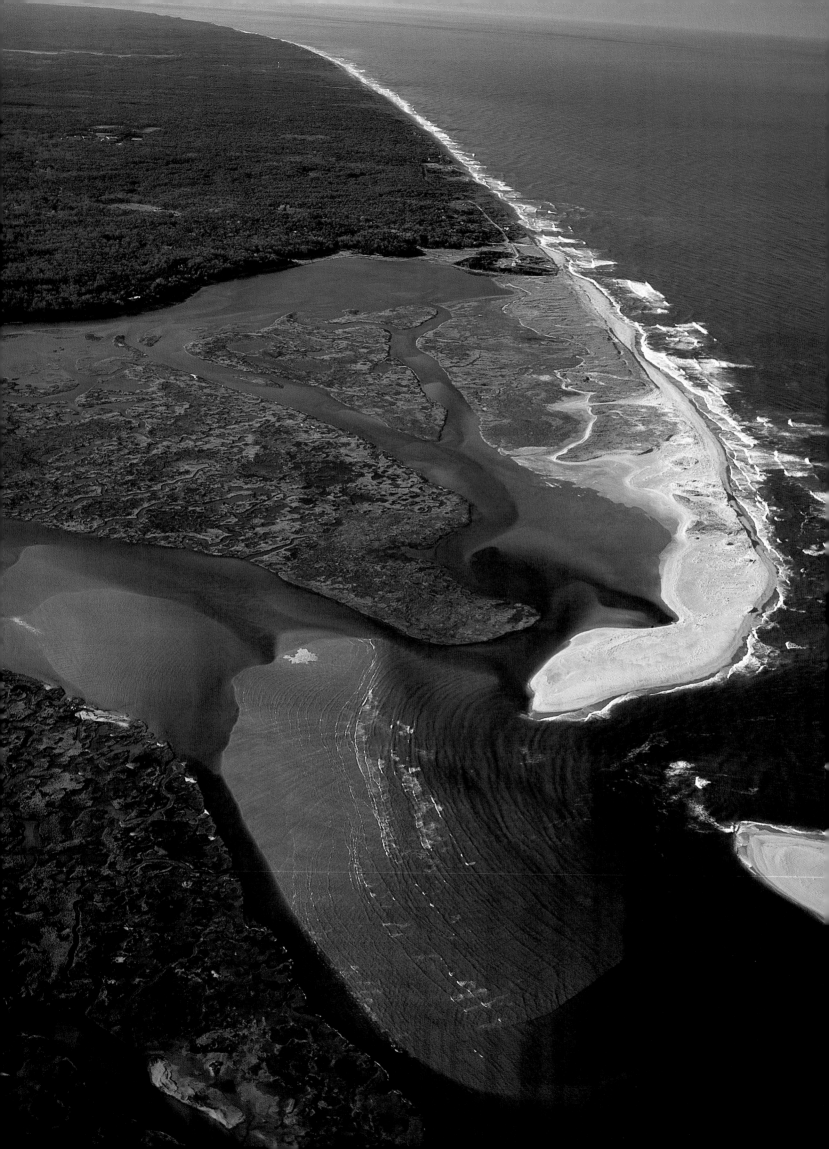

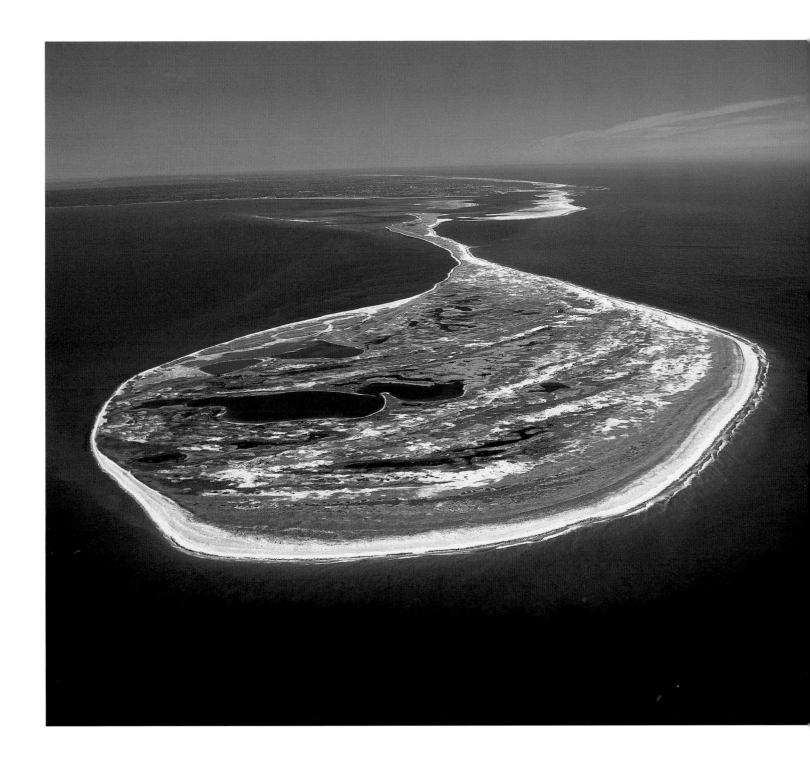

Above: Monomoy Island is the teardrop that falls from the southern end of Cape Cod. Shoals off the Cape have long been the bane of sailors; indeed, Monomoy Island's first European settlement was a tavern built in 1711 at Wreck Point. The shape of the island is constantly being changed by storms and longshore currents.

Left: The waters of Nauset Bay on Cape Cod extend well to the left of this photograph, covering two square miles that fill and drain, raising and lowering the water level by as much as ten feet, twice a day. Depending on the whims of recent storms and the resulting strength of longshore currents that flow along the Cape, the bay's inlet may be only a few hundred feet wide. With such a narrow opening, tidal currents are strong enough to form the underwater sandbar seen just inside the inlet.

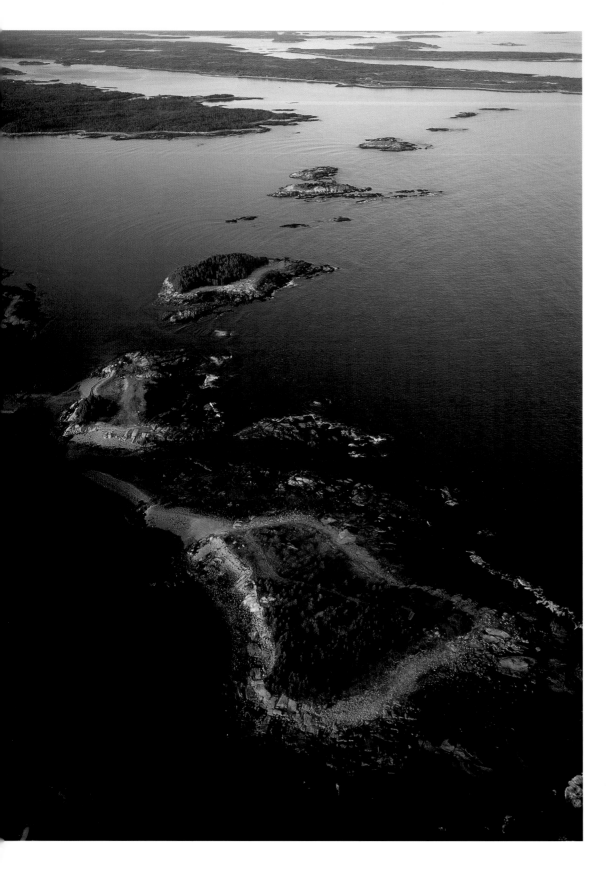

Left: Sheep, Sally, Eastern and other islands are strung like beads on a necklace across the throat of Gouldsboro Bay in eastern Maine. During the Pleistocene, this string of rocky outcrops lay across the path of glaciers that flowed from left to right, part of the vast icefield that carved Maine's fjords.

Right: Spruce and fir cover Turtle Island, part of Acadia National Park, Maine. At the bottom of the picture, the fabric of the island's granite is easily seen in the parallel ledges that run into the waters of Frenchman Bay.

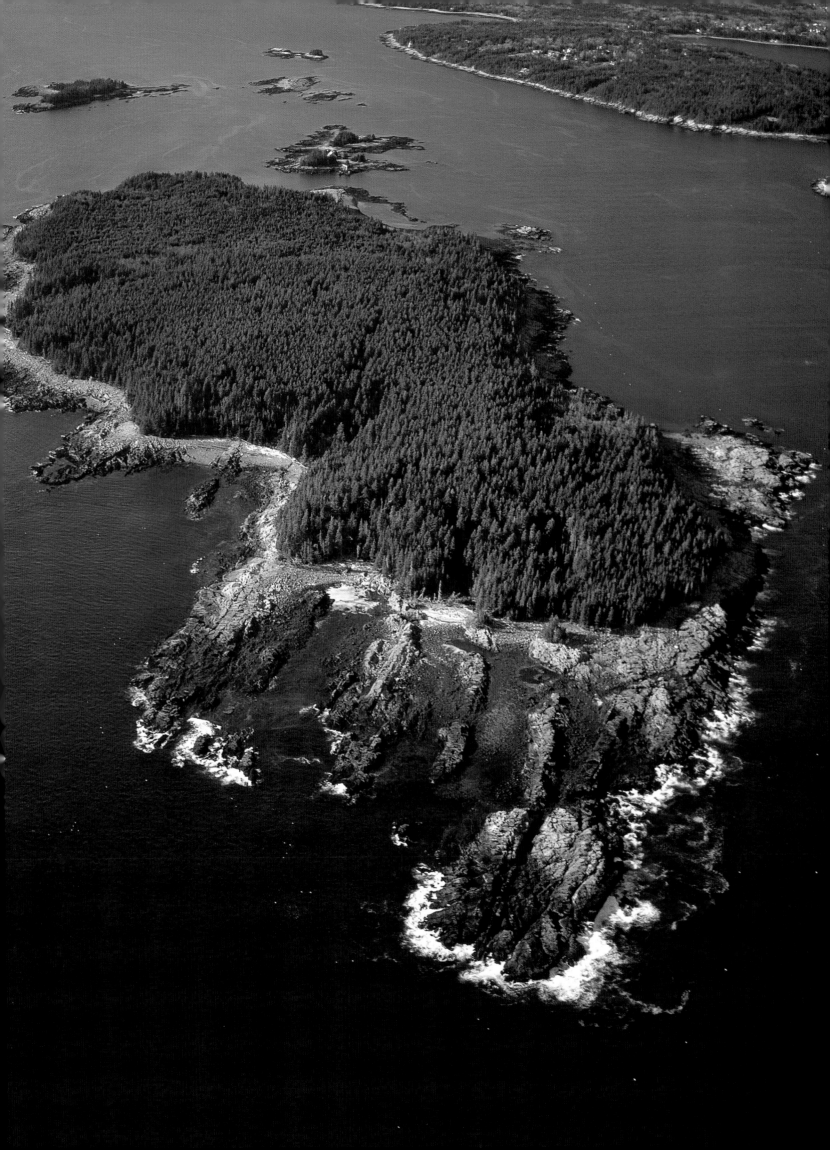

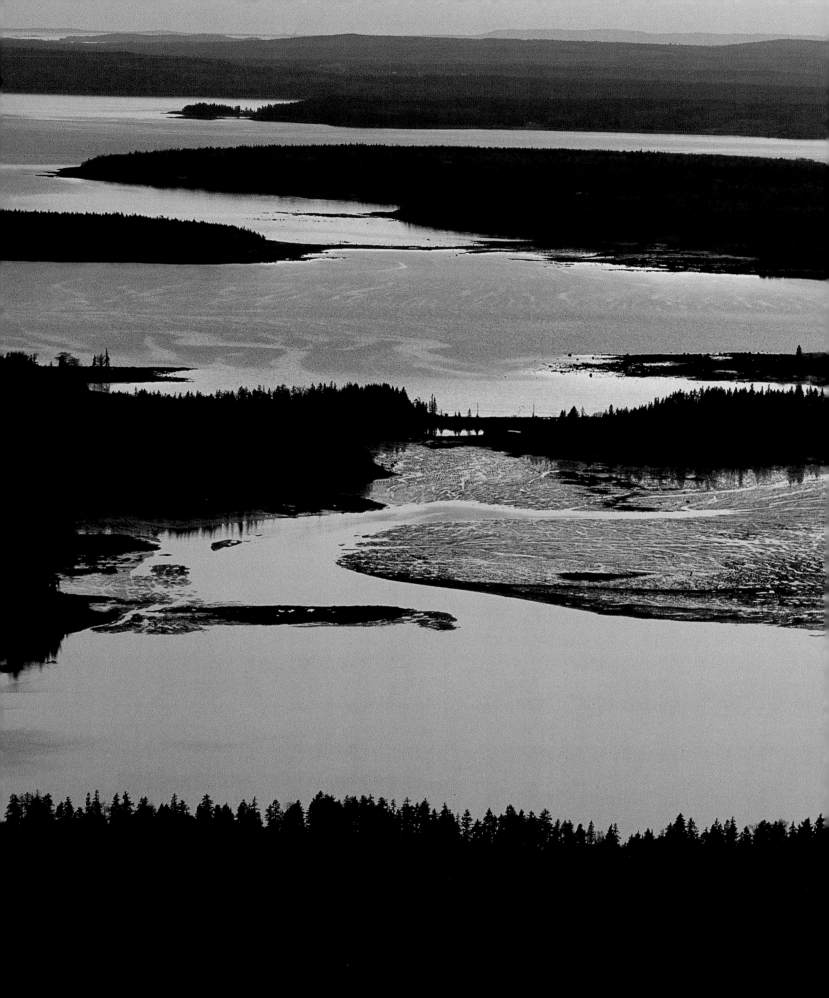

Pleistocene Epoch glaciers carved northern New England's coast into a scrimshaw of bays and channels, islands and peninsulas, as seen here in Acadia National Park, just south of Trenton, Maine. The glaciers scoured rock and soil as they ground their way out of the mountains of Maine toward the Atlantic. Upon reaching the coast, they dropped silt and sand that in time would be incorporated into mudflats like the one seen in the middle of this picture.

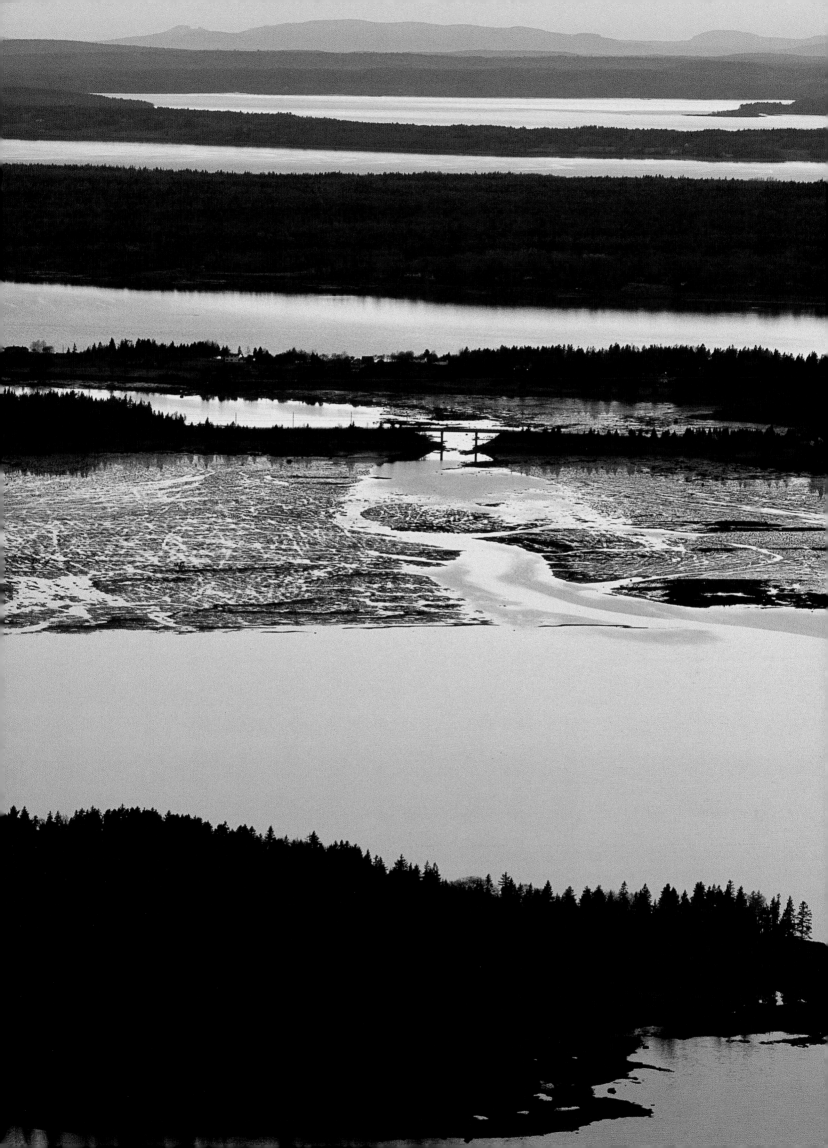

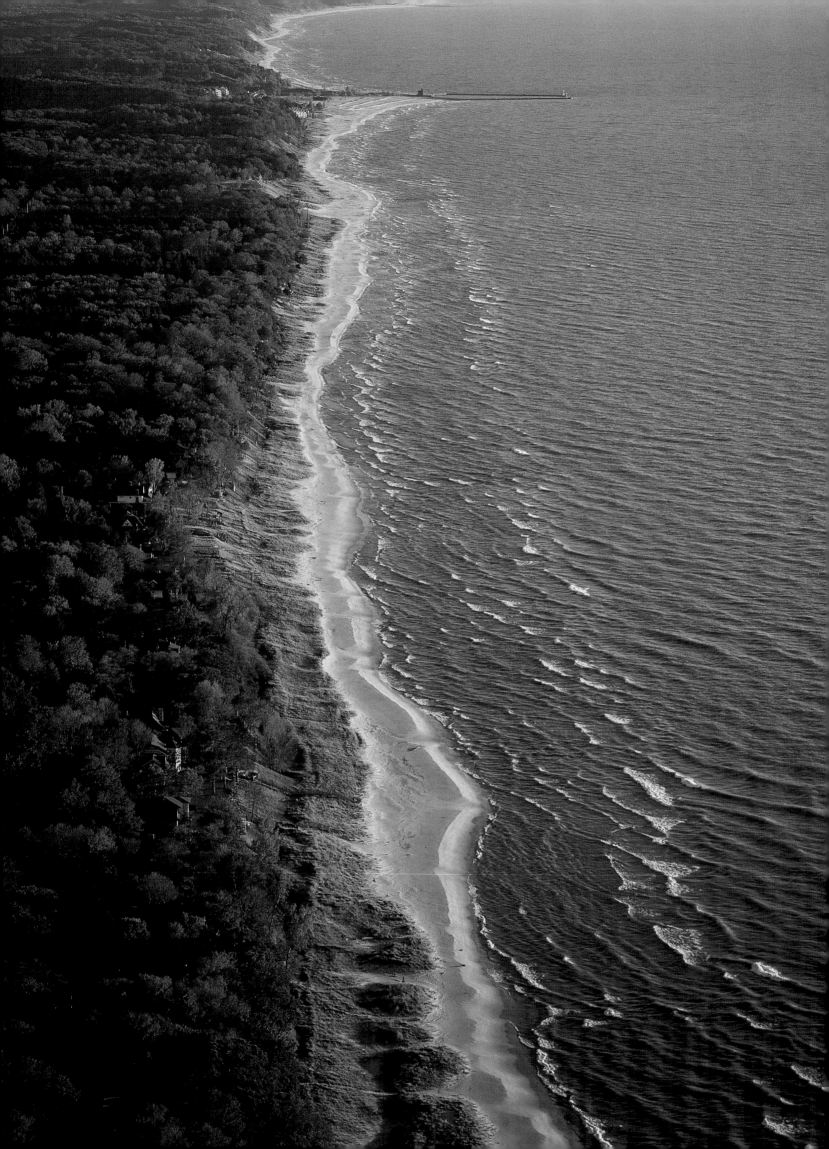

Great Lakes

Mine was once the great honor of driving a yellow D9 Caterpillar that weighed 110,000 pounds. My friend Dusty had hastily described the bulldozer's arcane array of levers and pedals, then turned me loose on a house-size hummock of dirt. I chugged and clanked back and forth, up and down, trying to harness the machine's infinite torque to the delicate job of controlling its business-end blade. In the course of my backings and forthings, I inadvertently dug three huge swimming pools. It took a while but eventually the dirt was smoothed, and Dusty finished the job by deftly filling in my mistakes. Never a politician, I'm unlikely to ever again wield such raw power. But for those few giddy moments, with levers clacking and heart pounding, I could imagine what it felt like to be a glacier, carving up New England and bulldozing out the Great Lakes. Mine was only a tantalizing taste, though; even a small glacier would have the unstoppable mass of millions of those D9s.

We've seen the Gulf and Atlantic coasts already and we'll soon visit a third coast—the Pacific. But along the way let's stop for a look at the border between the United States and Canada. Like New England's coast, the Great Lakes—Michigan, Superior, Huron, Erie, Ontario—were sculpted by Pleistocene ice. It's reasonable to think of their shores as our fourth coast. During the last ice age, this region was overrun by multiple sheets of ice that reached south almost to the modern Missouri and Ohio River valleys. Along the way, glaciers gouged the initial outline of the Great Lakes.

After each advance the ice retreated, and lakes ponded along the glaciers' snouts. Initially, meltwater from the Great Lakes had drained south into the Hudson, Ohio, and Illinois rivers. But as the glaciers retreated farther back into Canada, a new drainage system was created that directed outflow from the lakes toward the east rather than toward the south. By the end of the Pleistocene, the lakes were connected and flowed east along the Saint Lawrence River into the Atlantic Ocean, instead of south toward the Gulf of Mexico, thus putting the finishing touches on the Great Lakes as we know them today.

Winds persistently blow toward the northeast (down and to the left in this picture) across Lake Michigan to create sandy beaches on its eastern shore. Waves strike the beaches at an oblique angle which generates a long-shore current flowing to the north.

Now that the weight of the former ice sheet has been completely removed, the crust is rebounding upward, though the amount of uplift differs from place to place. The ice overlying the Great Lakes region was thicker in Canada than in the United States, so the north end of Lake Michigan is likely to rebound higher than the south. There is a chance that at some point in the future Lake Michigan, like a shallow soap dish, will be tilted to the south, abandoning its current northerly outlet into Lake Huron to flow once again toward tributaries of the Mississippi River.

The Great Lakes are the world's largest freshwater system, covering 94,000 square miles and holding one-fifth of all the drinkable water on earth. The lakes are dotted with 35,000 islands and ringed by 9,500 miles of shoreline with a wide variety of swamps, marshes, and bogs. Lovely cliffs line parts of Wisconsin's Door County on Green Bay, and billowing dunes frost the eastern shore of Lake Michigan. The sand at Sleeping Bear Dunes National Lakeshore, Michigan, is perched upon sinuous hills of poorly-sorted sediment called moraines, left stranded by the departure of Pleistocene glaciers.

The Great Lakes don't experience tides as oceans do, but wind and atmospheric pressure gradients do force water to swash back and forth within the five basins as if they were bathtubs. Lake Erie, being the shallowest and having the east-west orientation best aligned with predominant wind directions, has experienced the largest of these waves, called seiches, that commonly leave one end of the lake under six more feet of water than the other end.

Brown streamers of tannin, derived from the forests of Michigan's Upper Peninsula, swirl over underwater dunes just offshore of Garden Corners.

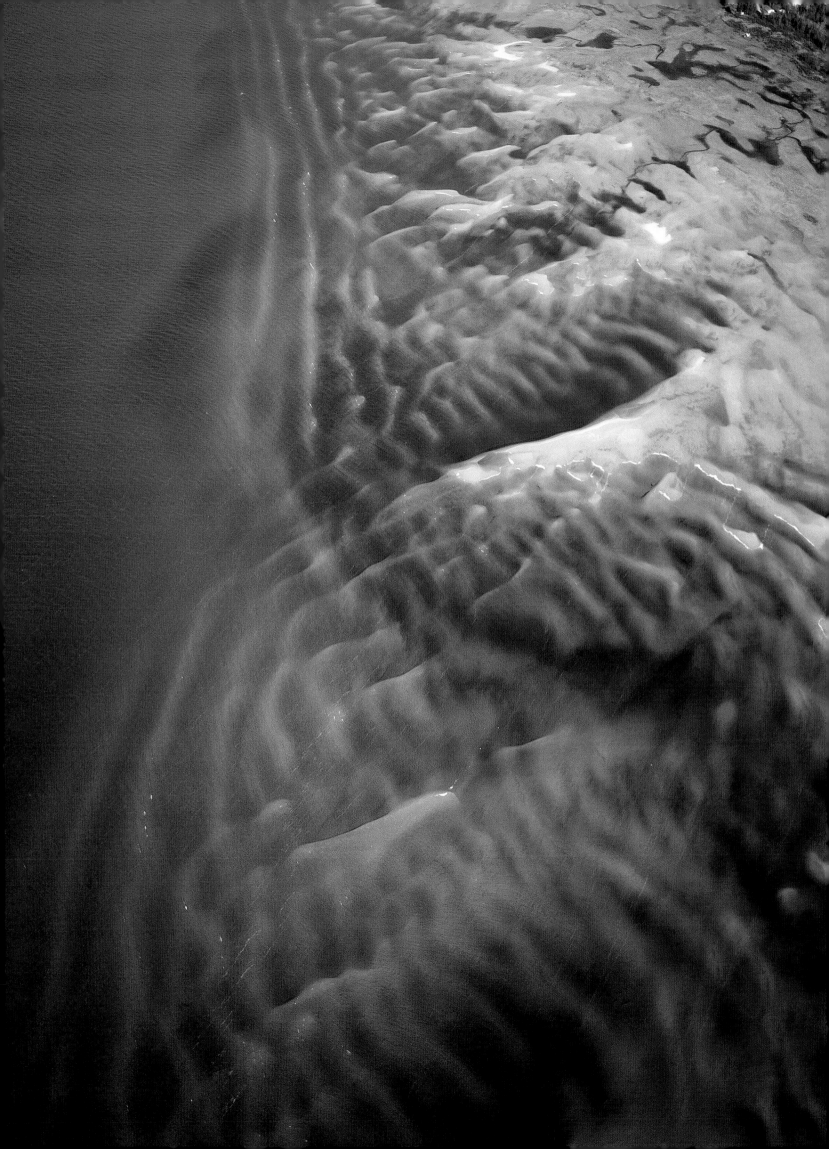

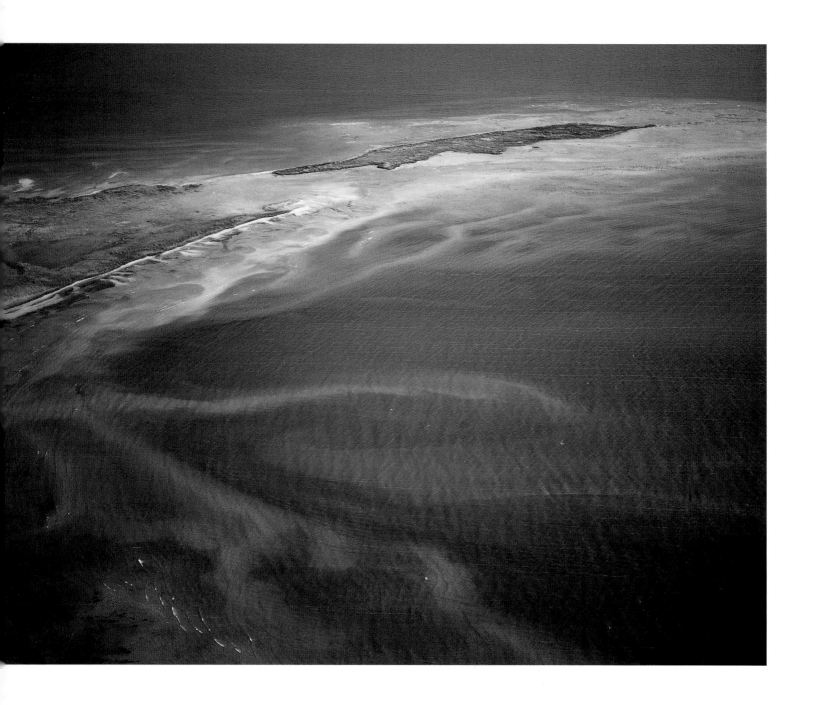

Above: Currents east of Escanaba, Michigan, weave underwater sand dunes around a point that projects out into Lake Michigan.

Right: A thin strand of sand and rock tries unsuccessfully to link Rock Island (at top) to Washington Island (bottom of picture) at the north end of Wisconsin's Door County Peninsula in Lake Michigan. Wind-generated currents, flowing left to right, have bowed the strand in the middle of the picture to the east.

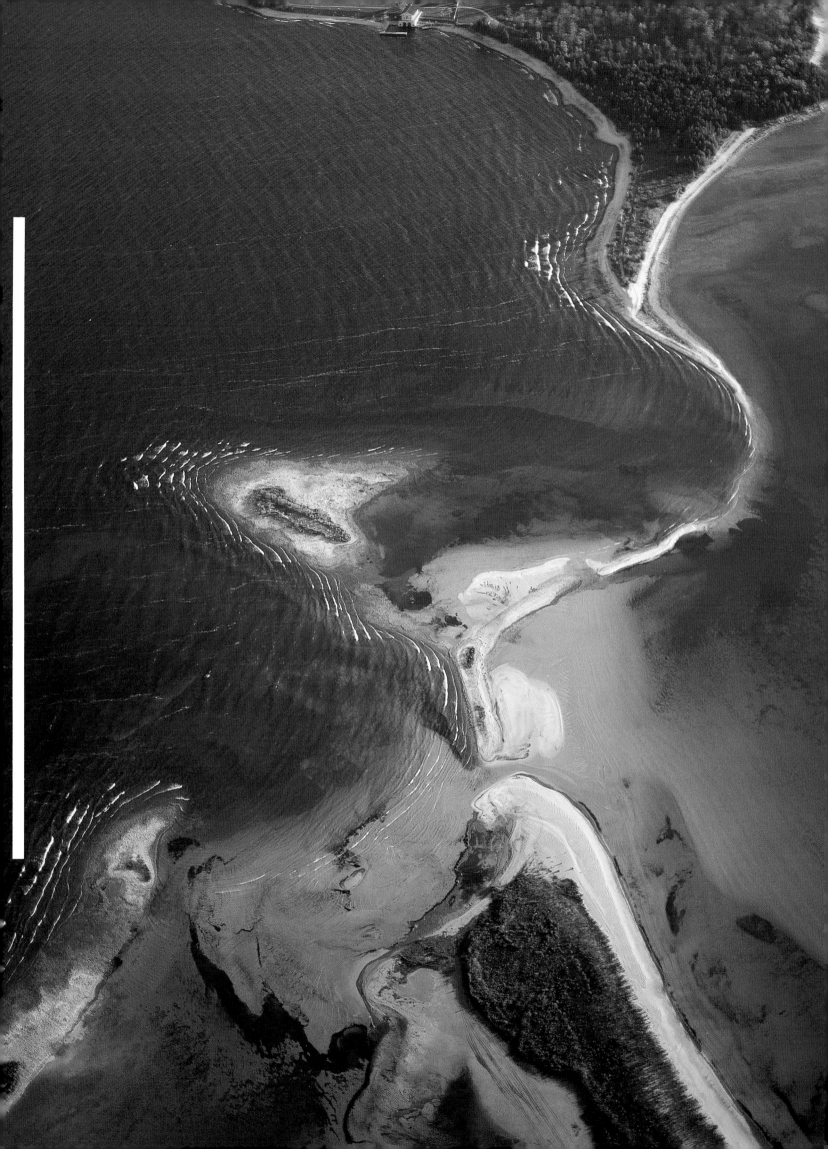

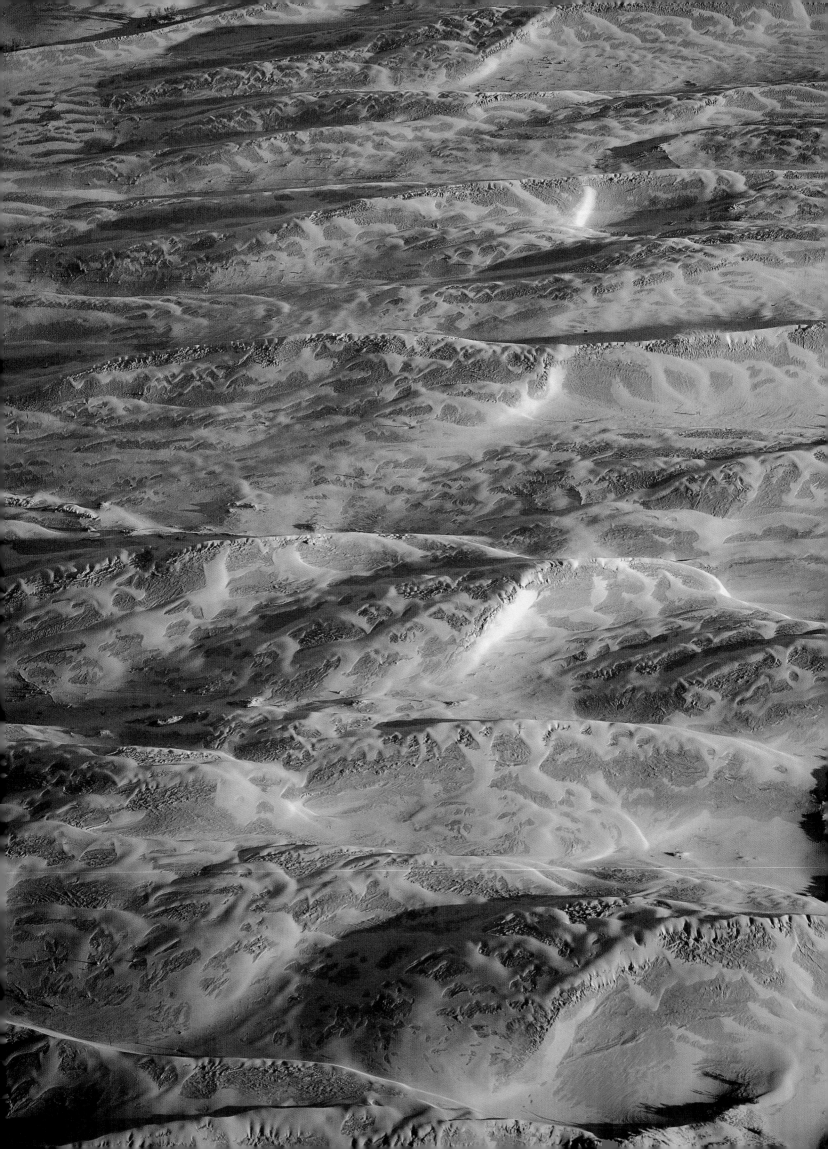

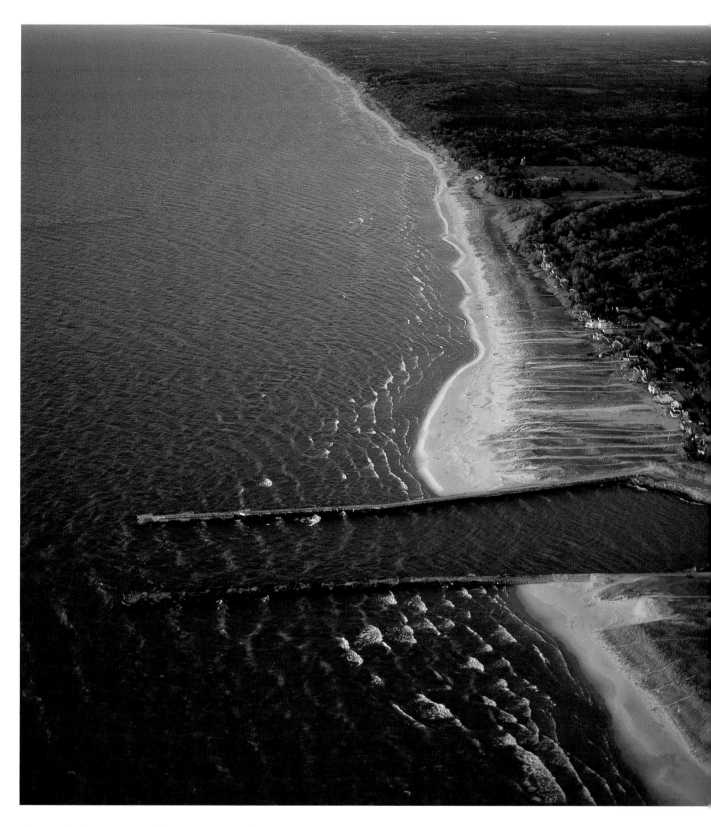

Above: A breakwater protects the entrance to Port Sheldon, Michigan, from the full brunt of Lake Michigan's waves. A pocket of sand nestles in the protected water behind this breakwater, revealing the northbound direction of longshore currents that transport sand up the lake's eastern shore (towards the top of the picture).

Left: Sand blown from the east shore of Lake Michigan piles up in dunes at Silver Lake State Park. The larger dunes are covered with a fine dusting of sand that records the most recent wind direction.

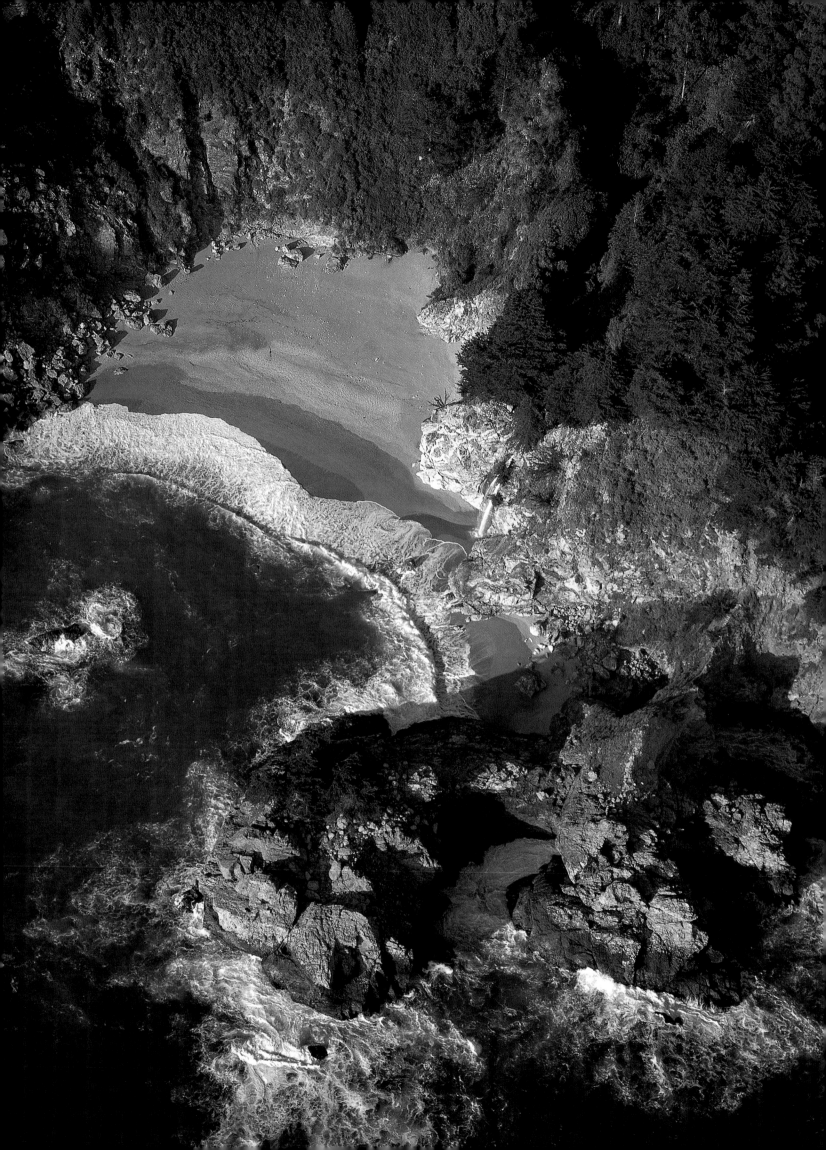

Pacific

North America's West Coast is the leading edge in the ongoing collision between continental and oceanic crust. Nowhere does the Atlantic's trailing edge coast look anything like the precipitous cliffs of California's Big Sur or the dramatic sea stacks that punctuate Oregon's shore. Washington's Olympic Peninsula west of Seattle is a classic example of a leading edge coast with its rugged cliffs and narrow, storm-battered beaches. The Olympic Range, full of contorted sedimentary rocks scraped off the colliding sea floor, rears up 8,000 feet, a mere 35 miles from the sea. Oregon's Humbug Mountain, barely half a mile from the shoreline, leaps 1,700 feet directly out of the ocean.

Farther south, earthquakes along the San Andreas Fault have sliced California into ribbons. In Hollister, your neighbor's home may look like it's just across the street, but it actually sits across the fault on a different tectonic plate: you're aboard North America; they're sailing away on the Pacific plate. While Los Angeles slips horizontally alongside North America, other parts of the California coast are being tortured skyward by the ongoing structural adjustments of two great pieces of crust.

The West Coast is geologically young, and erosion is still a hyperactive adolescent here. Streams are steep and, in flood, they carry great quantities of sediment to the sea. Northern California's Eel River, for example, annually strips a ton of soil from each acre in its 3,000-square-mile drainage, carrying this dirty business past Loleta, Singley Bar, Cock Robin and Cannibal Islands before sliding into the ocean. Sediment delivered to the open Pacific Ocean is not likely to stagnate into a delta as occurred in Louisiana because vigorous longshore currents usually whisk sand and silt away before much accumulation can occur.

Sand on the West Coast doesn't form the fully developed barrier islands seen on the East Coast because the sea floor here is not so shallow. Instead, Pacific longshore currents distribute sand into narrow spits that look like barrier islands but are attached at one end to the mainland. About a hundred spits are found from San Diego to the Olympic Peninsula. Some of these, like Point Reyes National Seashore, stretch for many miles, but others are tiny and lie tucked between headlands that punctuate the entire West Coast.

The continental shelf—that underwater extension of a continent—is much narrower along the West Coast. On the East Coast, the shelf's shallow water extends as much as 300 miles into the Atlantic off

A sliver of falling water (center) reaches the beach of McWay Canyon in Julia Pfeiffer Burns State Park southeast of Big Sur. Beaches on this portion of the California coast are limited to small dabs of sand hidden behind rocks away from the grasping sea.

Newfoundland. But the western shelf extends only a few miles into the Pacific. Sediments brought to the Pacific Ocean by rivers like the Eel collect on the shelf but soon spill over its edge and tumble into deeper water. In some places the continental shelf is pierced by submarine canyons. The underwater head of Monterey Canyon has eroded landward to a point very close to shore near Moss Landing, California. When the Salinas or Pajaro rivers are in flood, they disgorge muddy water into Monterey Bay that is significantly more dense than normal sea water. These discrete blobs of heavy water can remain intact and creep many miles along the sea floor before mixing. If one happens to tip into a submarine canyon, its muddy water will form a gravity-driven current capable of flowing well off shore into water 6,000 feet deep.

Sand is shuffled not only by water but also by wind, if it comes to rest on land and has a chance to dry. Afternoon breezes insistently blow inland off the Pacific, whipping up aeolian confections like the lovely Pismo Dunes in central California and the huge Oregon Coastal Dunes north and south of Reedsport. The Oregon dunes may date 30,000 years or more back to a time when low Pleistocene sea levels exposed sand perched on the continental shelf, making it available for shoreward transport by the wind.

Plate movements are jacking up the West Coast so fast you can just about see water pouring off its sides. Like a pod of great whales, the Santa Monica Mountains near Los Angeles are currently breaching upward at the rate of a tenth of an inch every year. Trust me, that's a lot. Kansas hasn't felt the earth move so much in millions of years. As a result of this uplift, many parts of the California coast include terraces that not long ago were underwater, where waves polished their tops to a flat surface. If a coastal region includes a stair-step series of such terraces, it's a fair guess that the land has been rising in a staccato fashion, an earthquake at a time. The edges of uplifted terraces will be steep, often lined with cliffs etched with surf-carved caves. Waves will try to divide and conquer, sometimes isolating spires of rock called sea stacks like the ones so well expressed along the Oregon and Washington coasts.

The West Coast's single greatest source of sediment is the Columbia

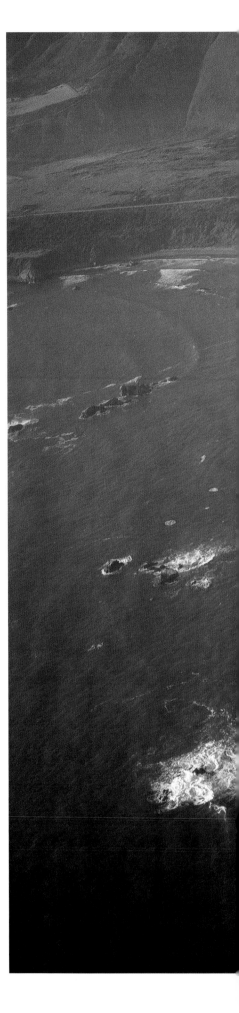

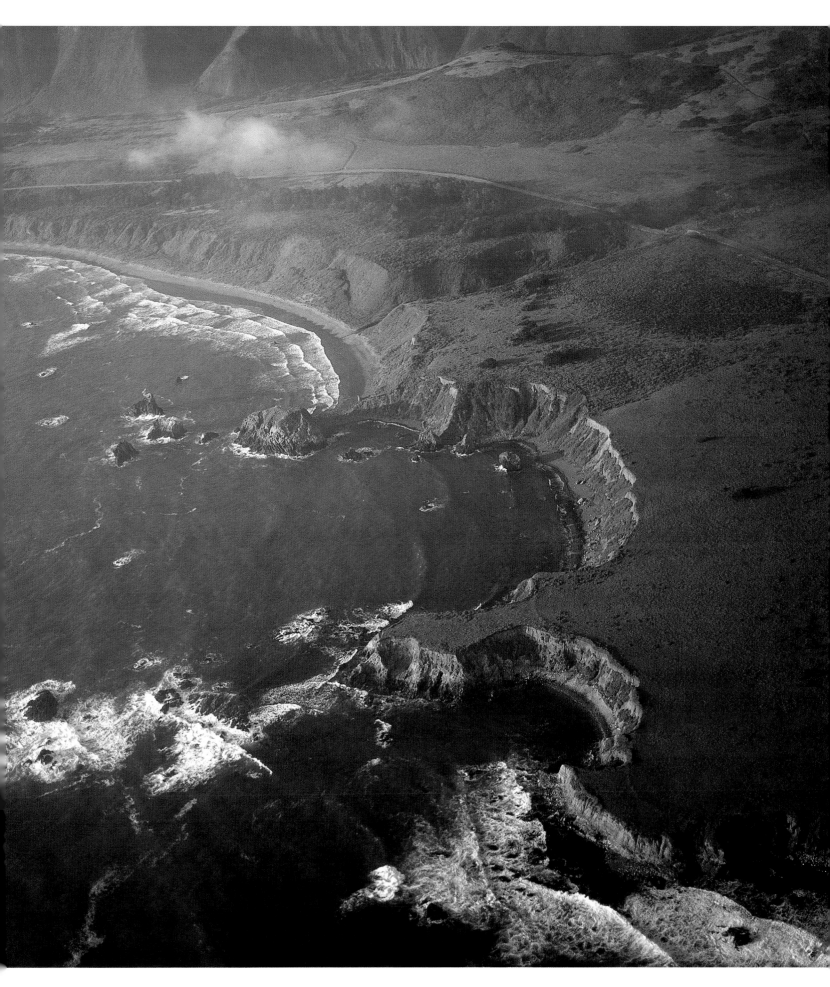

Many portions of the California coast, like this area south of Ragged Point, display terraces that were beveled flat when they lay just below water level. Uplift along this leading-edge coast subsequently hoisted the terraces above the waves.

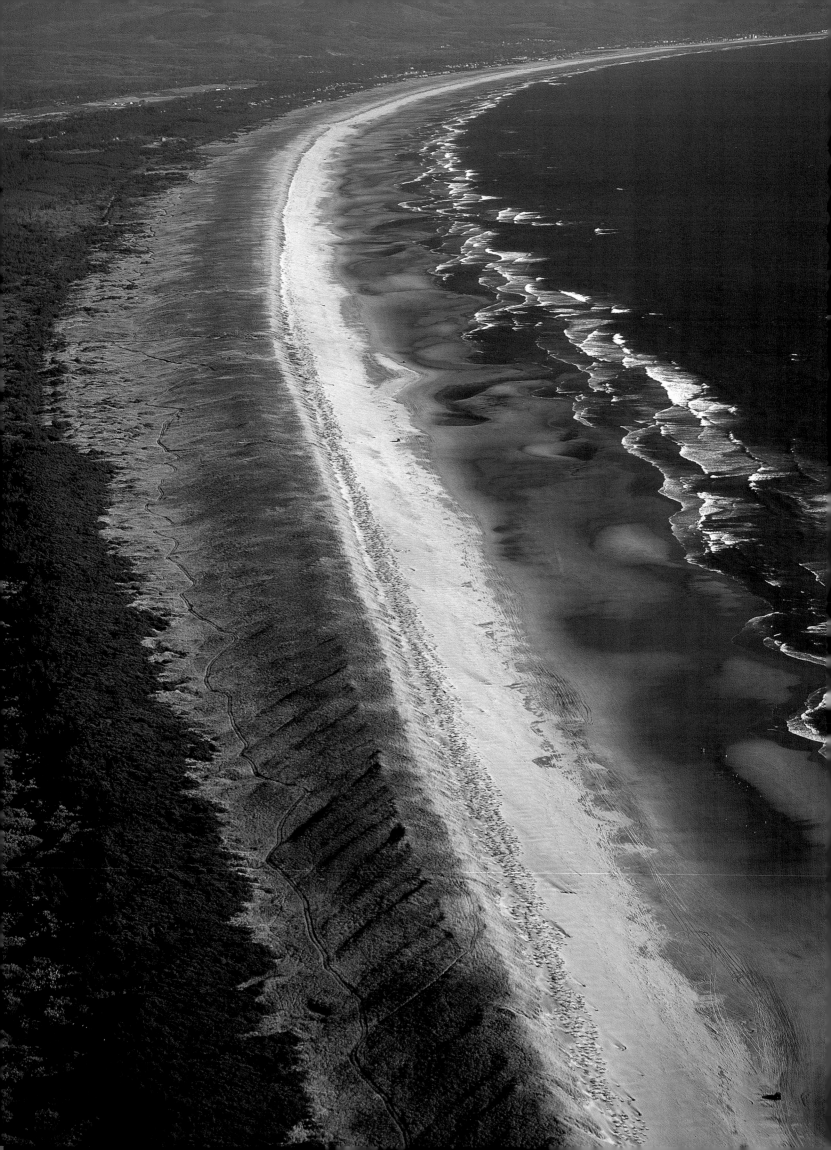

River along which the boundary between Oregon and Washington has been drawn. The river's mouth is shallow, gagged by shoals which make upriver navigation a challenge, especially after floods that reshuffle sandbars at its mouth. Currents out in the Pacific smear this sand north toward Washington, creating long spits that straighten that state's otherwise irregular coastline. Such spits have isolated two large estuaries from the open water of the Pacific—Grays Harbor on the Chehalis River and Willapa Bay at the mouths of the Canon and Willapa rivers. These estuaries are home to significant wetlands, and each sports a well-deserved wildlife refuge.

Geologists digging along the shores of Willapa Bay have found multiple layers of peat stacked one on top of the other, each separated by a dusting of sand, each a few hundred years younger than the layer below. And just north at Copalis Beach on the outside of Grays Harbor is a forest of cedar trees that drowned in 1699 when a great earthquake suddenly dropped this portion of the coast knee deep in salt water. Both locations show that huge earthquakes have rhythmically rocked the Pacific Northwest where oceanic crust continues to slide beneath North America.

This coastal area's glacial history is intimately intertwined with plate tectonics. There is good evidence that earthquakes in the Northwest might have occurred less frequently during the Pleistocene, when Puget Sound lay beneath a mile of ice. The ice was theoretically heavy enough to temporarily "lock" the faults, squeezing them tightly and delaying slippage. Now that the ice is gone, the faults should slip more easily, increasing the frequency of modern-day temblors along this coast. Seattle and Portland rest squarely in the crosshairs of earthquakes that are sure to return some year—or some day, some minute—in the future.

Clatsop Spit juts into the mouth of the Columbia River just west of Astoria, Oregon. Unlike the Mississippi River, which empties into the shallower Gulf of Mexico, the Columbia distributes its sand, not into a great delta, but into a series of elongate spits aligned with prevailing longshore currents.

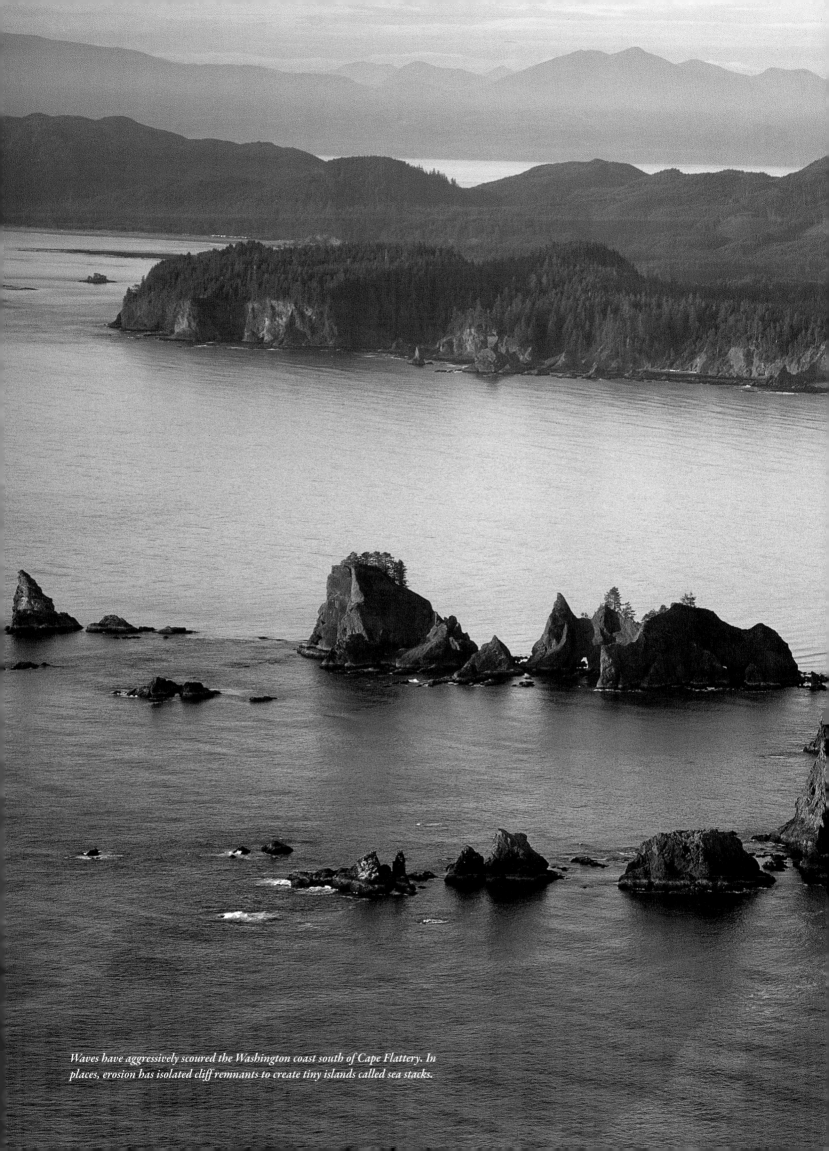

Waves have aggressively scoured the Washington coast south of Cape Flattery. In places, erosion has isolated cliff remnants to create tiny islands called sea stacks.

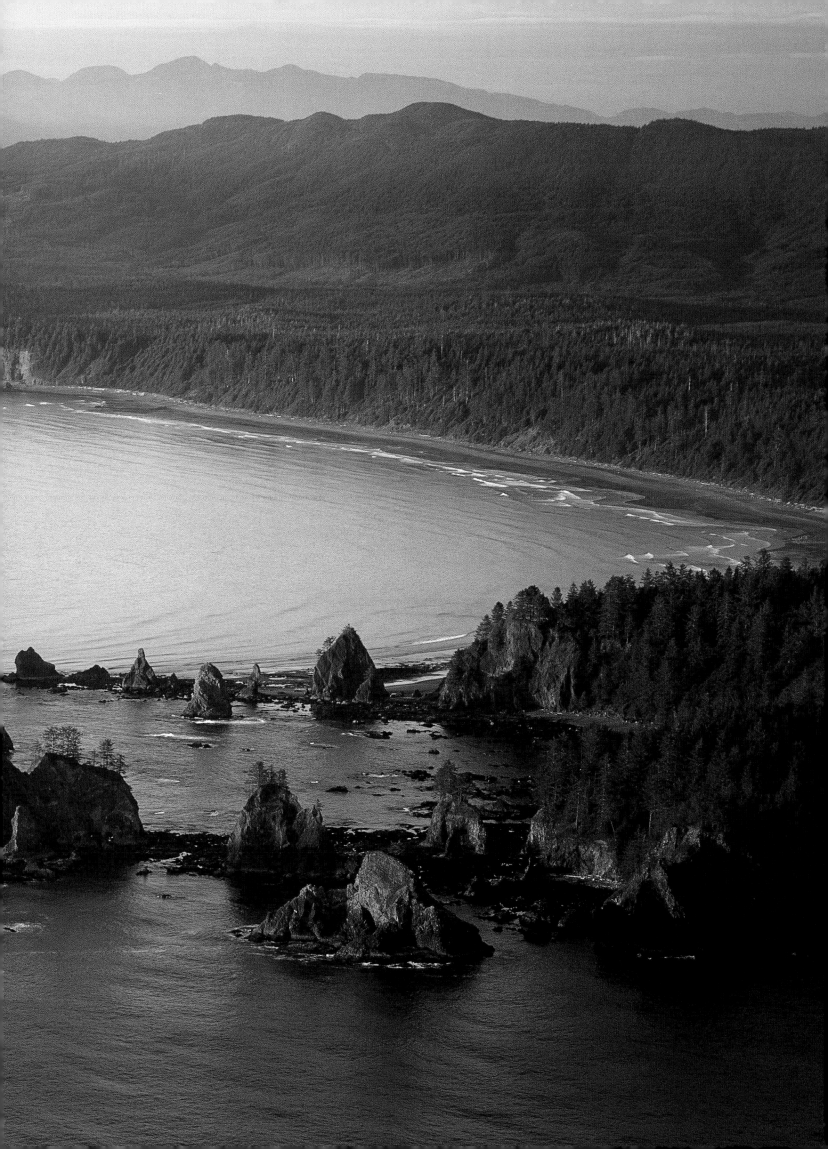

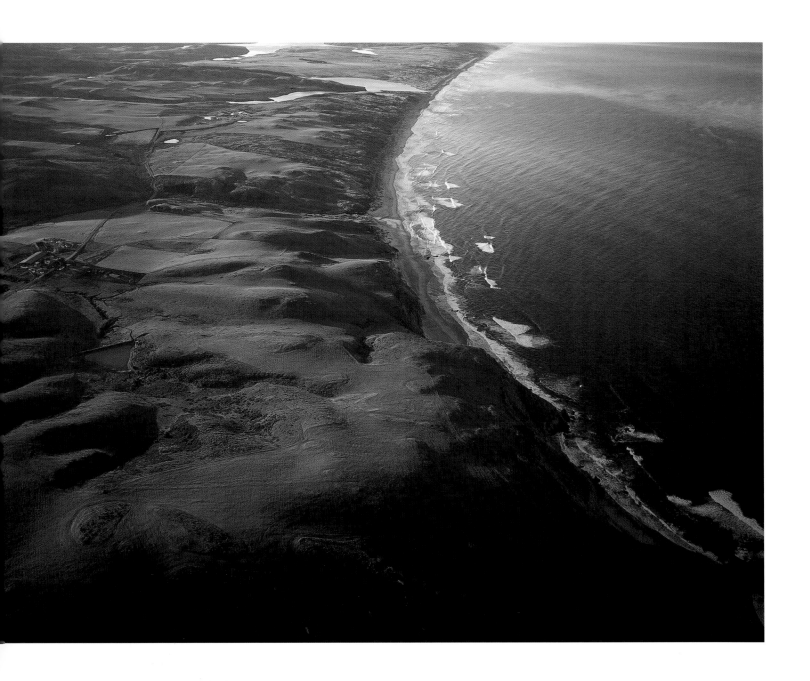

Above: The rocks of Point Reyes Peninsula were forged in mountains hundreds of miles to the south on the coast of California. The peninsula, on the Pacific Plate, slides northwest relative to the rest of North America.

Right: Sandbars choke the entrance to Drakes Estero on Point Reyes Peninsula. Tidal currents draining from the estuary become visible from the air when they pick up some of this sand. As the currents meet the open water of the Pacific Ocean at the bottom of the picture, they spin in counterclockwise, and then clockwise, eddies.

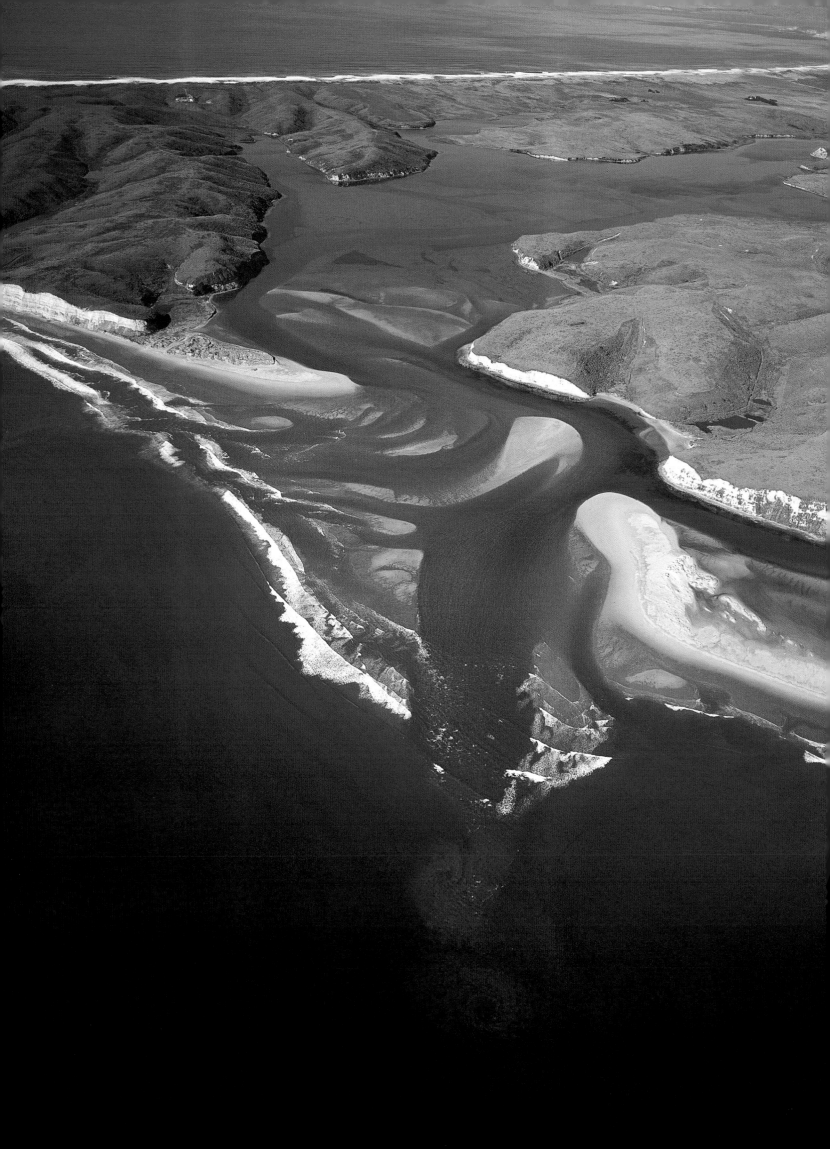

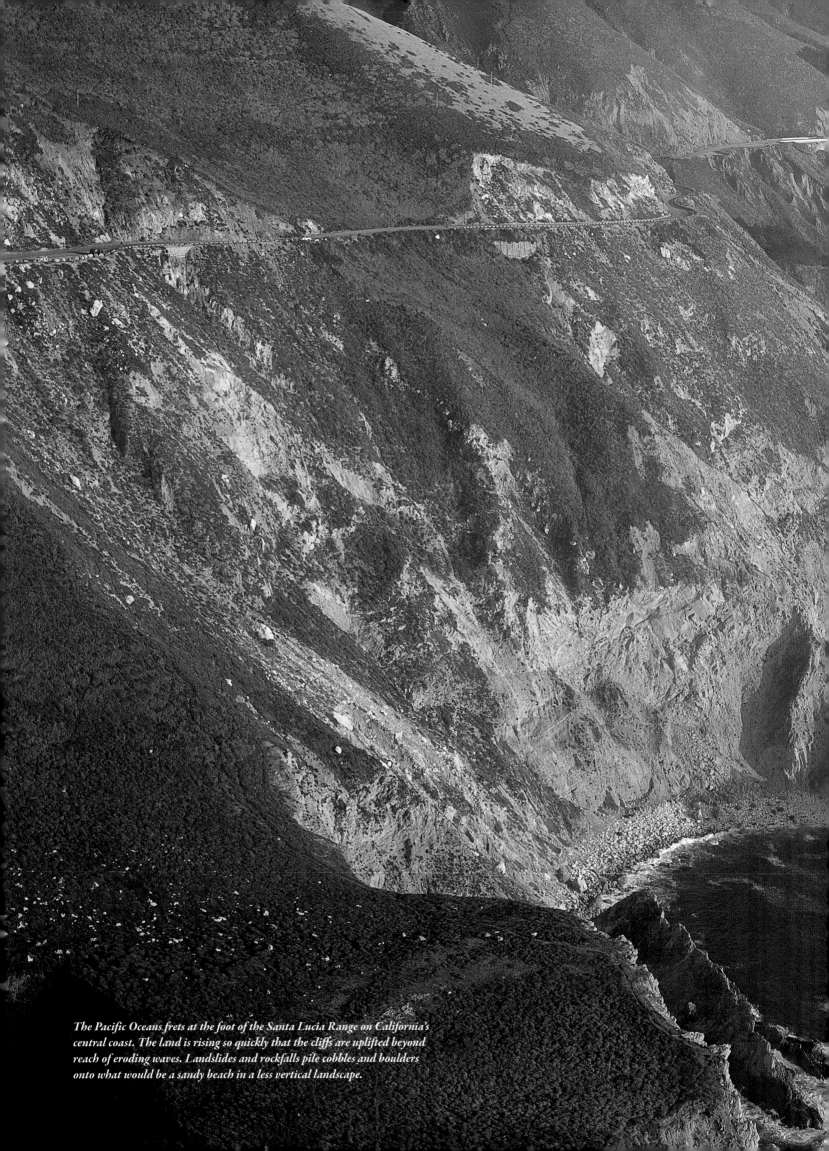

The Pacific Oceans frets at the foot of the Santa Lucia Range on California's central coast. The land is rising so quickly that the cliffs are uplifted beyond reach of eroding waves. Landslides and rockfalls pile cobbles and boulders onto what would be a sandy beach in a less vertical landscape.

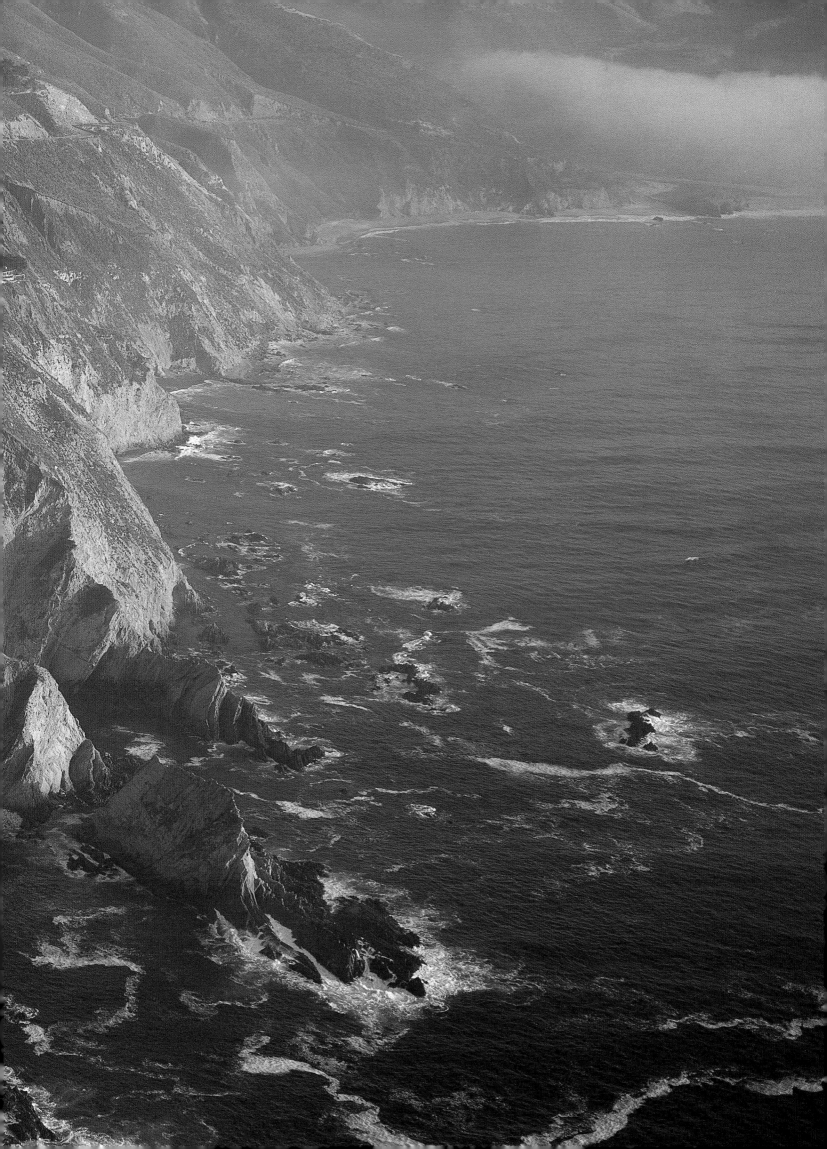

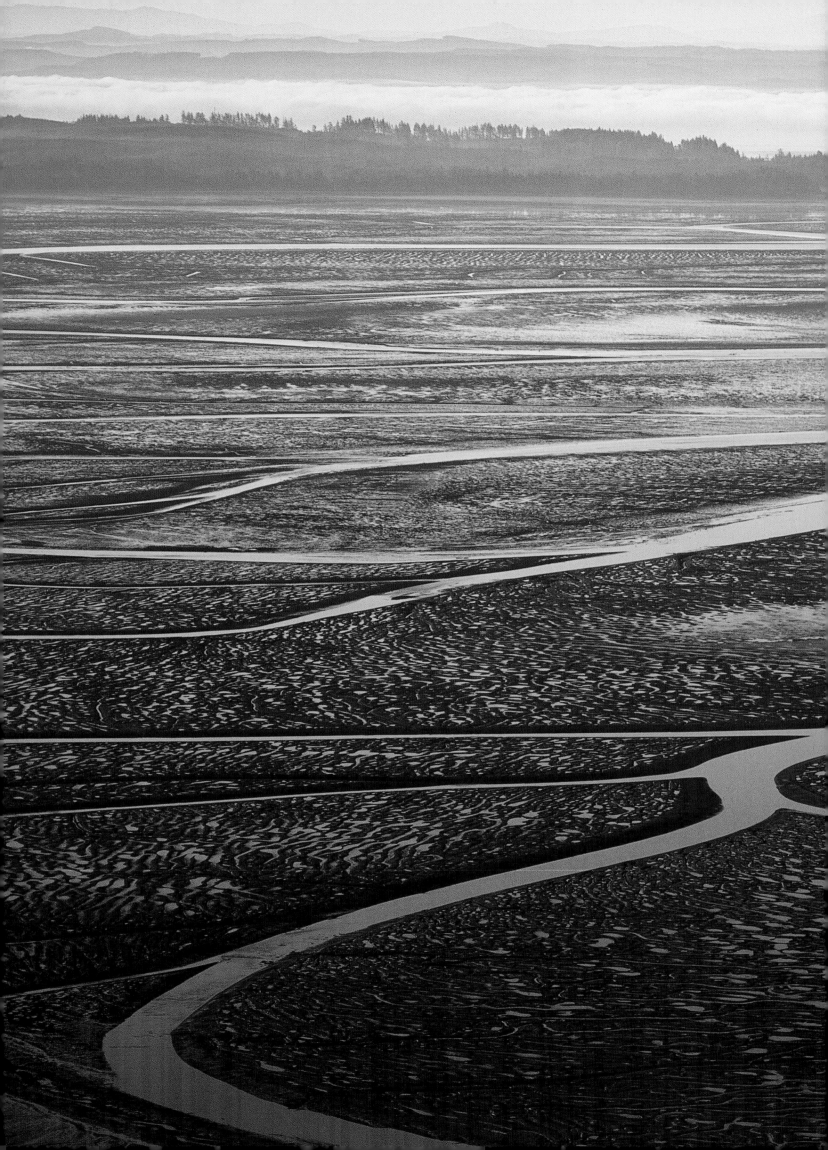

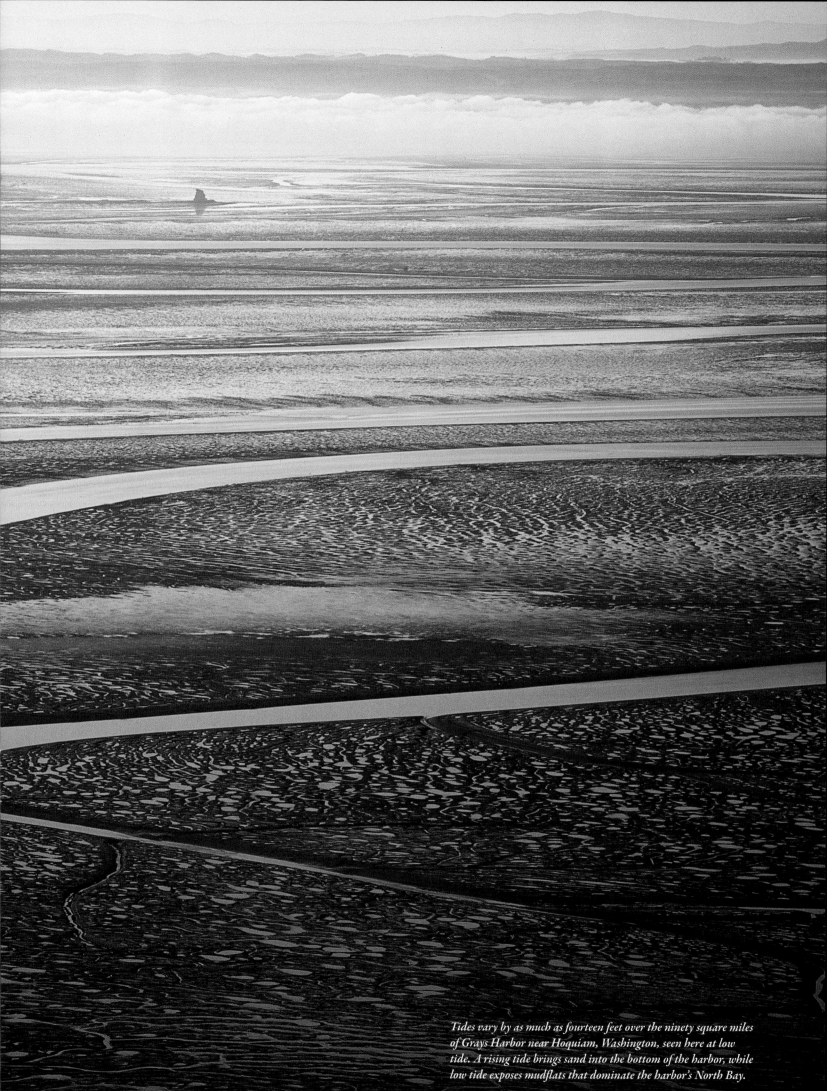

Tides vary by as much as fourteen feet over the ninety square miles of Grays Harbor near Hoquiam, Washington, seen here at low tide. A rising tide brings sand into the bottom of the harbor, while low tide exposes mudflats that dominate the harbor's North Bay.

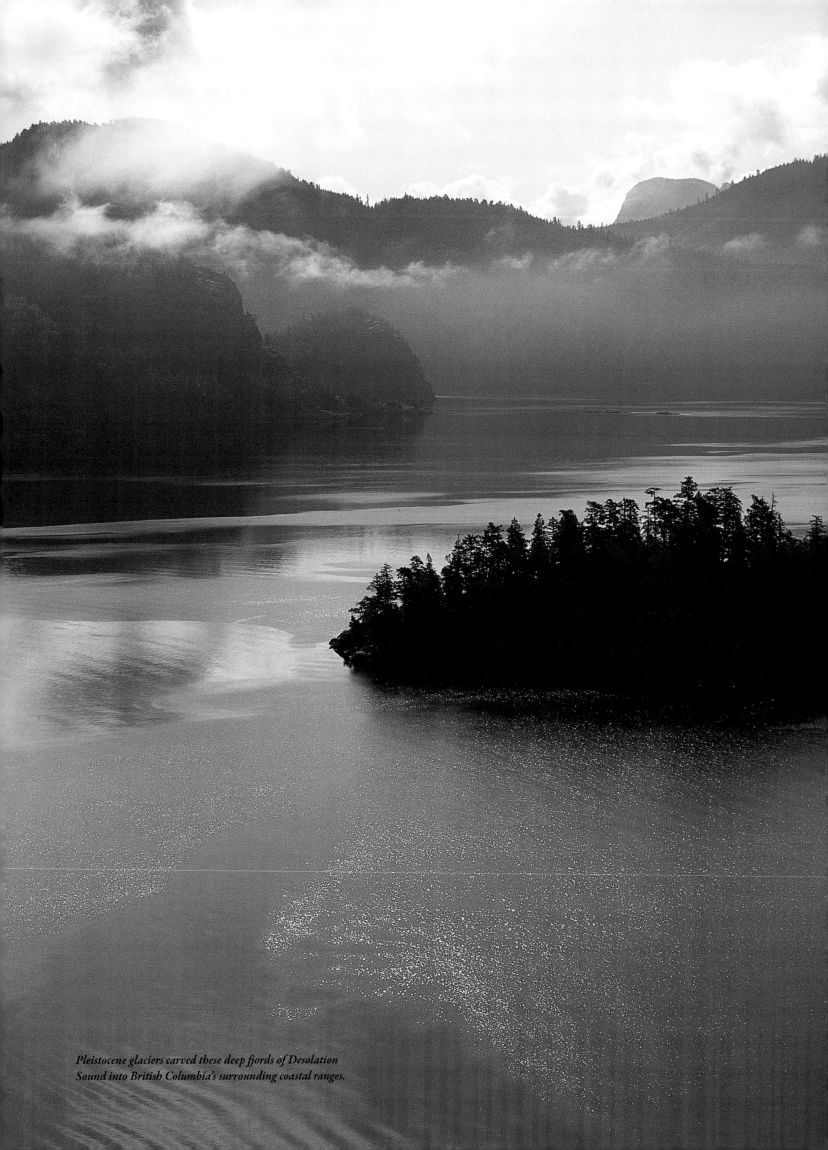

Pleistocene glaciers carved these deep fjords of Desolation Sound into British Columbia's surrounding coastal ranges.

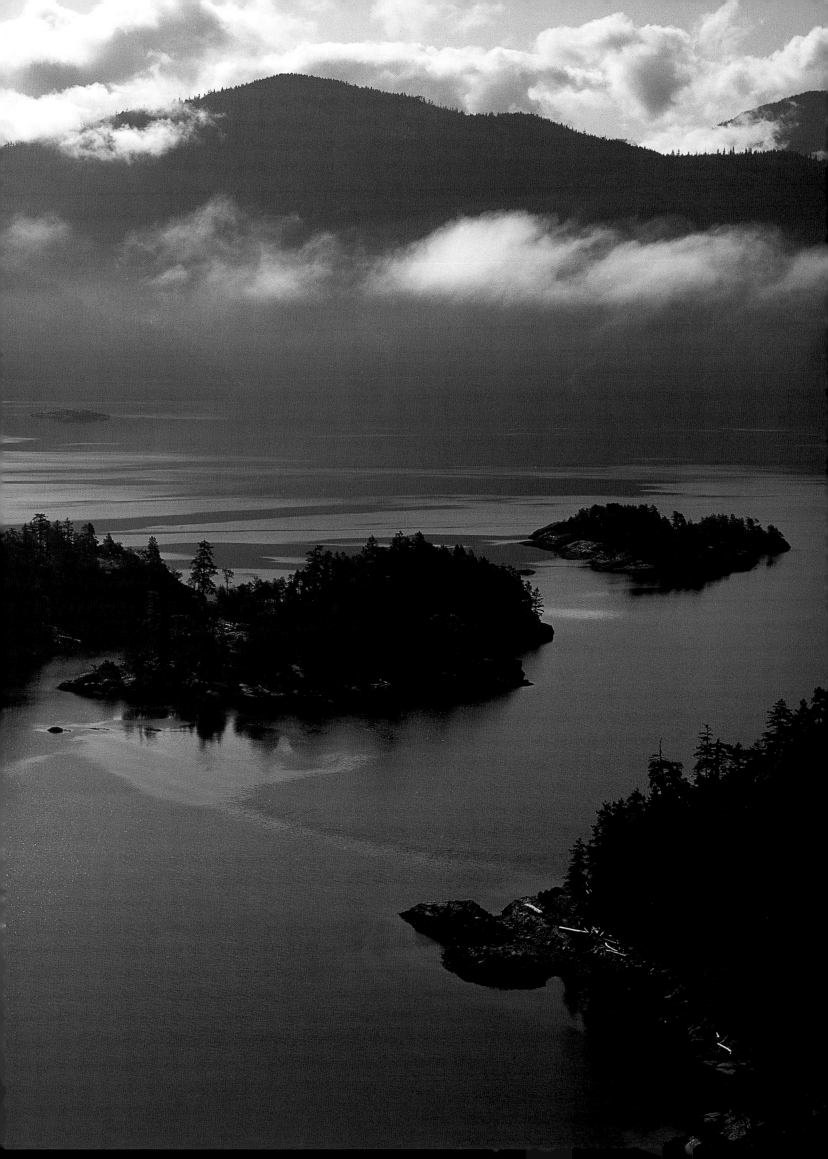

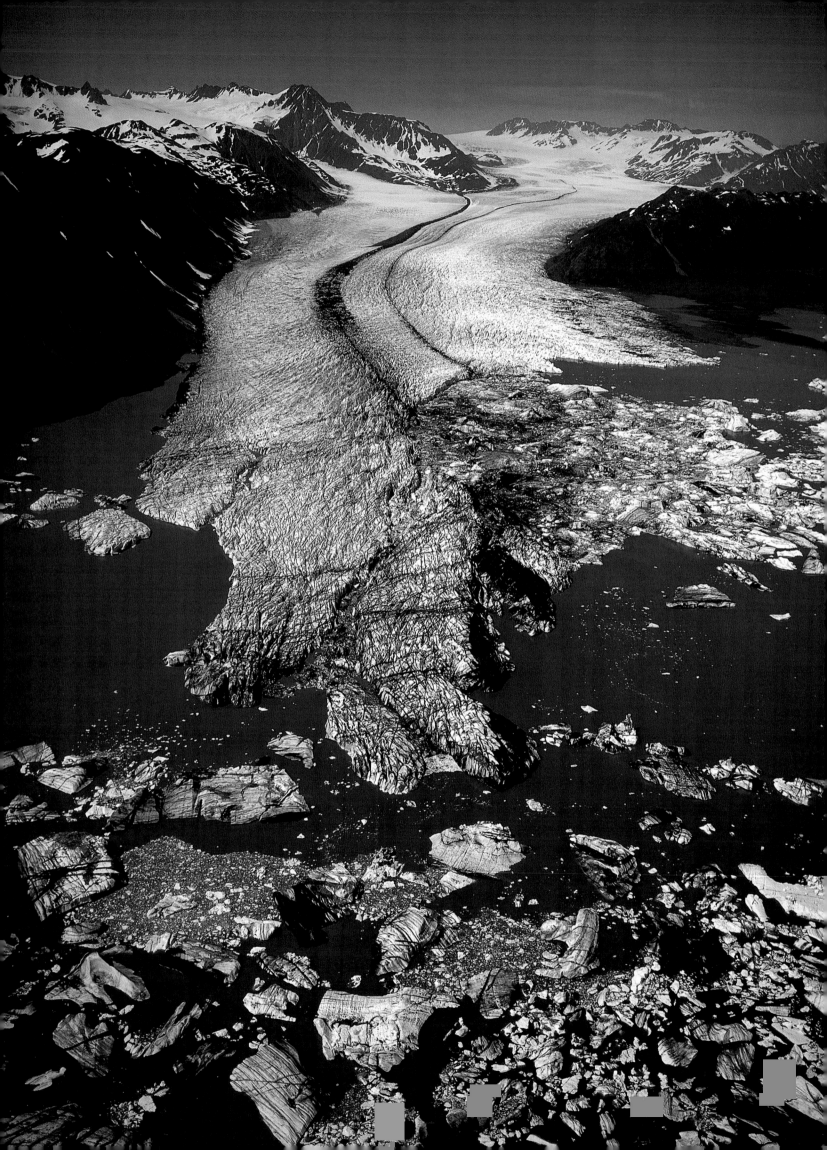

Alaska

The coast of Alaska is wilder and woollier than any shoreline in the Lower Forty-Eight states. If homeowner's insurance is a good idea in Seattle, it would be a great idea in Glacier Bay National Park—if homes were there to insure. On July 9, 1958, the Fairweather Fault snapped its fingers, sparking a Magnitude 8.3 earthquake. In a heartbeat, the two sides of the fault jumped 21 feet horizontally and 35 feet vertically. Ninety million tons of rock were jangled loose from the Fairweather Range and fell 3,000 feet into Lituya Bay. The rockfall triggered a wave that splashed 1,740 feet up nearby cliffs, carrying two boats out to sea. Wide-eyed sailors reported looking down 80 feet from their wave-tossed craft onto trees growing on the berm between Lituya Bay and the open Pacific. Wild and woolly times indeed.

The total length of Alaska's coastline with its innumerable embayments and projections approaches 44,000 miles. Many shoreline environments are represented—deep fjords shared with Canada in the southeast; glacial moraines that have been pushed down from the Saint Elias Mountains near Yakutat; protected waters of Prince William Sound; the Aleutian Islands with their belching volcanoes; the Yukon River's sprawling delta; and finally, the great white expanse of an Arctic shore that stretches back around to northern Canada.

Portions of Alaska's North Slope, from the Brooks Range to the Arctic Ocean, are covered by a vast network of lakes that are melting out of frozen ground. Backlit and seen from the air, the lakes look like a million shiny coins thrown out in a gesture of unimaginable generosity. Alternatively, from the ground, they are impossible barriers to travel if one must walk north past the Colville River toward Point Barrow on the coast. This is hardbitten tundra underlain by permafrost that extends thousands of feet into the ground. The growing season in Barrow has historically averaged ten days—not much time to harvest a crop of beans. Paradoxically, the North Slope was not glaciated during the Pleistocene because precipitation was insufficient—in climatologic terms, the growing season for glaciers was just too short.

Bear Glacier in Kenai Fjords National Park, Alaska, is a tidewater glacier—that is, one that disgorges ice directly into the sea. The ice at the glacier's terminus is breaking up faster than it can be delivered down from the mountains, which means that Bear Glacier is retreating.

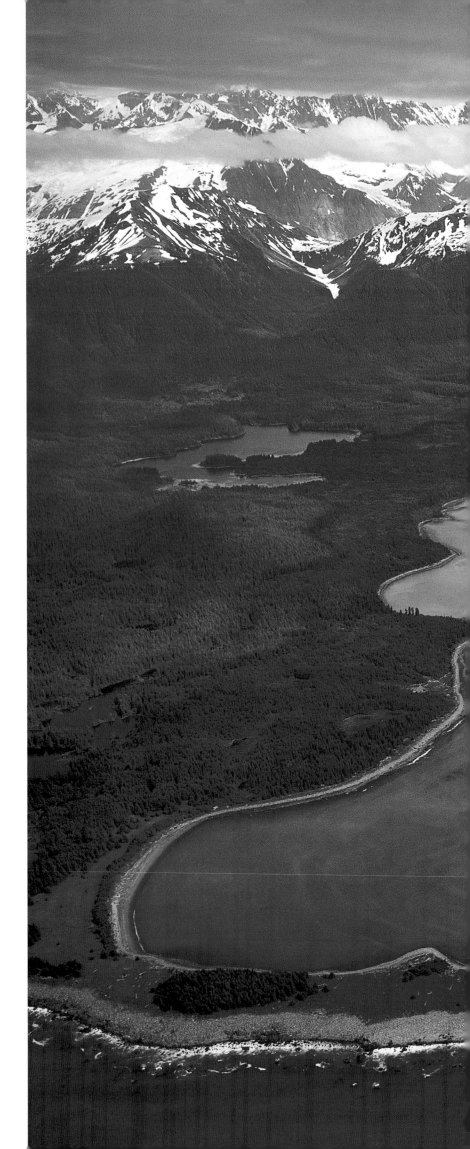

The Arctic—that fifth American shore—is locked in ice for much of the year. Here, the Inupiat have watched sea ice freeze fast to their beaches every fall for millennia. These native Alaskans have forever turned one eye out to the sea. Shorefast ice always protected their beaches around Shishmaref by October—November at the latest—before the destructive storms of autumn rolled in. The Eskimos knew in their genes when the ice was hard enough to support a dogsled or snow machine. They understood how the sea-going animals that they hunted would rise to breathe at leads that opened in springtime within the ice. But now freeze-up may not happen until December, maybe not until after Christmas. And the shorefast ice is not nearly as strong or trustworthy as it once was. The walrus and seals have migrated, searching for fish and seafloor food that has shifted further offshore as the ice has changed. Something is different; something doesn't resonate with the Inupiats' 4,000-year collective memory of this landscape.

The world's largest known wave was generated by a giant free-falling avalanche in 1958, triggered by an earthquake on the Fairweather Fault that runs across the back of Lituya Bay. The wave, which traveled toward the bottom of this picture, was still 200 feet high as it left the bay. Vegetation differences, clearly visible on the left side of the picture, reveal trim lines where the wave ripped away old-growth timber on both sides of the inlet.

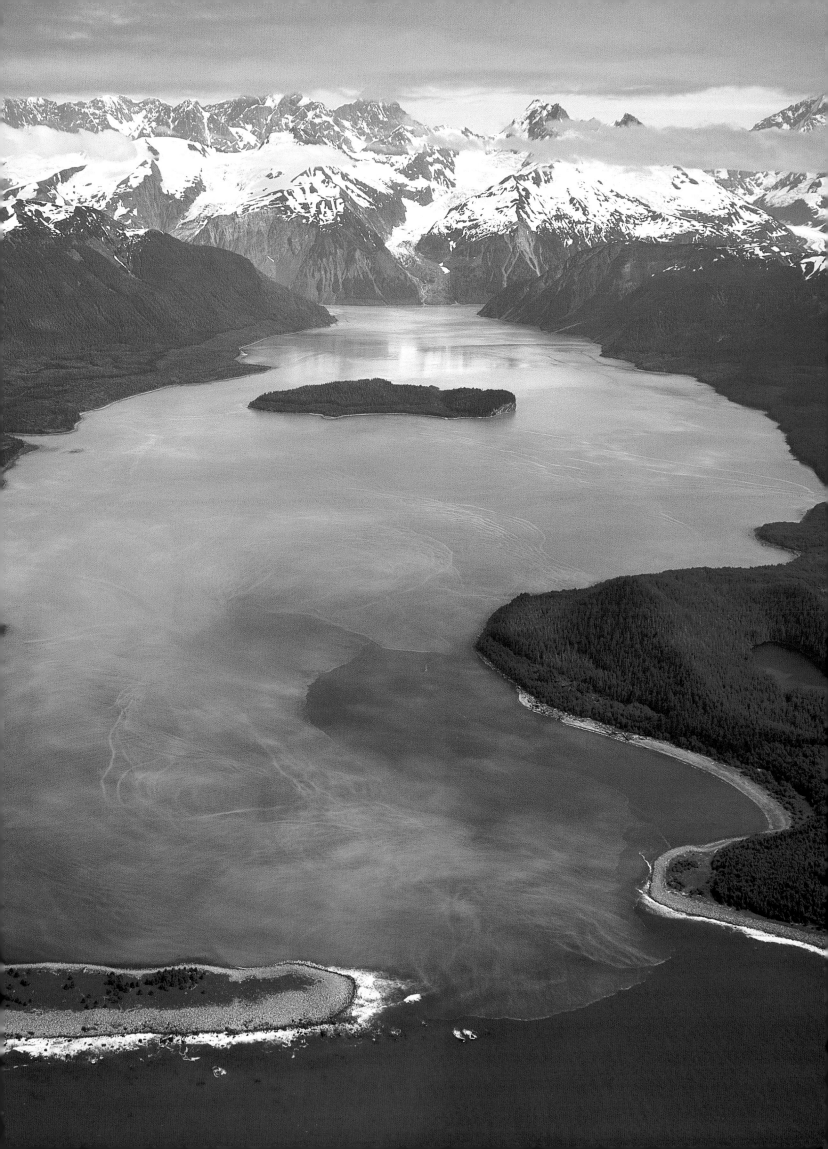

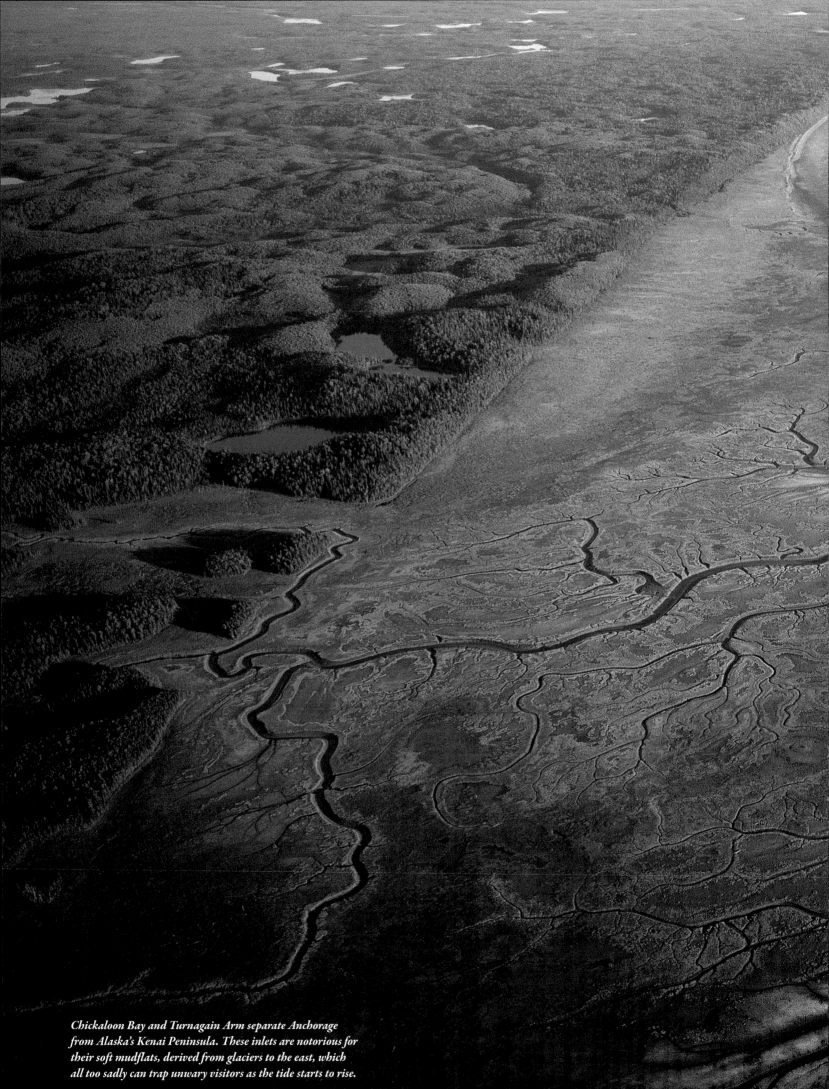

Chickaloon Bay and Turnagain Arm separate Anchorage from Alaska's Kenai Peninsula. These inlets are notorious for their soft mudflats, derived from glaciers to the east, which all too sadly can trap unwary visitors as the tide starts to rise.

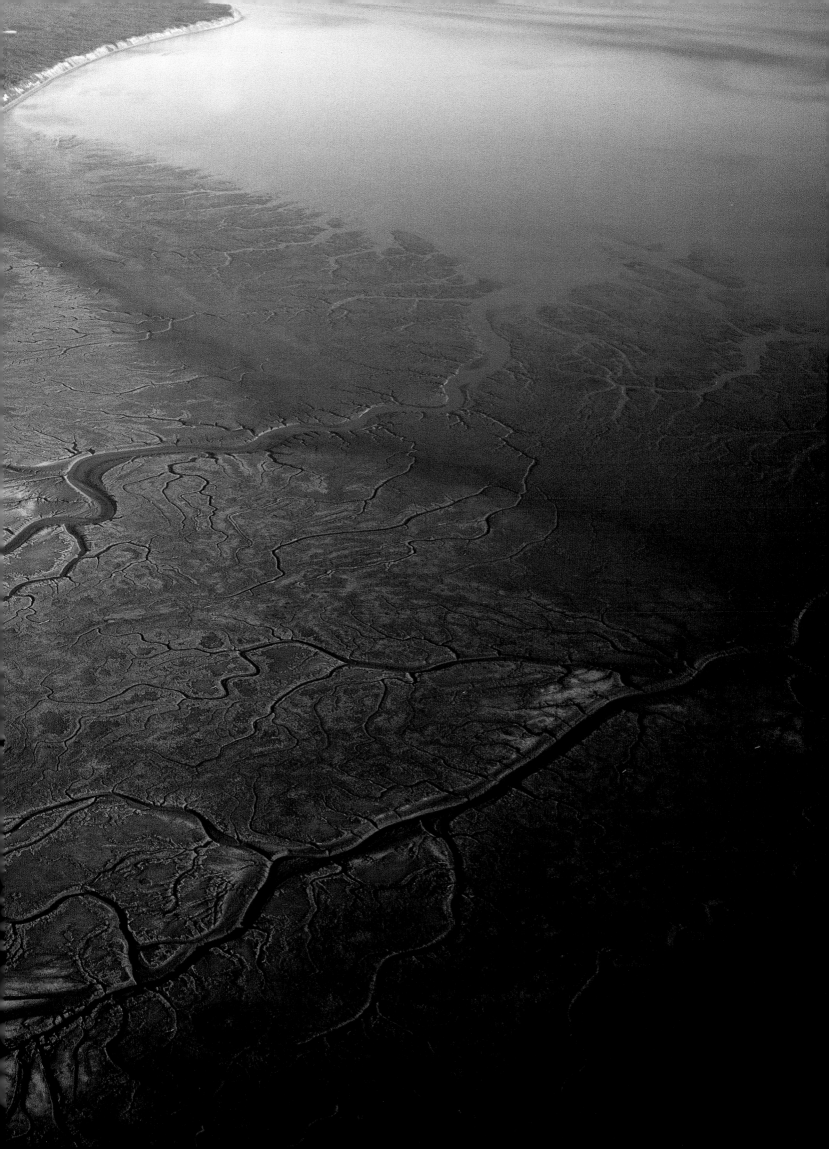

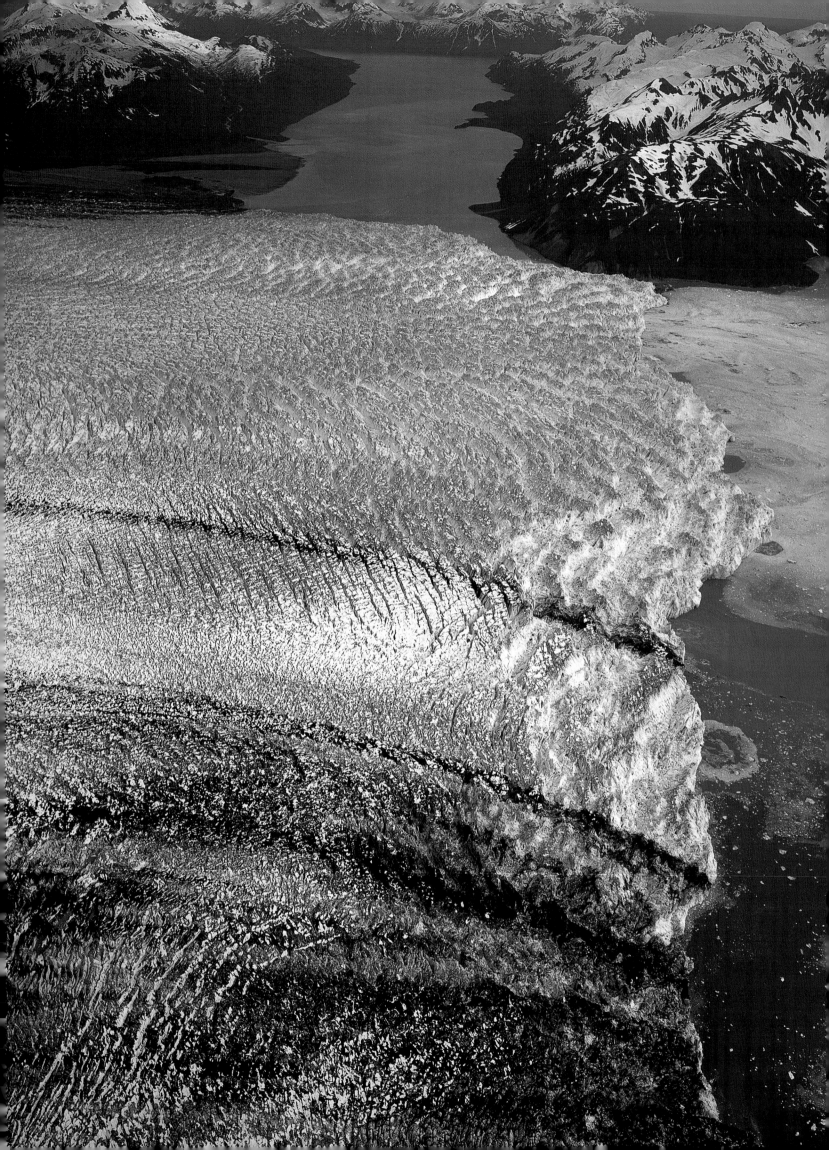

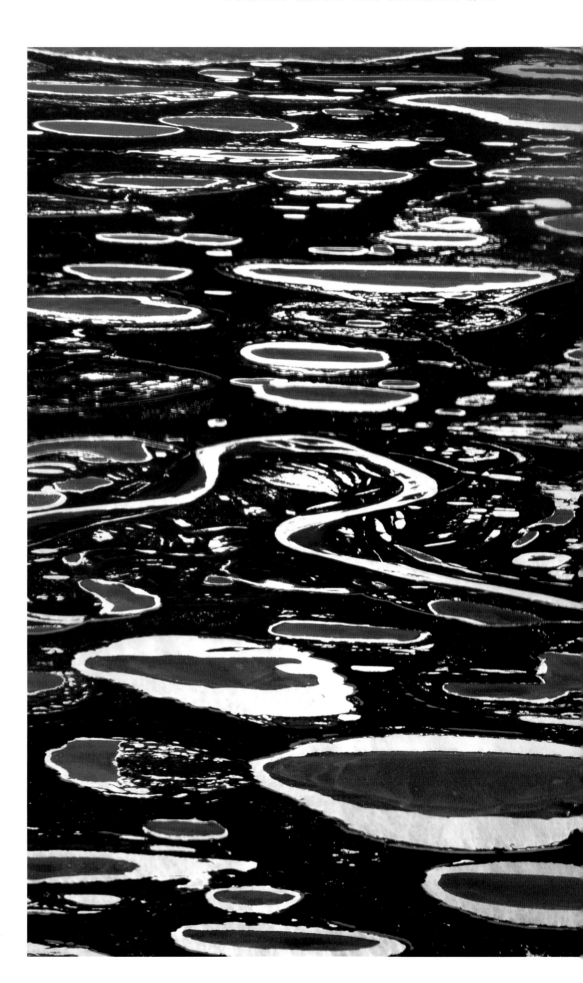

Right: Alaska's North Slope is entirely underlain by permafrost, soil that is frozen year-round. Here, near the Meade River south of Barrow, the permafrost extends thousands of feet down and well under the Arctic Ocean far beyond shoreline. As climates warm worldwide, however, top layers of this permafrost are melting to form these "thermokarst lakes," releasing great stores of carbon dioxide and methane which further warm the atmosphere.

Left: Hubbard Glacier flows down from the Wrangell Mountains of Canada and southeast Alaska. Like most tidewater glaciers, it regularly advances and retreats depending on how much ice flows down from the Wrangells and on the condition of the sea bed at its terminus. When the Hubbard advances sufficiently far into Yakutat Bay, it temporarily dams Russell Fjord seen at the top.

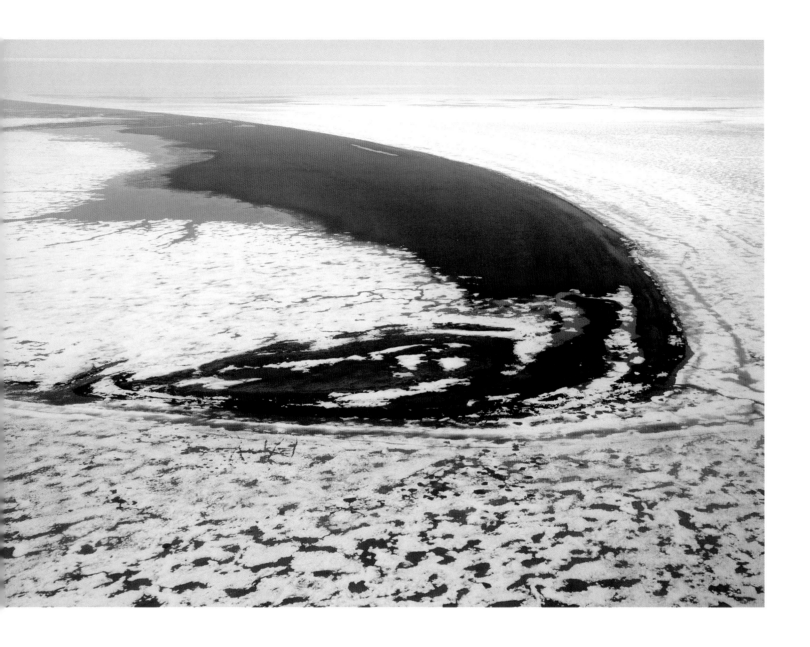

Above: Barrier islands separate Shishmaref Inlet from the Chukchi Sea in northwest Alaska. Sea ice usually freezes against this shore for eight months a year, but over the last three or four decades the seasonal ice pack has been steadily shrinking. Each year, as the world's climate warms, less and less of the Arctic Ocean is covered by ice at the end of summer.

Right: The Arctic Ocean's icepack began to shrink noticeably near the end of the twentieth century. What remains of the icepack is significantly thinner and now covers dramatically less area. Ice seen here offshore of Wainwright, Alaska, is less cohesive and more easily fractured as it heaves against the nearby shore.

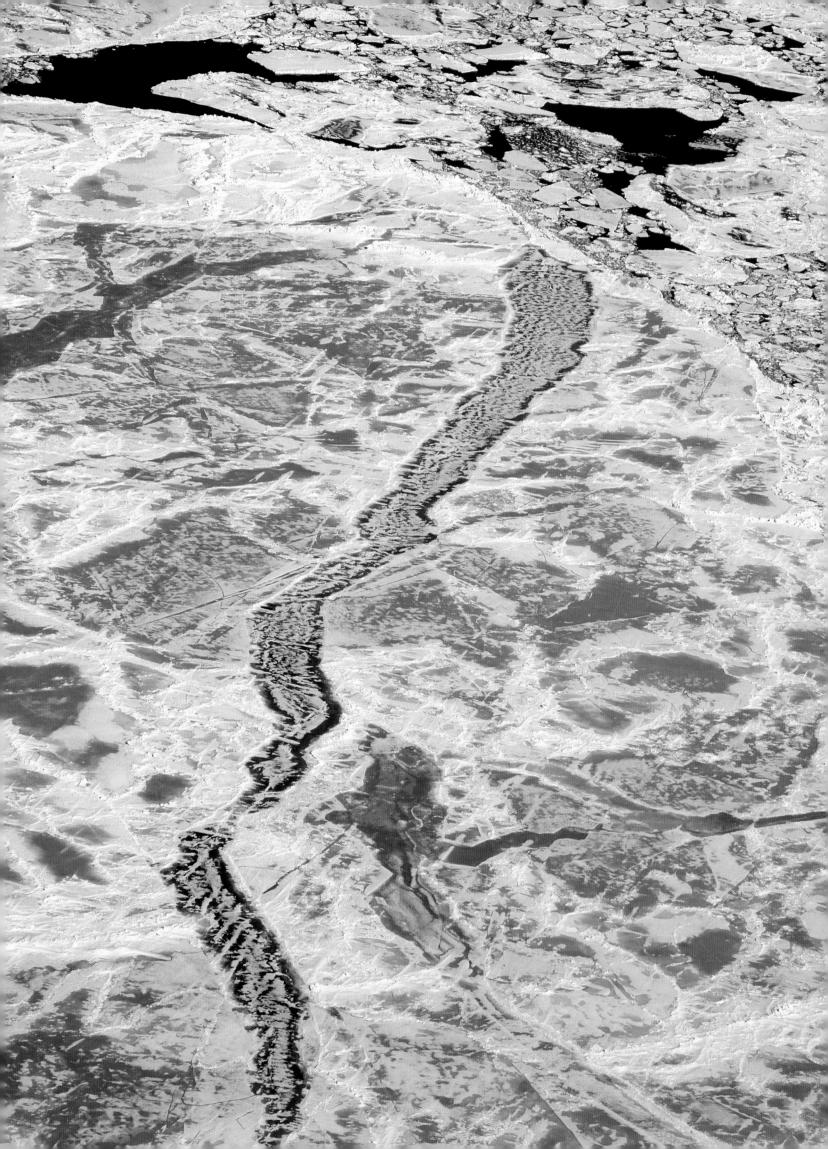

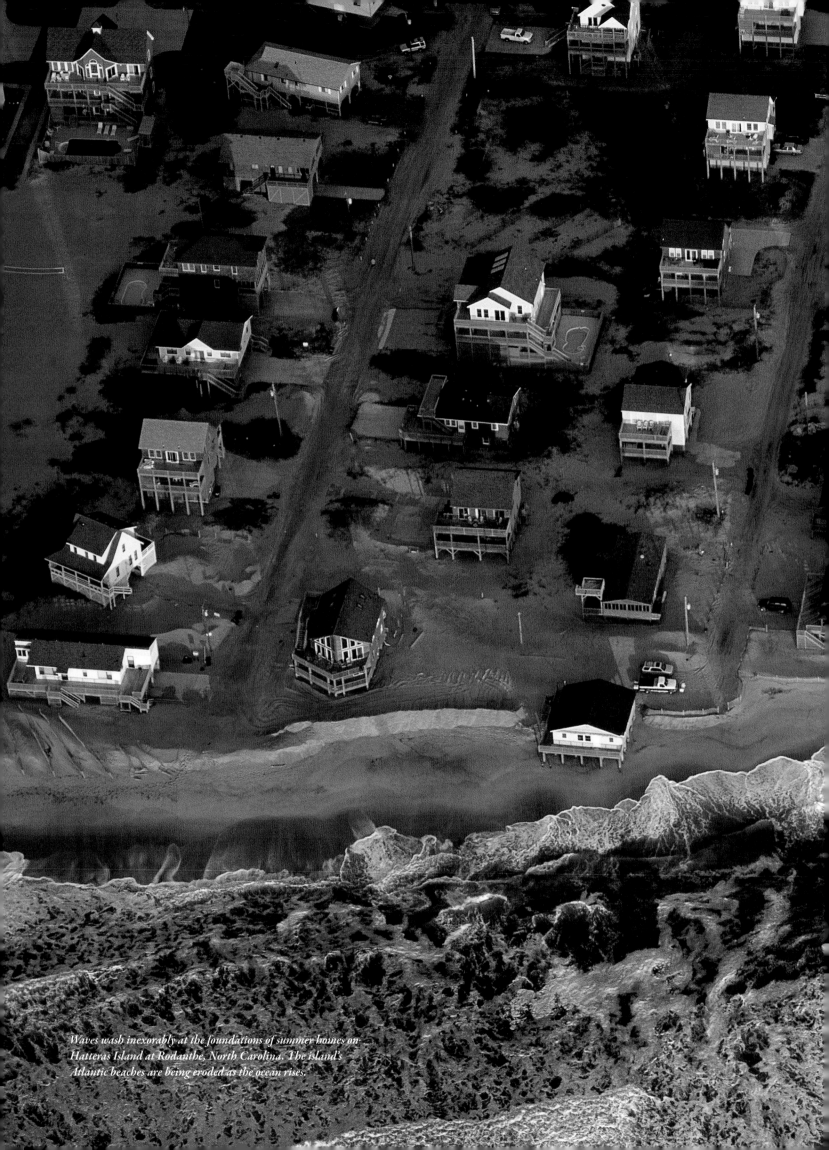

Waves wash inexorably at the foundations of summer homes on Hatteras Island at Rodanthe, North Carolina. The island's Atlantic beaches are being eroded as the ocean rises.

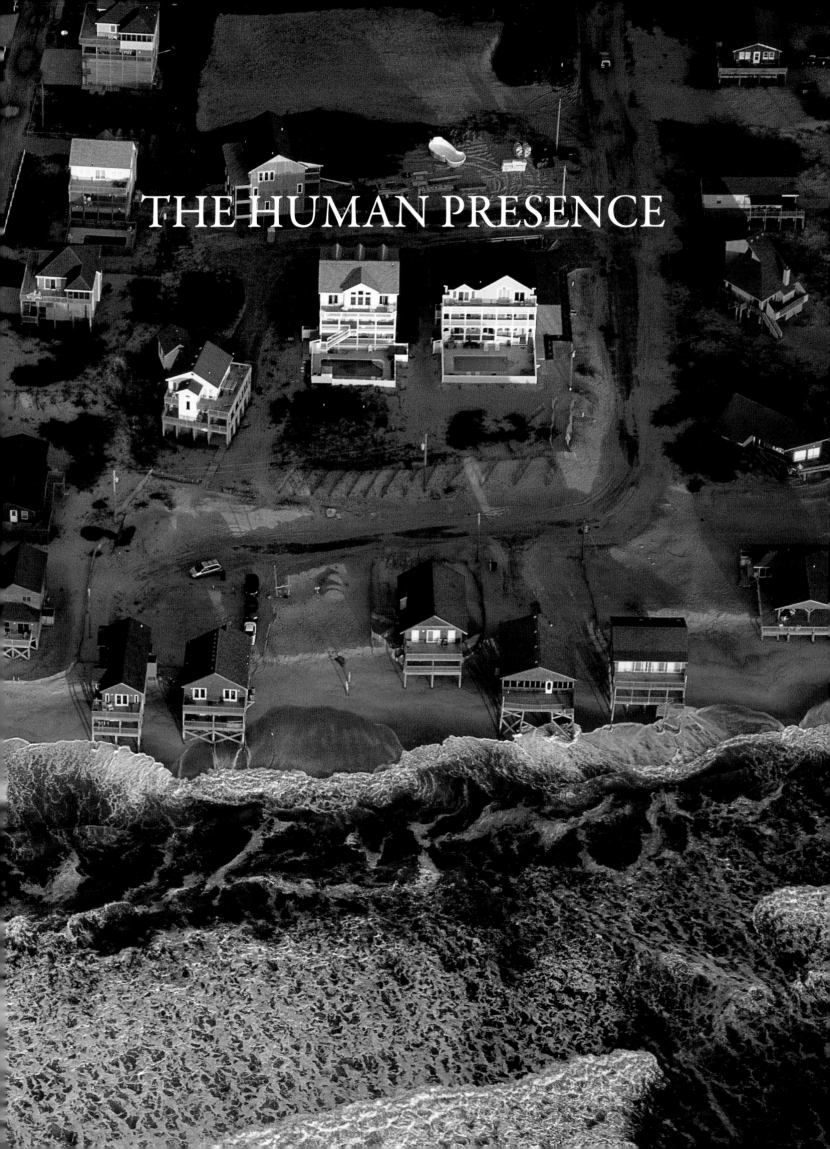

THE HUMAN PRESENCE

The real conflict of the beach is not between sea and shore, for theirs is only a lover's quarrel, but between man and nature. On the beach, nature has achieved a dynamic equilibrium that is alien to man and his static sense of equilibrium.

G. SOUCIE, *Smithsonian*, 1973

Richard Henry Dana spent two years before the mast on the brig Pilgrim that beat its way around Cape Horn and arrived off the coast of California in 1835. Monterey, which Dana found "pleasant and most civilized" with its one-story adobe buildings, was then the territory's capital. San Francisco Bay had been discovered, if not yet populated. Santa Barbara was already a gleaming jewel with its alabaster mission set back in the hills, but it lacked an adequate harbor, and the Pilgrim had to pull well offshore each time a storm approached. To the south, not far from the sleepy village which years later would become Los Angeles, San Pedro was already shipping goods to and from nearby ranches. There were no docks, however, and Dana complained bitterly about having to haul cow hides from primitive sheds through the surf to the hold of his boat. Times have changed and San Pedro has come of age. Now every year the port handles almost 3,000 oil tankers, cruise and container ships, and moves 200 million tons of cargo.

The men and women who staff the radar consoles of SoCal Approach are aeronautic magicians. One morning they led me and my plane through the not-always-friendly skies above Los Angeles so that I could photograph San Pedro harbor. Jets heading for LAX streamed above me. The controllers suggested I keep my head down and not climb above 900 feet. Over San Pedro I saw boats patiently bobbing offshore, awaiting their turn at the docks. Inside its breakwater the harbor crackled with activity. Ships nuzzled up against the shore like sucklings on a sow. The waterfront was a maze of roads clogged with tractor trailers, a spiderweb of rail lines and, in the background, innumerable white tanks with their oceans of oil. The forsaken outpost described by Dana was nowhere to be seen. I was looking down on one of the most feverish and manipulated landscapes in America.

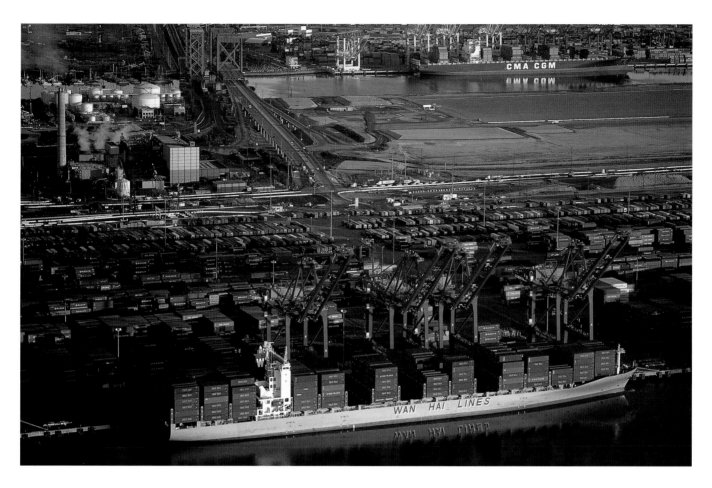

Container ships are loaded at San Pedro's Terminal Island in California. Once nothing more than a mudflat, the island was artificially constructed in 1918.

Sea-going people have always sought the protection of harbors. Jetties are built at the mouths of rivers and harbors to encourage tidal currents to whisk away sand that would otherwise block navigable passages. Unfortunately the jetties, which extend out into open water, block longshore currents, thus either piling up sediments on one side of the jetty or depriving beaches of sediment on the other side. Or, to protect boats inside a harbor, a breakwater is built so that surf breaks harmlessly on the outside. Inevitably sand accumulates in quiet water behind the breakwater. A shoreline can be hardened to resist wave erosion by building a seawall, but waves that would otherwise have broken here are reflected back to erode elsewhere. Engineers dream up solutions—dredges and pumps—but these are expensive and offer only temporary fixes to long-term problems.

People have always loved living alongside the ocean, and smiling real estate agents have forever been offering assurances that their lovely seaside cottages are built to last—unfortunately putting buyers on a collision

course with coastal environments which, by their very nature, are always changing. For years, New Jersey residents worried that their beaches were disappearing; so cottage owners and casino magnates built groins (barriers that extend out into the surf) to trap sand that would otherwise drift down the shore and out of their lives. Their neighbors then had even less sand, so yet another groin would sprout out into the waves.

Augmentation is an alternative approach to spiffing up beaches, an art form practiced to perfection along high-rise shorelines wherein fresh sand is pumped onto a depleted beach. Sand augmentation has perked up the pearly white playas so vital to Waikiki's well being—though on at least one occasion the replenished sediment was more silt than sand, and nearby coral reefs were suffocated. Folks still flock to these coastlines, though. The beaches of Florida are now spangled with 15-story condominiums strung from Pascagoula to Panama City, from Miami to Monday, looking for all the world like oversized coral reefs.

We must expect that any manmade disturbance of a natural coast will elicit a response: we push and nature is going to push back. Dam builders were eager beavers throughout the last century in the arid West. As a result sand, instead of reaching the ocean, is often trapped in reservoirs above the Pacific coast. With beaches diminished, incoming waves more aggressively attack seacliffs, eroding them back more quickly. So homes on bluffs above the ocean are undercut and tilt drunkenly toward the water.

On the other side of the continent, hundreds of miles of barrier islands on the Gulf and East coasts offer tempting locations for summer homes—dreams literally built upon sand. No landscape, though, could be less stable. By its very nature, a barrier island washes to and fro as hurricanes foam in from the Caribbean, as sea level rises and falls. And mother nature really doesn't care how precious that beach house, now being swallowed by the waves, used to be.

Two hundred years ago the Lower Forty-Eight states had 215 million acres of wetlands—those swamps, marshes, bayous, and tidal flats that buffer low coastal areas from the ravages of the sea. But the bulldozers have been busy and now only 100 million acres remain. Wetlands are disappearing throughout the United States for a variety of reasons. Forty percent lie within the Mississippi River's delta; upstream dams in Montana and South Dakota on the tributary Missouri River have trapped sediment in reservoirs that would otherwise have nourished bayous in Louisiana. Levees along the lower Mississippi River create a single flume that sends the river's sediment well out to sea, rather than allowing it to be distributed more constructively across the delta.

Over the past hundred years ground water has been increasingly pumped for use by cities like New Orleans, accelerating natural subsidence and encouraging the encroachment of salt water. Wetlands are drained for agriculture, logging, mining, and development of such ecologically friendly projects as subdivisions, shopping malls, and business parks. Artificial channels like the thousand-mile Gulf Intracoastal Waterway, which stretches from

Brownsville, Texas, to Fort Myers, Florida, introduce salt water and tidal erosion to fragile marshes, which were once isolated from the sea. We push and, each time another hurricane strikes Louisiana, nature pushes back.

Coastlines around the world are now feeling the greatest push-back since humans lit their first fires. The world is warming. Oceans are expanding. Sea level is rising. As the Inupiat have already realized, something very different is happening all around us. Polar icecaps and mountain glaciers are melting. Hurricanes are more frequent and more intense. Species by the thousands are disappearing forever because our climate is changing far faster than many animals can adapt. Within the last century the human race has learned to burn coal and oil at rates that have spiked the atmosphere's carbon dioxide content, creating a greenhouse that may become uninhabitable. The good people of Shishmaref, Alaska, and New Orleans, Louisiana, have already felt the rising waters of global warming lapping around their ankles. Residents of New York, Seattle, and Los Angeles will be next. It's hard to know where it will stop.

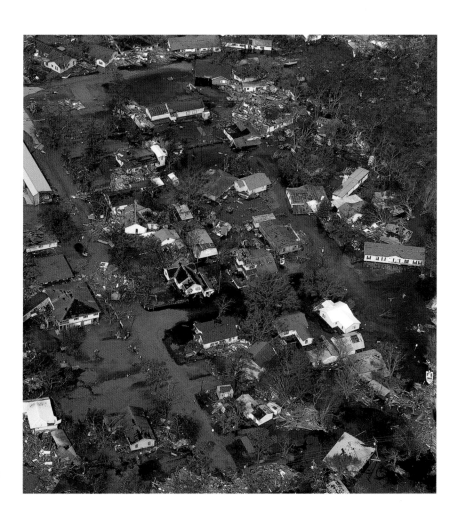

Cameron, Louisiana, was devastated by Hurricane Rita in September, 2005. The storm swept in from the Gulf of Mexico with howling winds that shredded homes and with a surge of high water that flooded the country-side for miles around Cameron.

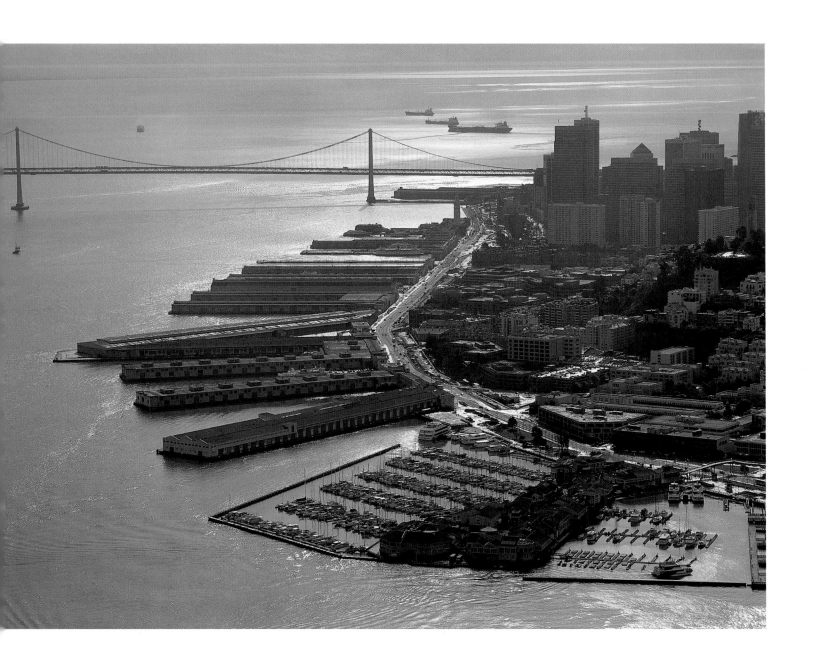

Above: Boats and the Bay Bridge surround San Francisco's waterfront. The shoreline of San Francisco Bay was once an undisturbed landscape with natural marshes and estuaries. Since the mid-1800s, though, wharves have wreathed the beaches, and wetlands have been filled in to form dry ground available for development.

Right: Sediment has accumulated in what were once salt water marshes on San Pablo Bay north of San Francisco. This sediment was catastrophically released by hydraulic mining in the Sierra Nevada during California's gold rush.

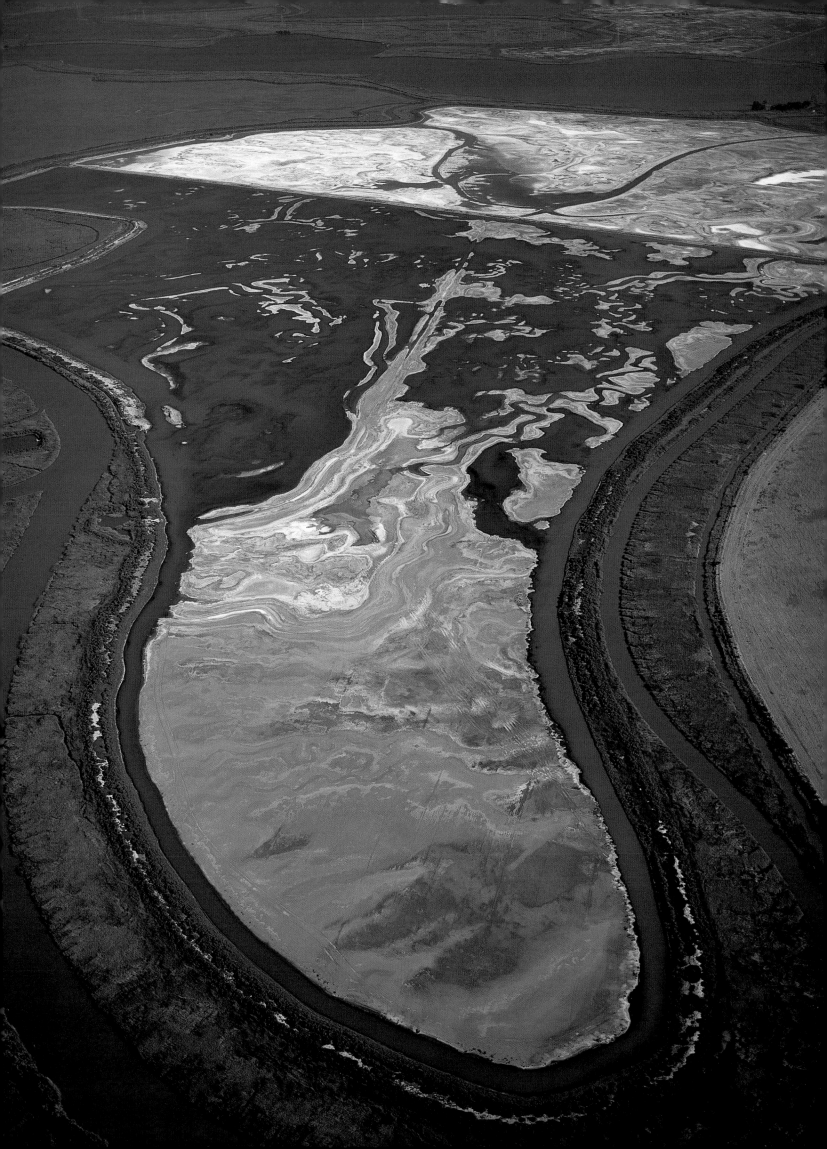

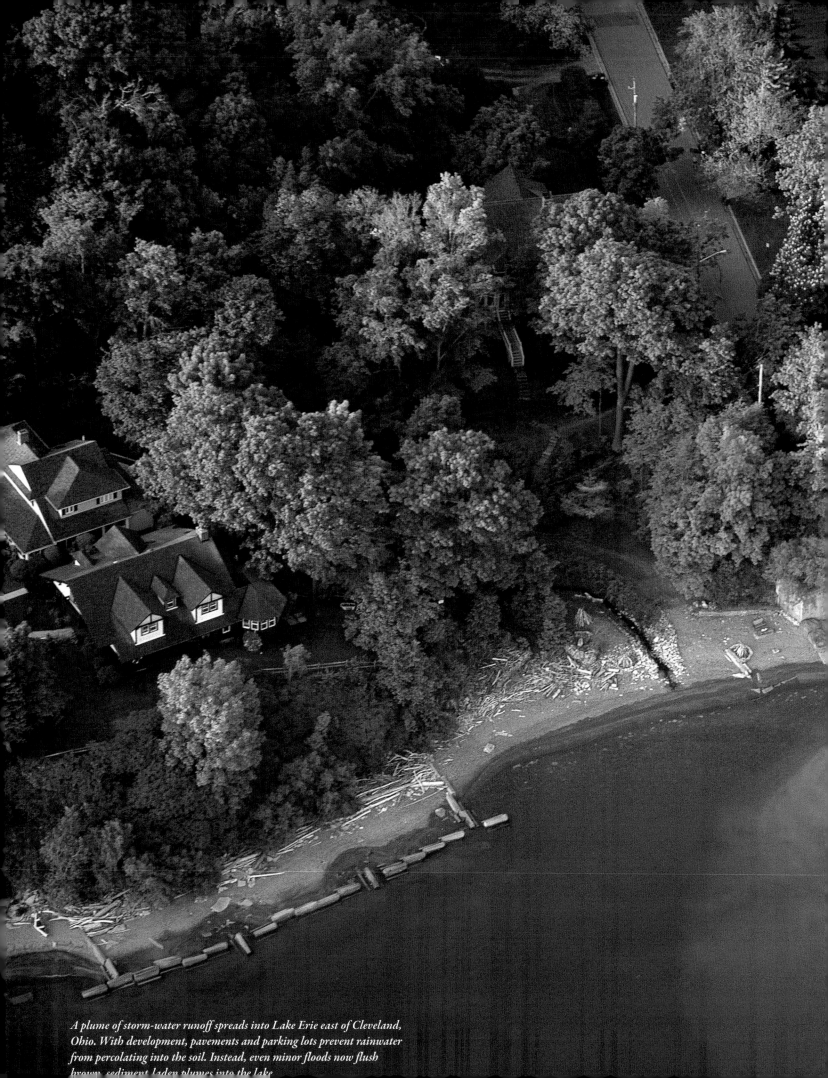

A plume of storm-water runoff spreads into Lake Erie east of Cleveland, Ohio. With development, pavements and parking lots prevent rainwater from percolating into the soil. Instead, even minor floods now flush brown, sediment-laden plumes into the lake.

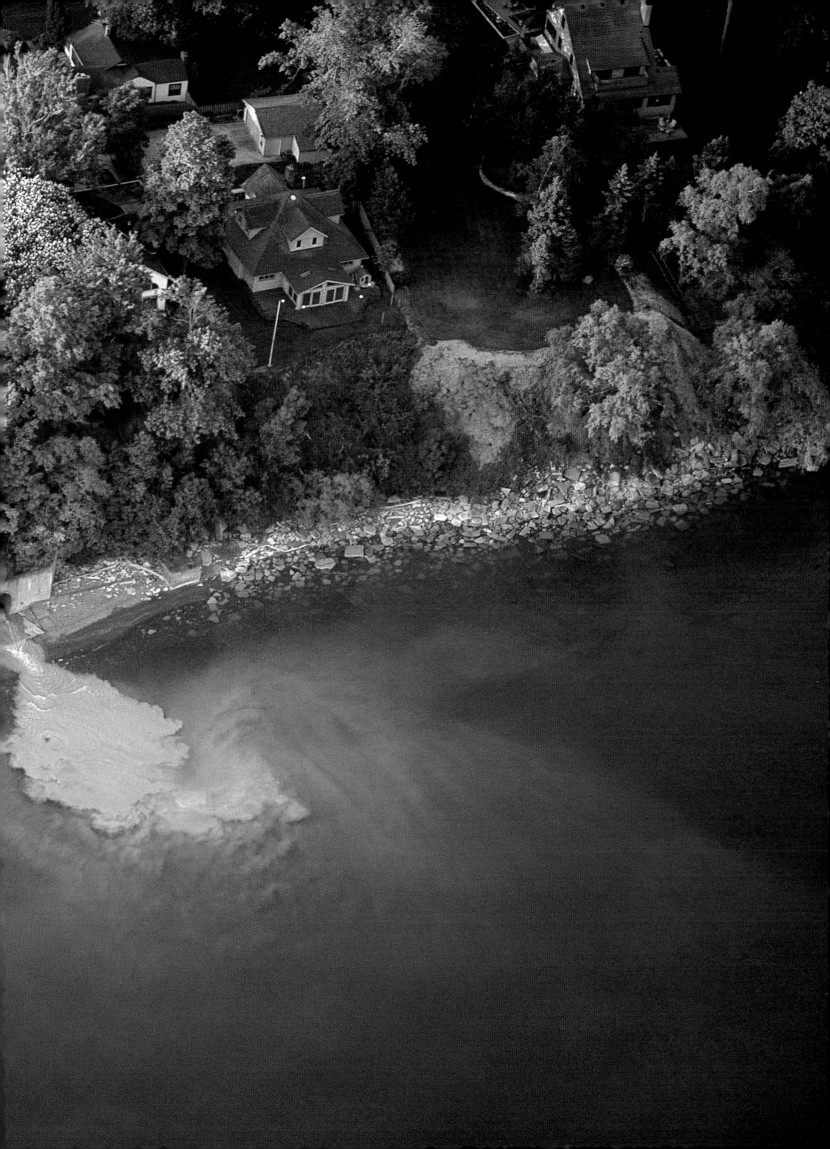

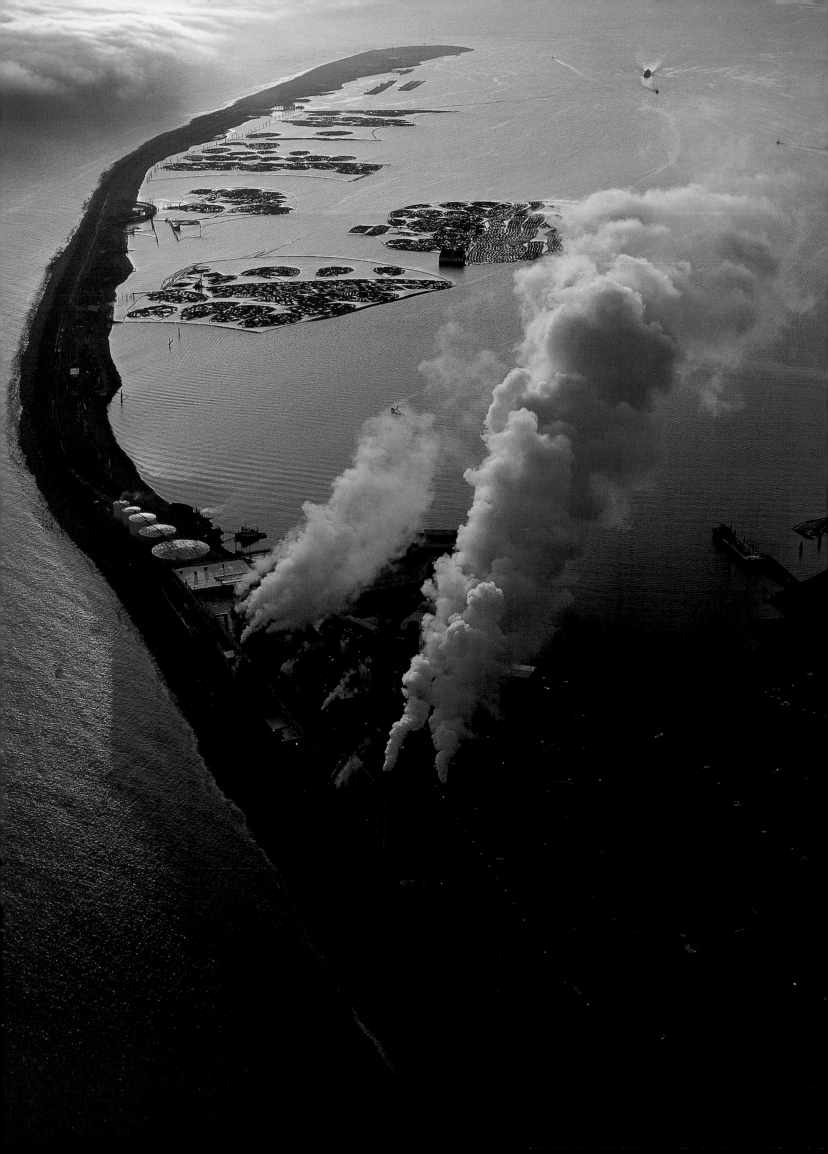

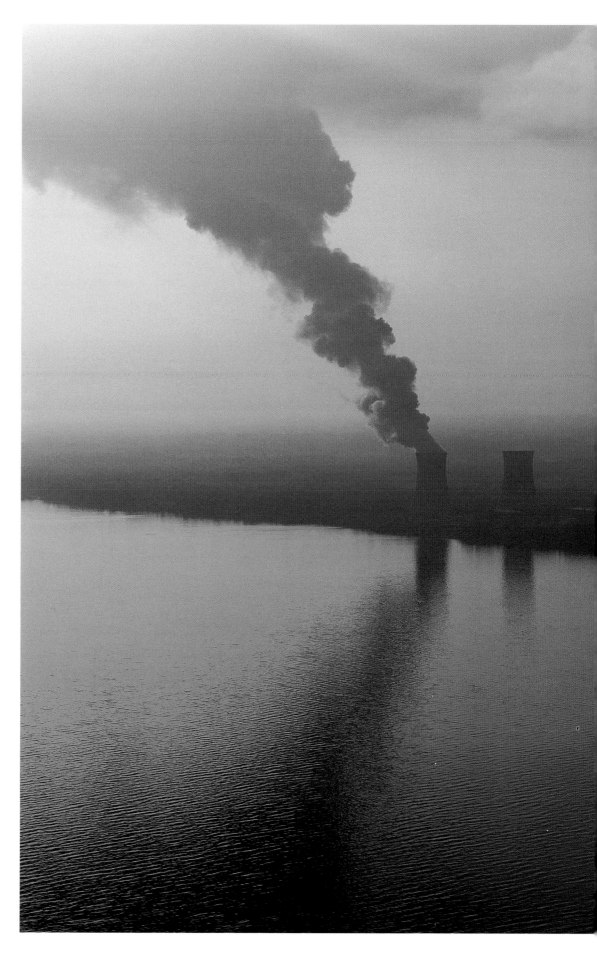

Right: Steam from the Perry Nuclear Power Plant rises over Lake Erie near Painesville, Ohio. Only one reactor is operational; the second was decommissioned before completion in 1985 because of an unexpected Magnitude 5.0 earthquake centered just ten miles away.

Left: Ediz Hook is a sand spit that projects into the Strait of Juan de Fuca from Port Angeles, Washington. Log rafts have been parked inside the hook, awaiting their fate at the Daishowa America paper mill at the bottom of the picture.

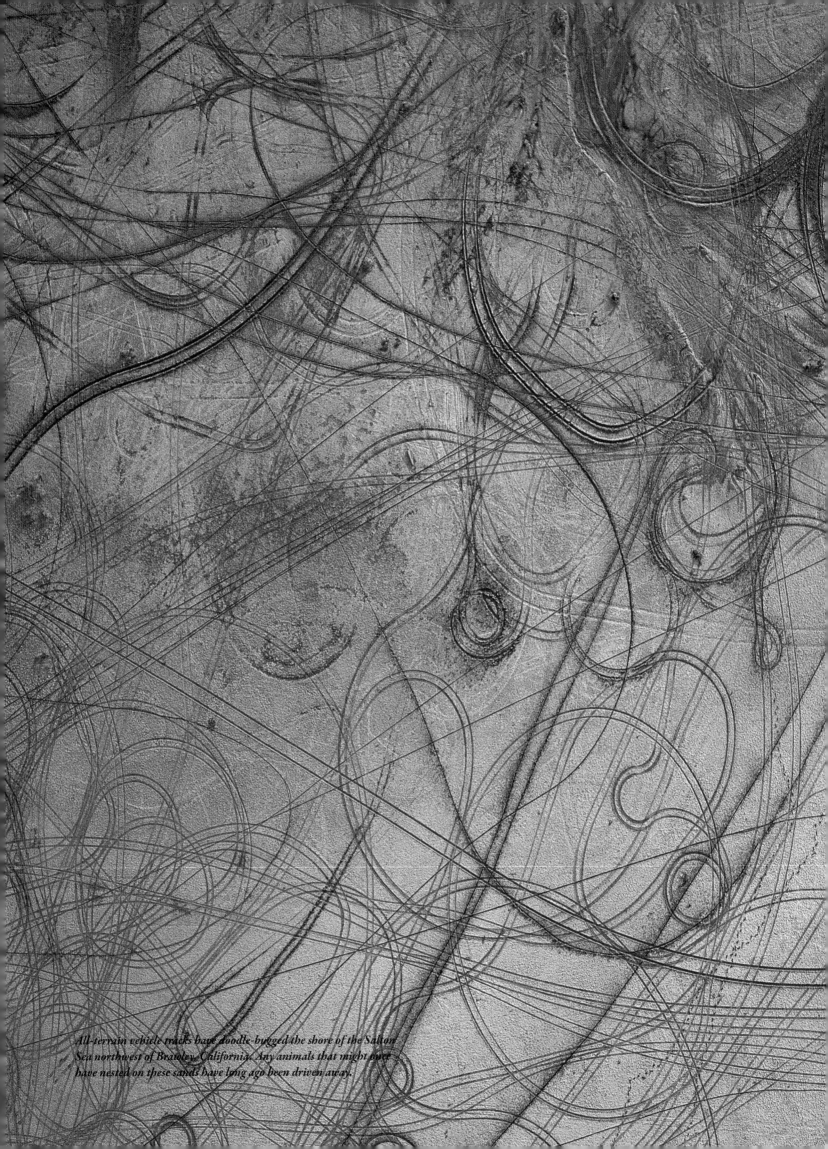

All-terrain vehicle tracks have doodle-bugged the shore of the Salton Sea northwest of Brawley, California. Any animals that might once have nested on these sands have long ago been driven away.

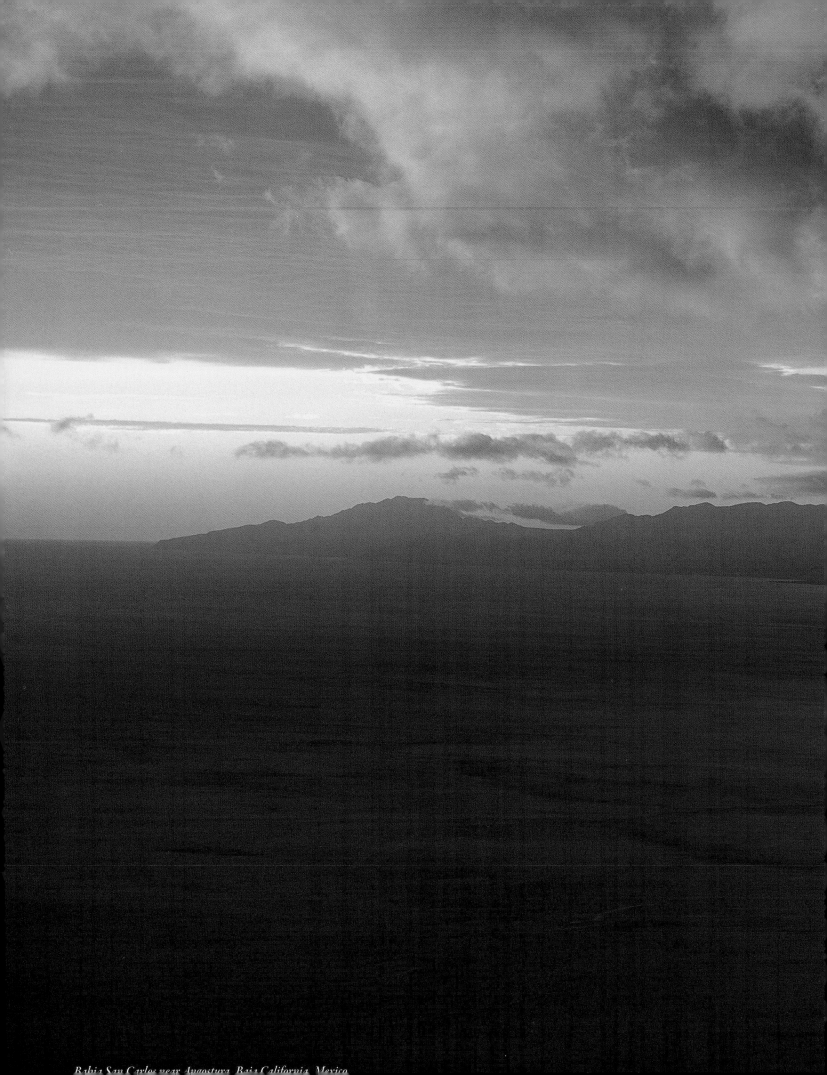

Bahia San Carlos near Angostura, Baja California, Mexico

A SOLACE OF WINGS

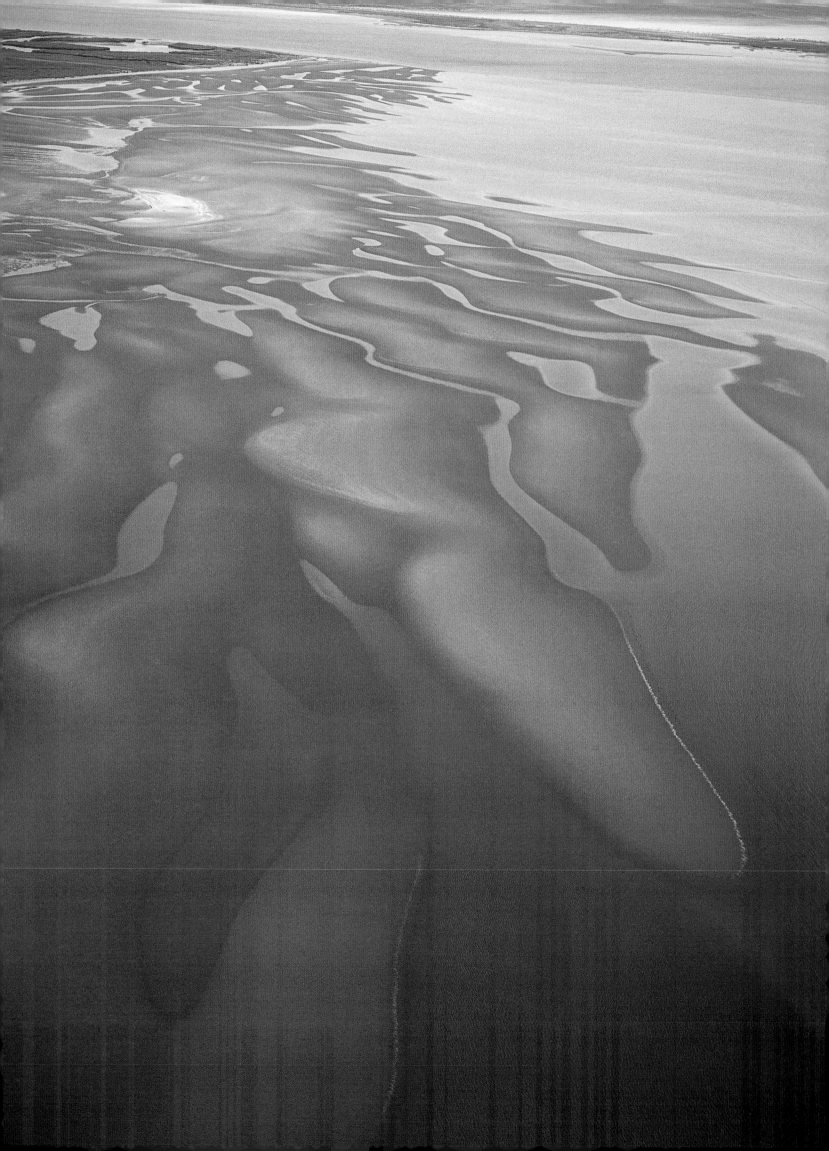

A certain recluse,
I know not who,
once said that no bonds
attached him to this life,
and the only thing he
would regret leaving
was the sky.

YOSHIDA KENKO, 1283-1350

I once watched two ravens soaring above a cliff. A strong wind blew through a six-foot notch, up and over the cliff. The sleek black birds spiraled down in aileron rolls as they dove through the notch. Then with the flick of a wing and a waggle of tailfeathers, each would pop back up to do it again and again. And again. I watched their pleasure and joy until I thought my heart would burst. That's how I fly; my fingers are wingtips; I waggle my tail. I don't want to come down.

A few years after beginning to fly, I decided to expand my horizons in a different direction: while continuing to write and photograph, I managed to stumble through medical school and survive residency to became a physician. I now work half-time as a family physician in Arizona, and occasionally fly to Baja California in Mexico to volunteer at a small clinic on the Pacific coast.

On the way down, crossing the Sea of Cortez from Guaymas to Mulege, I'm always relieved to hail the coast of Baja California. My flying techniques have grown more sophisticated since those early days dangling beneath a hang glider. I have radios and usually an engine. But Mulege is a 40-minute flight over 80 miles of open water, and I don't relish the thought of arriving upside down again. Along the way, I keep track of fishing boats, just in case. I wear a life vest and carry a raft, but still it's nice to be back within gliding distance of land as I pass Punta Chivato. Not that I want to come down; it's just good to know that I can do so without getting my socks wet.

Baja California shields the Sea of Cortez and northern mainland Mexico from the brunt of the Pacific Ocean. Unlike the Pacific, waters of the gulf are warm. Looking down, I've seen currents stirring its surface into vortices five miles across, swirling as if someone had pulled a plug on the world. As I head west, the spine of Baja rises a mile above sea level across my path, spilling canyons and cliffs down on both sides. I resist the

Sandbars at the mouth of Laguna San
Ignacio, Baja California, Mexico.

temptation to turn south and explore the blue water of Bahia Concepcion, or the siren's call of a shrimp cocktail at the Hotel Serenidad near the beach at Mulege.

Instead I climb over the Sierra de La Giganta. Desperate dirt roads penetrate this de facto wilderness, though I've never had the occasion or patience to drive them. I fly on toward the Pacific and the shallow protected waters of Laguna San Ignacio which extends twenty miles inland. Gray whales come here in February to give birth to their young; from above, I see a line of bulls guarding the narrow entrance against intrusion by orcas. All the lessons I've learned about coastlines are writ large across this empty Mexican landscape—the mangrove swamps at Estero de Coyote, the giant dune field streaming away from Bahia de Ballenas, the empty beaches that stretch past San Juanico, the spit of sand and hiss of waves on the lagoon below.

At the village by Laguna San Ignacio, I treat fishermen and grandmothers for their shoulder pains and diabetes. These people have laid out an intaglio that welcomes pilots like a beacon toward their dirt landing strip. It's made of white shells piled up wide enough to be seen from space—the outline of a mother whale swimming alongside her calf. It never fails to draw me out of the sky and into the lives of people living on this coast.

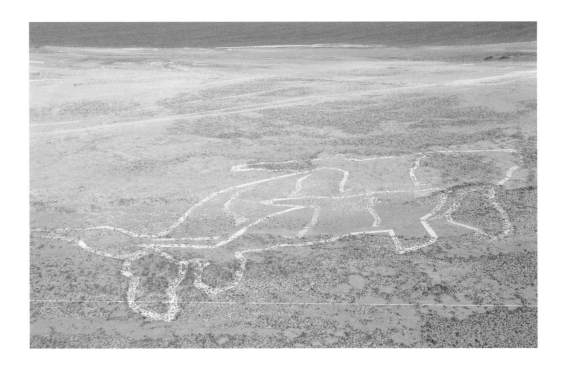

Above: Whale intaglio at Laguna San Ignacio.

Right: Sand dunes adjacent to Bahia de Ballenas in Baja California, Mexico.

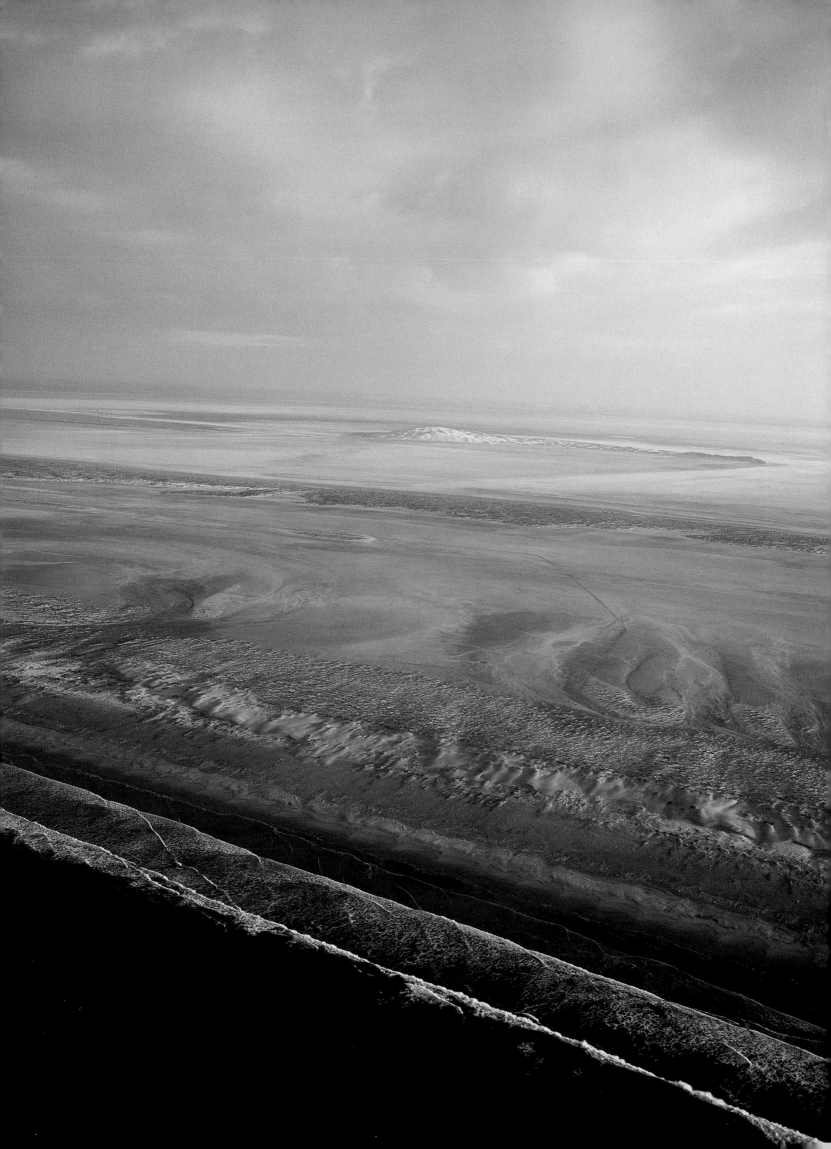

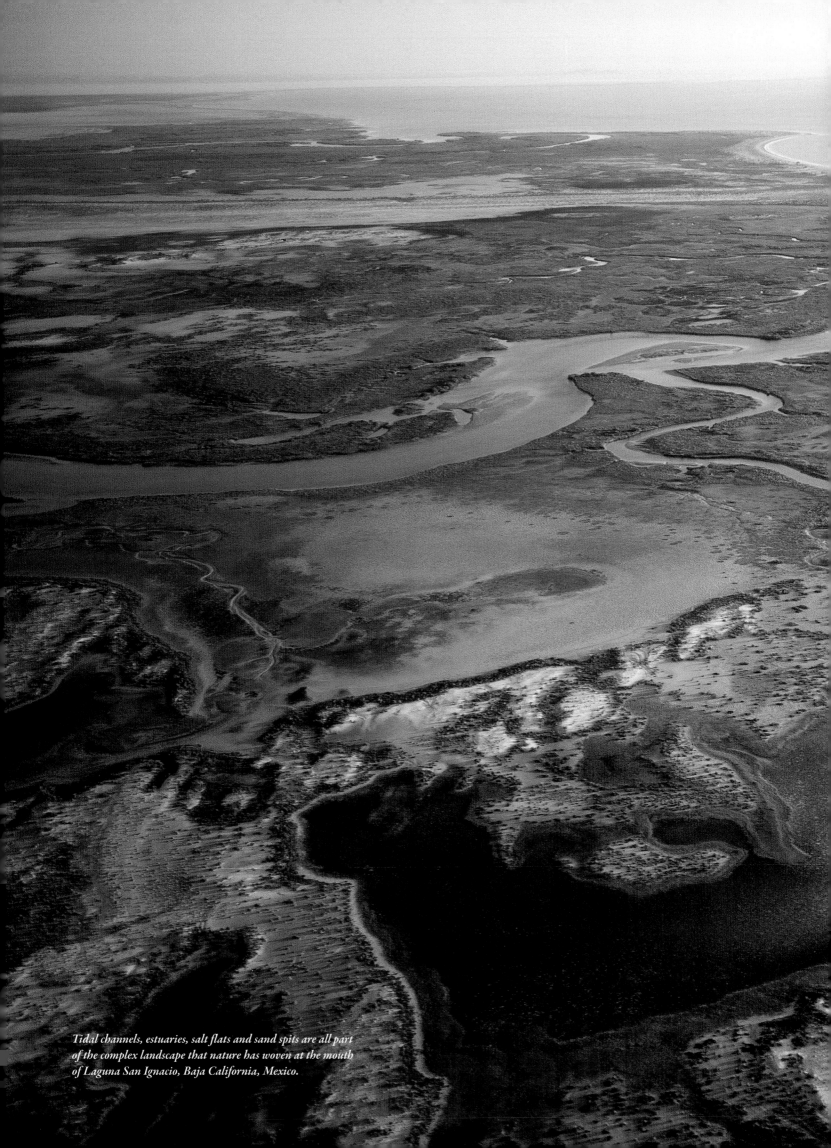

Tidal channels, estuaries, salt flats and sand spits are all part of the complex landscape that nature has woven at the mouth of Laguna San Ignacio, Baja California, Mexico.

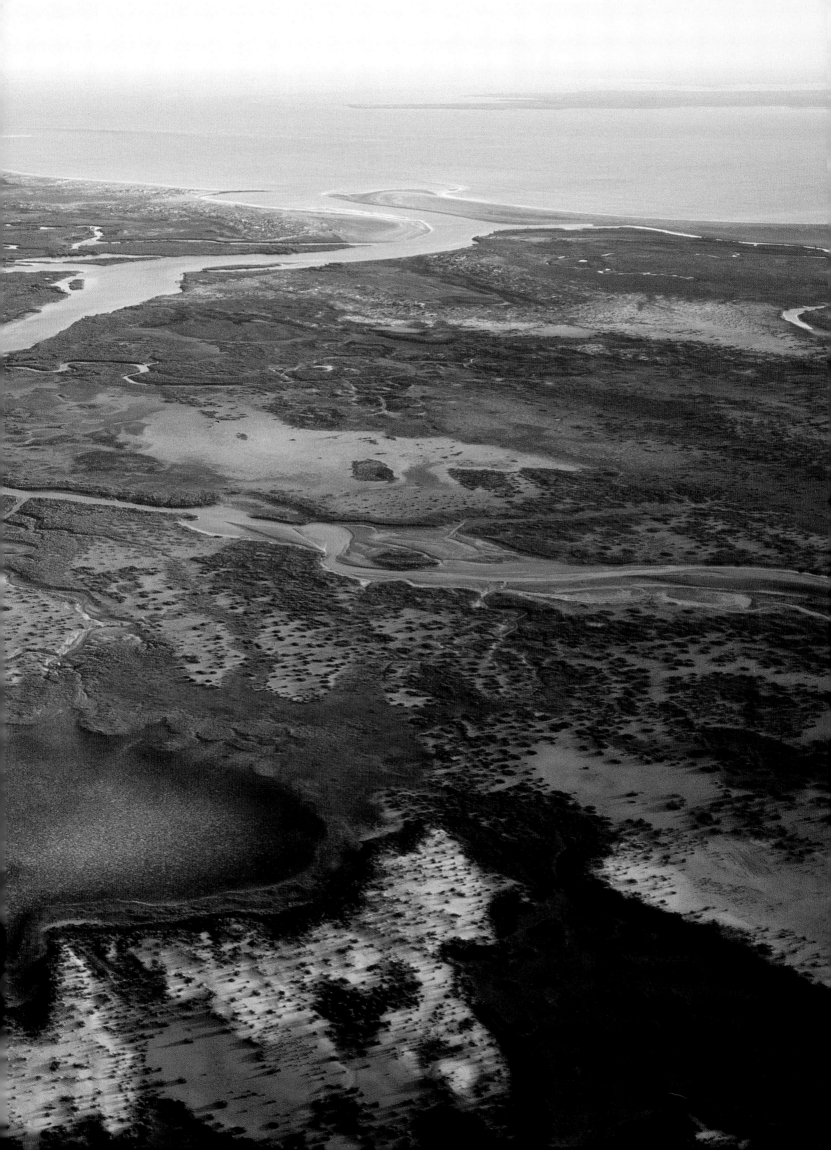

Photo Locations

Glossary

Barrier island– *offshore ridge of sand lying parallel to a coastline*

Beach– *sediment accumulated along a shoreline*

Breakwater– *protective structure built to prevent waves from entering a harbor*

Coast– *land near the sea including wave-disturbed sea floor, beach, and adjacent ocean-related features such as dunes*

Continental shelf – *gently sloping, submerged edge of a continent*

Delta– *body of sediment deposited at the mouth of a river*

Dune– *ridge of sand deposited by wind (or, if submerged, by water)*

Estuary– *coastal embayment with a significant influx of fresh water, regularly stirred by tides*

Fjord– *glacier-carved valley now flooded by the sea*

Groin– *wall built into the sea to trap sediment*

Jetty– *structure built into the sea to protect the mouth of a harbor or river from waves*

Lagoon– *saltwater body protected from tides and cut off from fresh water*

Leading edge coast– *steep coastline formed by collision of two crustal plates*

Longshore current– *nearshore current that flows parallel to the shore*

Marine terrace– *relatively flat, raised surface, beveled by waves before uplift*

Moraine– *poorly sorted pile of course sediment deposited on the sides or terminus of a glacier*

Peat– *unconsolidated accumulation of plant matter preserved under anaerobic conditions*

Plate tectonics– *theory describing the earth's crust as an interactive set of crustal plates*

Pleistocene– *recent geologic epoch characterized by several glacial ages*

Rip current– *current flowing away from a beach that returns water to the sea*

Sea stack– *coastal remnant isolated from a seacliff by waves that unevenly erode a coastline*

Sea wall– *structure built to prevent or slow coastal erosion*

Sediment– *unconsolidated particles derived from weathering, erosion, or chemical precipitation, and transported by wind, water, or glaciers*

Seiche– *oscillation of the water surface driven by differences in the wind or atmospheric pressure at different ends of a lake*

Shore– *zone extending from seafloor affected by waves to the area above high-tide line*

Shoreline– *instantaneous dividing line between water and land*

Spit– *elongate ridge of sand created by currents and projecting into a body of water*

Submarine canyon– *underwater canyon carved into a continental shelf*

Surge– *large bulge of water driven by wind ahead of an approaching hurricane*

Tide– *local temporary change in sea level, driven by gravitational attraction of the sun and moon*

Trailing edge coast– *shallow coast formed when two crustal plates separate*

Tsunami– *seismically generated sea wave*

Wave– *disturbance of water that occurs when energy propagates across the sea surface*

Wetland– *vegetated mud or sand flat that is frequently inundated by water*

Spit on the north end of Harwood Island, Strait of Georgia northwest of Powell River, British Columbia.

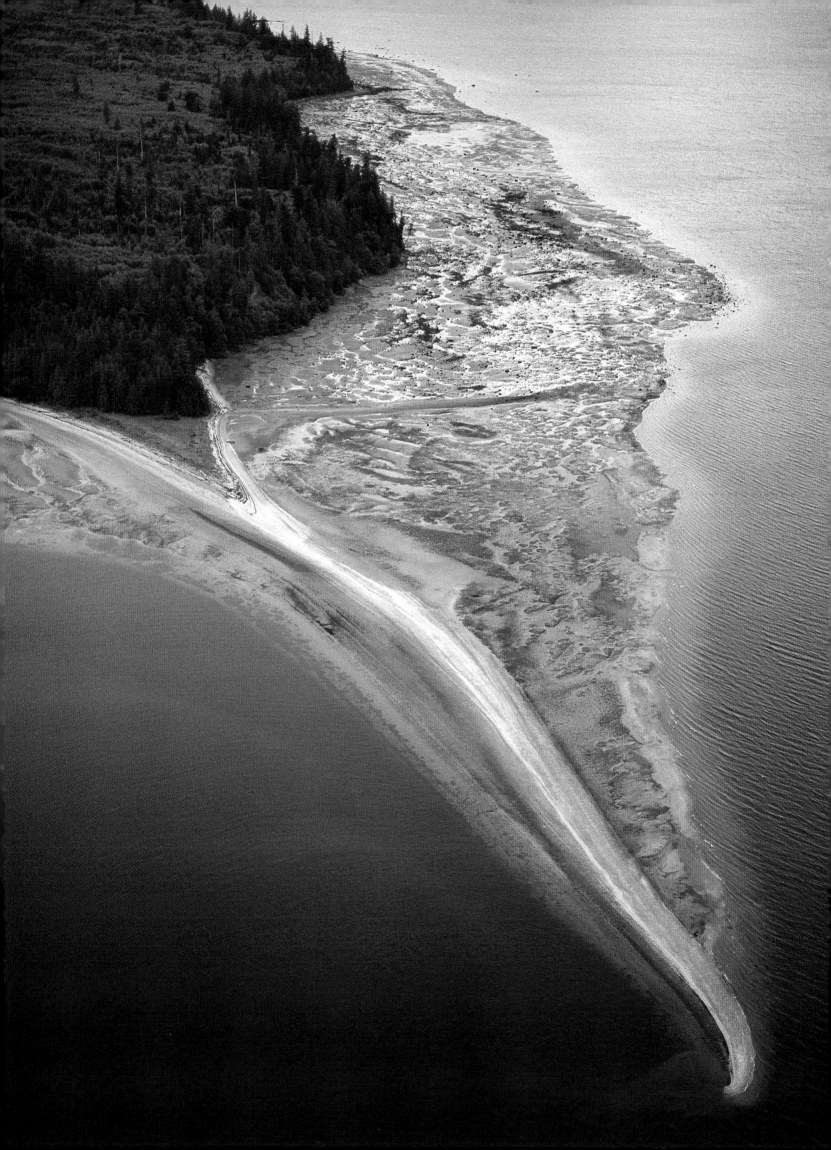

Recommended Reading

Davis, Richard A., 1995, *Coasts*, Prentice Hall

Pethick, John, 1984, *An Introduction to Coastal Geomorphology*, Edward Arnold

Shepard, Francis P. and Wanless, Harold R., 1971, *Our Changing Coastlines*, McGraw-Hill

Tarbuck, Edward J. and Lutgens, Frederick K., 2005, *Earth*, Pearson Prentice Hall

Woodroffe, Colin D., 2002, *Coasts*, Cambridge University Press

Acknowledgments

I deeply appreciate the support of the people who make this series of aerial geology books possible. Stu Waldman and Livvie Mann at Mikaya Press, and Lesley Ehlers of Lesley Ehlers Design have left their mark on every word, picture, and page. Without Pat Leahy, Ann Benbow, and Chris Keane at the American Geological Institute I would never have seen so many miles of these beautiful coastlines. Jay Kerger, John Atterholt, and Ron Weaver at Arizona Air Craftsman keep breathing life into my 54-year-old Skywagon. Joey Flynn and the Flying Samaritans introduced me to the wonderful people at Laguna San Ignacio. And Rose Houk remains the one with whom I most enjoy seeing these coasts and the rest of the world.

Lighthouse at Point Piedras Blancas, California.

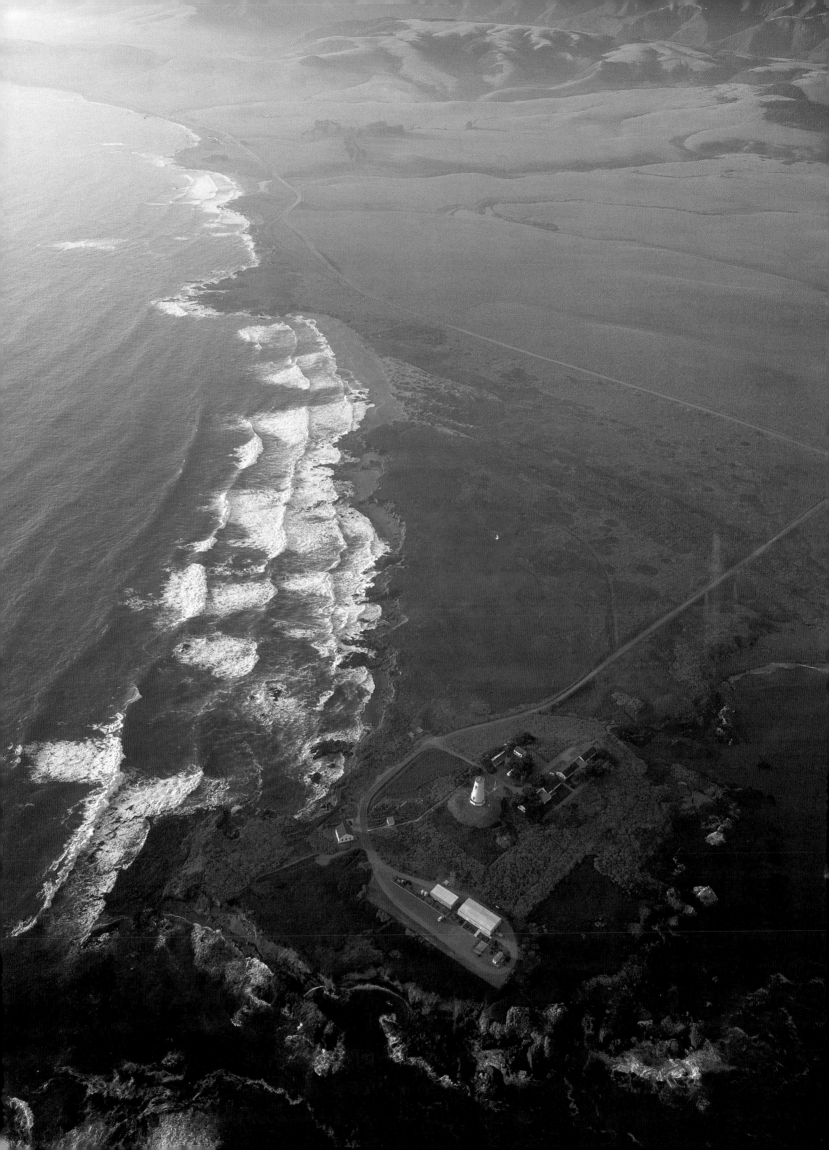

Index